Arts & Numbers

A FINANCIAL GUIDE FOR ARTISTS, WRITERS, PERFORMERS, AND OTHER MEMBERS OF THE CREATIVE CLASS

Elaine Grogan Luttrull, CPA

AN AGATE IMPRINT

CHICAGO

Author photograph copyright © Kim Long

Printed in the United States of America.

Library of Congress Cataloging-in-Publication Data

Luttrull, Elaine Grogan.
 Arts and numbers : a financial guide for artists, writers, non-profits, and other members of the creative class / Elaine Grogan Luttrull.
 pages cm
 Includes bibliographical references and index.
 Summary: "A guide to financial planning, budgeting, and business basics for creative professionals, artists, and nonprofit managers"--Provided by publisher.
 ISBN 978-1-932841-75-6 (pbk. : alk. paper) -- ISBN 978-1-57284-717-0 (ebk.)
 1. Finance, Personal. I. Title.
 HG179.L88 2013
 332.0240024'7--dc23
 2013010801

The advice contained herein is not intended to be a substitute for consultation with a certified professional who has a complete understanding of your situation.

10 9 8 7 6 5 4 3

B2 is an imprint of Agate Publishing. Agate books are available in bulk at discount prices. For more information, go to agatepublishing.com.

For my father, who taught me the secrets to success; my mother, who made sure I enjoyed the ride; and my brother, who mastered it all

CONTENTS

As you begin your numeric pursuits, or at least begin thinking about numeric pursuits, you may experience frustrations. Numbers and finance often give rise to long strings of expletives, shouted and muttered with equal enthusiasm. They may be in the forefront of your mind even now. If, for example, an unsuspecting certified financial planner or credit counselor asks you to complete a financial questionnaire—a standard form they use to ascertain your financial savvy, goals, and habits—you may feel like cursing with enthusiasm. So let's modify that "financial questionnaire" to honestly acknowledge our true feelings about finance. It might look something like this:

- ➤ Favorite expletive: _____
- ➤ Favorite expletive related to finances: _____
- ➤ Favorite expletive when budgeting: _____
- ➤ Favorite expletive when paying taxes: _____

Feel better? Now that's out of the way, so let's head in a slightly different direction. Feel free to relax and conjure images of blue skies, fluffy clouds, green pastures, and sunshine. Numbers and finance really aren't that bad.

Hi. It's Lovely to Meet You

This is not the most important book you'll ever read. This book won't make you millions, help you find true love, or inspire you to lose 20 pounds. But it does end happily.

It ends with a basic understanding of numbers and finance in the context of your creative career. It ends with artistic empowerment and financial stability. If you have a solid financial plan, if you have a small reserve of funds, and if your financial situation is under control, then you have full artistic liberty. You can say no to a gig you deem unworthy of your time and effort, and you can produce work for the audience you'd like to reach (rather than the one likely to buy your material). In other words, you can pursue your craft on

your own terms and not between waiting tables or amid hopping from couch to couch.

That is artistic empowerment: the ability to accept or decline a project for purely creative, rather than financial, reasons. Nothing is more important than your craft.

Lots of tasks and tools can support a creative career, from marketing services on social media to displaying portfolios on a well-designed website to managing a professional brand. Even if you're not a "tech person" or an "ad person," you can ultimately develop a basic appreciation for these tools and figure out how to use them to your advantage. You make them complement—not replace—your artistic point of view.

Why not do that with numbers, too? You should. You can.

Have a Seat. Let's Get Acquainted

You and I have a lot in common. I am a serial entrepreneur, and I've been freelancing in one form or another since I began teaching art classes at age nine to the other children in my neighborhood.

Exposure to art and creative expression is vital to a child's development. It is as important as reading and math, and it contributes to developing problem-solving skills, an appreciation for hard work, and empathy. My childhood was full of art. I won second place in an art contest when I was seven, and since then, every home I've inhabited has displayed at least one work of art I created.

I love to dance and still join the occasional formal class, although any delusions of grandeur vanished when my ballet instructor gently suggested I try Pilates instead. My brother is the greatest musician I know, although I've been privileged to meet other incredibly gifted individuals. I know enough from years of piano and flute lessons to be musically dangerous, but beyond muscle-memory renditions of *Moonlight Sonata*, I'm not a pianist.

I have bundled my incredibly creative childhood and adulthood into a career as an accountant. Despite my numbers-oriented profession, I am part of what I and others call the **creative class**—a creative accounting entrepreneur, specifically. In 2009 I formed a consulting company called Minerva Financial Arts to help artists

and other creative entrepreneurs bridge the gap between business and the arts. Minerva is Roman mythology's goddess of arts, commerce, wisdom, and a long list of other disciplines. She knew, as I do, that business and artistic pursuits are not mutually exclusive. My clients include tiny, newly formed arts organizations that need help with simple tax filings as well as larger, more established groups that have complex and technical finance questions.

Today I spend much of my time teaching college classes, seminars, and boot camp–like conferences on financial topics for artists and arts organizations. I have been touched by the incredible stories and adventures of those I've met in these sessions, which remind me that the world is full of talented people—artists, entrepreneurs, and members of the creative class—with interesting and well-rounded careers.

Mine has followed a meandering path and unpredictable detours through mountains, valleys, and plains. I can't wait to hear about yours.

Thanks for Picking Up This Book

I hope you enjoy *Arts & Numbers* and share it with peers, friends, colleagues, and family. I hope some of the stories resonate with your experiences. And I hope this book sparks your own creativity.

Whether you read it cover to cover or flip through certain parts is entirely up to you. You may keep it on your nightstand or bookshelf as a reference, or you may devour it in one sitting as part of a fit of productive procrastination. You may read a sentence as you fall asleep and dream of cities built from numbers. You may read it on the train and then leave it for the next person to find and enjoy.

My wish is not that you will discover a dormant love for accounting and finance after reading the book. Your contributions to the world are too important to subordinate to another role forever. I simply hope this book complements your creative career and convinces you that a basic appreciation of numbers makes you a better, more sustainable artist—just as an appreciation of art makes financiers or business types more compassionate, empathetic people.

Each chapter covers a financial topic of interest to a creative entrepreneur through fictional scenarios and financial advice. The advice is my own, and it is meant to be a starting point to building your financial foundation. It should not be taken as a substitute for consulting a professional accountant or attorney who has knowledge of your specific situation. The fictional scenarios are just that—fictional. They are loosely based on cases I've observed and shared with friends and colleagues, but any direct resemblance to actual situations is coincidental.

Some parts of *Arts & Numbers* may inspire the use of expletives, but I hope that impulse is short lived. Other parts may inspire the feeling of financial empowerment and conquest; I hope those parts are long lived.

No matter how you found this book, how you leave it, or what it awakens in you, thank you.

The Creative Class

Still harboring dreams of a starving-artist existence? Let them go. Starving artists have been marginalized and replaced by entrepreneurial artists and creative entrepreneurs. These are creative professionals who are willing and able to fight tirelessly for artistic empowerment and financial stability.

Two main tools distinguish entrepreneurial artists from starving artists: numerical literacy and portfolio careers, both of which are discussed in this chapter. Skim the statistics herein if you must, but don't miss these main points:

> ➤ Numerical illiteracy is as socially unacceptable as actual illiteracy.
> ➤ Creative entrepreneurs should build a portfolio career full of what I call starring roles, supporting cast jobs, and production assistance gigs, rather than following a singular pursuit.

Abby's Secret

Abby sits on a park bench, watching a building across the street. She arrived too early at this address—the venue for a fund-raising event—because she had no idea how long the train trip would take.

People in business attire rush to and from the building. Parents and nannies corral children as they traverse the sidewalk. Maintenance men exchange informal handshakes in greeting—gestures that seem out of place in this formal, professional setting.

The scene is a microcosm of her world, and Abby cannot help but wonder about her part in the mix. Although she has had significant success in her career as a painter, she is not used to the recognition that comes with this level of success. Her paintings are featured at a prominent gallery, which necessitated her attendance at the fund-raising event. Now she waits anxiously to enter a party in which she fears she doesn't belong.

The party, as it turns out, is full of interesting people from all sectors of the art world: patrons, sponsors, hobbyists, enthusiasts, and even professional artists. Abby spots a well-known art critic, and then she runs into a friend of a friend who is attending on behalf of a local politician. As they talk by a window, a tall man in a dark suit joins them. He introduces himself as an art connoisseur and professes himself a fan of Abby's work. As she describes to him a new technique she has been experimenting with, he mentions a magazine article he just read about it.

"Did you see it?" he asks, curious about her opinion on the writer's assessment of the technique.

"No," Abby answers flatly and dismissively. "I can't read."

A stunned silence falls over their conversation, leaving the connoisseur's mouth agape. The waiters carrying hors d'oeuvres pause and stare, and the art critic drops an olive from his drink. The hush seems to extend across the packed room.

"I'm sorry, what?" the connoisseur says. "What do you mean you can't read?"[1]

Numerical Illiteracy

The reaction of the party guests to Abby's statement is expected. We pride ourselves as educated individuals with at least basic literacy skills, which allow us to expand our minds. We read to learn about things with which we aren't familiar, to stay informed about our particular surroundings and the larger world, and to navigate daily life. We communicate through the written word, whatever form it may take. Because we don't come across much illiteracy in the professional setting, a confession like Abby's is shocking to hear.

This scene, of course, never happened. And it probably wouldn't. Even if Abby cannot read, she is not likely to proudly declare it. She may say that she has not read the article in question, or she may ask the connoisseur to tell her about it.

But imagine if the scene unfolded just a bit differently. Imagine that the connoisseur says instead that he is interested in commissioning a public artwork and asks Abby to estimate the level of investment such a project might require.

"Oh, I don't do numbers," Abby replies lightheartedly, dismissing the question.

"I don't need an exact number," the connoisseur assures her. "Just a ballpark. What did the installation at the gallery cost, for example?"

"Really," she insists. "I have no idea. Numbers aren't my thing."

As Abby proudly asserts her *numerical* illiteracy, no one notices. There is no stunned silence, dropped jaw, or rude stare. Someone may even nod sympathetically.

The reason for this reaction is that it has become socially acceptable to be numerically illiterate, even while actual illiteracy appalls. What's worse is that numerical illiteracy seems almost to boost the esteem of artists. They can't be bothered with numbers because they are too creative.

Creative Professionals: We Are the 0.7 Percent

According to the National Endowment for the Arts (NEA) Research Note #105, in 2009 there were 2.1 million artists in the United States. Another 264,000 of US residents were "nights and weekends" artists—those who worked in paid artist jobs but whose primary source of income was another pursuit.[*]

In general, the artist population comprises people who are entrepreneurial, educated, and gainfully employed. This group is 3.5 times more likely than the general population to be self-employed. Fifty-nine percent of all artists surveyed from 2005–2009 received at least a bachelor's degree (compared with only 32 percent of workers in the general population). The median annual artist wage was $43,230, while the median wage of the entire US labor force was $39,280. Although the artist wage exceeded the labor force wage by about $4,000 per year or 10 percent, it was considerably lower than the median wage of business professionals. The mean annual wage of those in management occupations in May 2011 was $107,410, while the mean annual wage of artistic occupations was $53,850.[3]

Median Wage of Artist Population, 2005–2009

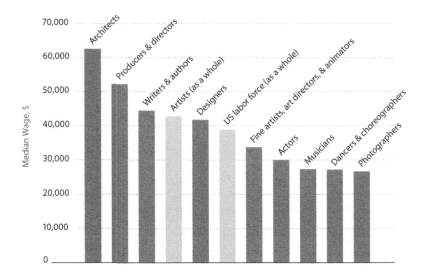

Source: National Endowment for the Arts Research Note #105, "Artists and Arts Workers in the United States," 2011. http://www.nea.gov/research/Notes/105.pdf.

Artists, on the surface at least, have some sense of balance in their lives. Forty-four percent of this population worked part-time (defined as fewer than 35 hours per week) or part-year (defined as fewer than 50 weeks per year). Whether this balance is achieved intentionally, because of artists' desire to juggle various aspects of their lives, or unintentionally, because of an underdeveloped market for artists' work, is a question that cannot be answered by the data alone. In addition, artists appear to be in the prime of their lives. In 2009, the median age for this group was 40. *Entrepreneurial, educated, employed, balanced,* and *mature* are adjectives that are not stereotypically associated with the term "starving artist." More often, we would think of these individuals as young, poor, nonworking, and certainly not entrepreneurial.

Who Are Entrepreneurial Artists?

The artist population includes actors, TV and radio announcers, architects, dancers, choreographers, designers, fine artists, art directors, animators, musicians, various entertainers, photographers, writers, producers, and directors. This list, used in the NEA's Research Note, is by no means exhaustive, given the huge number and diversity of entrepreneurial artists, but it's a start.

According to the NEA's Research Note, these artists listed art as their "primary" job, which means they spend a majority of any given week working in an arts field—rather than, say, bartending. Fifty-four percent were employed by the private, for-profit sector, while thirty-four percent classified themselves as self-employed. Those who worked for neither private companies nor for themselves (twelve percent) were employed by either the nonprofit or government sector.

Breakdown of Artist Employment

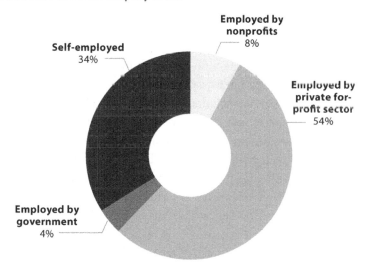

Source: National Endowment for the Arts Research Note #105, "Artists and Arts Workers in the United States," 2011. http://www.nea.gov/research/Notes/105.pdf.

Fifty-nine percent (1.24 million) of these employed artists received at least a bachelor's degree, although in the United States only about 9 percent (3.9 million) of the adult, degree-holding population majored in art or an arts-related field in college. The disparity

between the number of people who studied art formally and those who ended up working as actual artists is certainly striking. Pretend that the bachelor's degrees of all of the 59 percent (again, 1.24 million people) were in art or an arts-related discipline (which is, arguably, a conservative assumption because at least some working artists likely studied something other than art). That means approximately 2.66 million people (out of the 3.9 million) who studied art chose to pursue a different career.

Where Have All the Artists Gone?

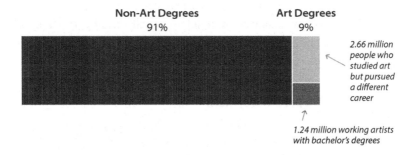

Non-Art Degrees
91%

Art Degrees
9%

2.66 million people who studied art but pursued a different career

1.24 million working artists with bachelor's degrees

What happened to the 2.66 million? Maybe they are still artists, but their work doesn't qualify as a primary job, as defined by the NEA study. Maybe they decided to leave the arts industry altogether. Maybe they failed to become professional artists for one reason or another. Maybe they honed a nonartistic skill and became creative entrepreneurs in another field. We don't know exactly. We do know that artists are sprinkled across a lot of industries, and that the artist population is sizeable and not restricted to one discipline or another. The omnipresence of creativity in and out of the traditional artist profession is comforting, especially to those of us who define ourselves as creative entrepreneurs.

Who Are Creative Entrepreneurs?

A crucial part of the creative class missing from the NEA report is the growing group of business professionals who choose to manage their careers in entrepreneurial ways. Specifically, they are the attorneys who run their own legal practices, the accountants who work

independently, the teachers who maintain and manage a portfolio career of education-related activities, and the other professionals who have developed an expertise and now leverage it by being consultants or contractors. These are creative entrepreneurs. They face many of the same occupational challenges entrepreneurial artists encounter. They juggle multiple gigs, differentiate themselves from fierce competition in their fields of work, and manage the cash flow and expenses related to their business ventures. (Later in the book, you will meet Elizabeth [a financier] and Alison [a human resources expert], both of whom are knowledge-based workers who fit the extended definition of the creative class.)

Together, entrepreneurial artists and creative entrepreneurs are driving the employment shift we see in the US labor force. The savviest, most talented individuals now seek more entrepreneurial roles, transforming themselves from self-employed-but-starving professionals to creative entrepreneurs. By approaching careers in this way, they gain more control of their livelihood and thus are more empowered than they ever thought possible.

The idea of the creative class; the creative economy; or a future world built on the knowledge, skills, and talent of ambitious and hardworking people isn't new. Many cultural observers, among them Paul Fussell, Peter Drucker, Fritz Machlup, Daniel Bell, David Brooks, and Richard Florida, have studied and reported this phenomenon. Their collective work has given a voice to the community of creative professionals who dare to dream (and work through sweat and tears to achieve that dream) of finding self-fulfillment through the work they love, no matter their core pursuit—accounting, law, engineering, design, technology, painting, acting, or writing. Of course, pursuing career empowerment, independence, and fulfillment comes with challenges; being a creative entrepreneur is not for the faint of heart or the tremendously risk averse.

What Is the Industry Outlook for the Arts?

All things considered, the creative class is doing fine. The following table presents average wages for certain professions (as of May 2011) compiled by the Bureau of Labor Statistics (BLS).

Annual Mean Wages for Selected Professions, as of May 2011

Occupation Title	Annual Mean Wage
Lawyers	$130,490
Management occupations	$107,410
Advertising and promotions managers	$103,350
Art directors	$95,500
Agents and business managers of artists, performers, and athletes	$92,250
Producers and directors	$92,200
Fashion designers	$73,930
Accountants and auditors	$70,130
Media and communication equipment workers	$69,570
Writers and authors	$68,060
Technical writers	$67,280
Artists and related workers	$61,520
Editors	$60,490
Music directors and composers	$53,760
Fine artists, including painters, sculptors, and illustrators	$53,400
Graphic designers	$48,960
All occupations	$45,230
Choreographers	$44,160
Costume attendants	$40,600
Photographers	$36,580
Fitness trainers and aerobics instructors	$36,150
Craft artists	$32,270
Bakers	$25,160
Retail salespeople	$25,130
Bartenders	$21,550
Waiters and waitresses	$20,890
Actors	$33.82 per hour
Musicians and singers	$31.74 per hour
Dancers	$19.53 per hour

Data from Bureau of Labor Statistics, "May 2011 National Occupational Employment and Wage Estimates," accessed April 2012. http://www.bls.gov/oes/current/oes_nat.htm#11-0000.

According to the 2010–2011 edition of the *Occupational Outlook Handbook*, published by the BLS, employment in the arts industry is projected to grow about 12 percent through 2018, a rate on par with the average growth expected in other industries. Multimedia

artists and animators can expect slightly better growth (14 percent through 2018), while fine artists and crafters can expect growth that is slightly less (9 percent and 7 percent, respectively). The nature of the work performed by an artist, however, leads to a field saturated with creative individuals, which makes competition for work stiff.[4,5]

For actors, job growth is forecasted to be 4 percent from 2010 to 2020, which is considerably slower than the average. Although the demand for film and television productions is expected to increase, growth of acting jobs is not expected to keep pace due to curtailed demand for live performances and experimentation with new media and nontrained actors.

Unlike actors, dancers can expect job growth of 18 percent. This is good news for dancers, whose mean wages round out the bottom end of the scale (see Annual Mean Wages for Selected Professions from May 2011). There is no indication, though, that pay will increase along with the number of jobs. And, given the popularity of dance as a field of study, more people are expected to enter the dance workforce than there are (projected) jobs, which will create intense competition for the positions.

The demand for musical performances is expected to rise, resulting in the long term growth projection for employment in the music field—10 percent from 2010 through 2020. As is true in other arts disciplines, though, this means that competition for the available jobs is expected to be tough.

Jobs for producers and directors are expected to grow 11 percent from 2010 to 2020, a projection made as a result of the continuing demand both nationally and internationally for films and motion pictures. In addition, producers and directors may benefit from the forecasted increase of new forms of content delivery, such as streaming and mobile technologies.

The projected job growth for writers and authors is 6 percent from 2010 to 2020, a rate slower than the average for the arts industry overall (12 percent), although the outlook exceeds that for actors (4 percent). Competition for writing jobs, as a result, is expected to be particularly fierce, and even more challenging given that there is unpaid access to written content posted on the Internet or printed in free publications.

Projected Job Growth for Artists

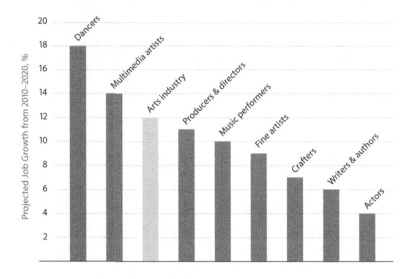

Data from Bureau of Labor Statistics, "May 2011 National Occupational Employment and Wage Estimates."

The Creative Professional Spectrum

There is an entire gamut of entrepreneurial artists and creative entrepreneurs—from dabblers to those who earn significant success doing what they love. There is also a large group who remain hobbyists, without making their artistic pursuits a part of their profession. Neither extreme represents the bulk of the creative class. Instead, most of us fall somewhere in the middle. To illustrate this spectrum, I created the following chart:

Creative Professional Spectrum

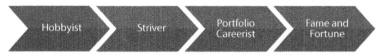

Most of us start off in the "striver" category. We pursue our craft (be it accounting, fine art, or dancing) earnestly, but we also

maintain another form of employment for job stability, health insurance and other benefits, or cash flow purposes. Amassing a fortune would be nice, but we'd be happy just pursuing our art. The "portfolio careerist" category is the point at which we have a self-directed career that allows us to pursue our craft (and perhaps tasks related to our craft) without maintaining other (unrelated) employment for financial stability.

Portfolio Careerist

Three types of work make up an entrepreneurial portfolio career: what I will call the **starring role, supporting cast**, and **production assistance**. Each type is discussed in this section.

The difference between a hobbyist and a striver is the amount of time spent on one's chosen craft. Entrepreneurial artists who are strivers, not hobbyists, are always writing, sketching, painting, playing music, performing, or producing something for their primary occupations. The same can be said of creative entrepreneurs more broadly. They are always thinking about ways to grow their business or pursue something fulfilling and challenging. This doesn't mean that everything they create is good, and it doesn't mean they are working on their craft 100 percent of the time. But it does mean that a little of that work should happen every day, or at least most days per week, consciously or subconsciously. Different people keep different schedules, so "always" can be defined according to each person. Once people stop producing regularly, even if they are artists at the core, their art becomes a hobby.

The difference between being a striver and having a portfolio career is that portfolio careerists have far less production assistance work—in other words, work that is unrelated to the craft or field (discussed more on page 26). Everything a portfolio careerist does or produces professionally (which may include various supporting roles) is related to the craft, not to a production assistance gig (such as temping or bartending).

Lastly, the difference between a portfolio careerist and fame and fortune are the extras. Someone who has achieved outrageous success from her art doesn't have to complete supporting roles.

She may choose to take on a supporting cast role, perhaps adjudicating an event, guest-judging on a panel, or contributing an article of interest to a related publication, but such roles are part of the artist's contributions to the industry as a whole rather than part of a sustainable career.

Time Spent on Primary Craft, per the Creative Professional Spectrum

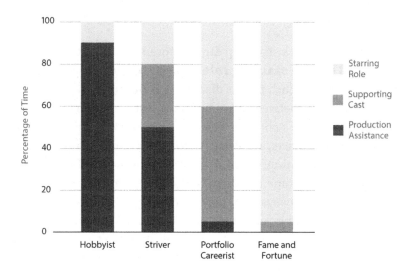

Starring Role In a portfolio career, one thing stands out: one talent, one passion, or one ultimate goal. This thing can be defined broadly (e.g., writer) or narrowly (e.g., playwright, screenwriter, poet), but it must be just one. A starring role is what you would do if money were not a consideration or if you could do whatever you wanted. It is your truth. It may be something you have been steadily building since childhood or something that has always simmered in the background as you go about your life. It is always there.

Do you know your starring role? If not, how can you find it?

In his book *The Pleasures and Sorrows of Work*, the British writer and philosopher Alain de Botton describes one way of identifying a starring role. A career counselor—a psychotherapist who formed a company called Career Counseling International in London—asked

his client to fill in the blank areas on two sheets of paper, one of which was labeled "Things I Like" and the other "People I Envy." After reviewing his client's written musings about her passions and her envy, the counselor probed deeper into the client's feelings and reasoning about her lists. What was it about something that she liked, particularly? Why did she envy her colleague or close friend? Why did something or some place stir her passion? How could she articulate her envy in a positive way? By reducing her "Things I Like" list into one-word nouns and by harnessing the power of envy to illustrate the client's desires for herself, the counselor helped the client come to a realization about what she wanted to do with her life. She found her real starring role.[6]

Although it is the foundation for building a portfolio career, the starring role doesn't have to be creative and it can be defined broadly or narrowly. There is no singularly correct description. What matters is your sincerity in articulating the starring role.

Supporting Cast A great supporting actor can make the lead star shine brighter. Such is the case with supporting cast roles for a portfolio career. Supporting cast jobs or gigs are related to the starring role, but are not the same as starring roles. For example, a musician may have a supporting cast job as a weekend music teacher to children or as a part-time music store clerk. Similarly, an actor may lead acting workshops, be a stagehand for a local theater, or review plays for a blog or print publication. A writer, meanwhile, may tutor high school students in English or coach them on their college application essays.

You may not want to fill any of these roles full time, but all of them are related to your craft and provide you with both financial and creative benefits. In other words, such gigs are not exactly what you dream of doing, but they help keep the lights on, offer a creative outlet, and even contribute to skill development and work experience while you pursue your starring role. If you actually glean a lesson from supporting cast jobs, instead of grudgingly filling them, you'll have a much more interesting story to tell (maybe to James Lipton, the host of *Inside the Actors Studio*).

Production Assistance In some cases, work that is unrelated to the craft or field is preferable. It can be a completely separate discipline, short term, and flexible, allowing the creative entrepreneur to juggle it along with creative commitments. This type of work is called "production assistance"—a job that pays the bills and other expenses. The classic production assistance roles include waiting tables, bartending, being a nanny, and temping in an office.

By allowing your brain to have idle time—time where it is engaged in a noncreative task unrelated to your art—you empower it to relax and form connections in the background. You give your brain a break creatively. Production assistance work comes with little or no pressure because it is unrelated to your passion, and it is easier to walk away from production assistance work without compromising your creative career than it is to walk away from supporting cast work.

Although temporary in nature, production assistance work may continue for a long time. It is repeatable, meaning it can be done in a lot of different cities, for a lot of different employers, and as frequently (or infrequently) as desired. It supports the starring role *indirectly* in that it prevents starvation, homelessness, or other dire situations. This stable financial source, especially given the cash flow and budgetary challenges many creative professionals face in the course of living and pursuing their craft, isn't taken lightly. Rather, it can be the difference between a long-term, sustainable career and failure as an entrepreneur. By making the *choice* to include production assistance jobs in your portfolio career, you take the pressure off of your creativity and starring role. This type of work fills the gaps not only in cash flow but also in job experience and skill.

Don't view production assistance gigs as a shortcoming or embarrassment. Taking them doesn't mean you've sold out or failed as an entrepreneur. In fact, quite the opposite is true. Although they aren't the most important things you can be doing, they make the most important thing (your starring role) possible. For this to happen, though, you have to be transparent and communicate your needs. You must find a source of income (production assistance role) that is flexible, predictable, and full of supportive people (especially a boss) who are aware and supportive of your creative passion;

otherwise, the job isn't a good fit. And if the production assistance gig offers opportunities for growth and learning difficult skills or traits (like public speaking and patience), that is even better.

Starving Artist

"Starving artist" isn't anywhere on the creative professional spectrum. It isn't before the striver category nor beyond the portfolio careerist category. In fact, in the modern world of the creative class, the idea of a starving artist seems quaint and passé. You do not have to live only in dangerous and underdeveloped neighborhoods full of like-minded individuals waiting to meet a billionaire patron to finance their crafts. You do not have to sleep on sagging couches or dirty rugs nor convince yourself that the subpar surroundings justify your artistic pursuits. Taking a production assistance job and pursuing supporting roles can prevent this meager existence.

The reality of a portfolio career is that it takes time to build, and during that period, income may be unstable. When gigs aren't forthcoming, cash flow is hindered, although life continues to unfold. A portfolio career doesn't come with paid maternity or paternity, sick, or bereavement leaves. It doesn't come with personal days off or comp time earned from excessive hours worked.

Crossing over from a striver to a portfolio careerist is a lengthy journey, and plenty of creative professionals oscillate between the two points throughout their careers. Meanwhile, they supplement their portfolio careers with additional production assistance tasks or projects when needed, rather than abandoning their starring roles.

One More Thought

Cultural theorist Richard Florida chronicles the phenomenon of the creative class in his book *The Rise of the Creative Class*. He defines the class as an economic force whose members "add economic value through their creativity." According to Florida, the members' creativity and values affect their "social, cultural, and lifestyle choices," and he takes pains to articulate that others started noticing the emergence of this group in the United States as early as the 1960s,

although these people's economic impact was comparatively less at that time.[7]

By 1999, the creative class represented 38.3 million people in the United States (30 percent of the population), and the average salary was $50,000. The existence of a creative class has "a strong positive effect on regional earnings [and] lessen[s] unemployment, especially since the [2008 financial] crisis," according to economist Todd Gabe.[8] The existence of a creative class has also proven to be a more reliable measure of employment growth than human capital, another commonly used measure.

Whether you believe the creative class drives growth or is a product of that growth or whether you associate diversity, tolerance, or art funding with the positive aspects of the creative class, is beyond the point. The point is that you, as a creative entrepreneur, aren't going anywhere and your group is growing in numbers. In the United States at least 2.1 million people (the artists) consider themselves part of this group (based on 2005–2009 data); the equivalent number in 1982 was a little more than 1 million.[9]

Thanks to the rise of the creative class, you are considerably more empowered today. You are much more able to drive your own career and build a portfolio of work (either directly or indirectly related to your craft) that allows you to live successfully and productively.

So, yes: becoming a creative entrepreneur can be risky, but it comes with tremendous rewards.

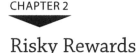

Risky Rewards

Companies and organizations are noticing the emergence of the creative class, and even as some are redefining cultures and benefits to address employees' evolving needs, others are shifting risk from the entity level to the individual level. In other words, risk has shifted from institutions to people in the arts industry. With that shift comes incredible freedom, flexibility, and reward—but also risk. Let's look at some examples.

Stories of artists affiliated with just one movie studio, one theater, or one gallery for the duration of their careers are nearly obsolete. Consider the film industry. Hollywood in the 1930s and 1940s was filled with actors (e.g., Joan Crawford, Clark Gable, Spencer Tracy, and Greta Garbo) who were under contract with one major studio or another—such as MGM, which boasted the largest collection of film stars under contract.[10] MGM paid each actor a salary, and he or she was expected to fill whatever roles MGM requested. Actors rarely shared in the profits of a film; nor did they wonder whether a paycheck would be forthcoming. The studio bore the risk (and the reward) of the film. Today, many actors are no longer under exclusive contract; nor do they have guaranteed salaries. It's riskier for the actors because they don't have guaranteed employment; but it comes with more rewards because they are able to share in a movie's profits and exert more control over their roles.

Consider the change in the writing world as well. Lady Augusta Gregory was the hospitable Irish patron to literary giants such as George Bernard Shaw, John Millington Synge, and William Butler Yeats. These writers visited her home, Coole Park in western Ireland, for (underwritten) refuge and inspiration during the Gaelic literary revival of the late 1800s and early 1900s.[11] Aside from formal (and competitive) residencies, literary patrons have all but dissipated in the modern day. Similarly, theaters no longer employ playwrights and companies of actors, dancers, and musicians to execute whatever

new or recycled works are slated for the season. Now, about 22 percent of a playwright's average income comes from commissions, and such commissions are generally paid to contractors rather than to employees of the theater. Actors, musicians, and dancers are hired per production rather than per season, increasing the flexibility for the performer along with the risk of unemployment.[12]

As these instances show, creative entrepreneurs now face personal and financial risks in equal measure. They must face failure on an ongoing basis, in nearly every aspect of their careers. There is no company to protect them, no colleague to share blame, and often no safety net to catch a failed opportunity before it becomes catastrophic.

Many of the financial risks creative entrepreneurs face are discussed at length in this book. They face the risk of cash shortages (and the inability to pay bills); they face the risk of choosing to forgo insurance or other benefits for the sake of purchasing more supplies; they face the risk of living gig to gig or paycheck to paycheck instead of building a budget—a financial plan—to get ahead; they face the risk of interminable work because they have no savings for retirement, no pension.

In the investment world, the reward gleaned from an investment is commensurate with the investment's inherent risk. The more risky an investment, the more an investor demands in compensation (reward) for undertaking the risk. But what rewards could possibly justify the risks enumerated above for creative entrepreneurs?

Empowerment. The ability to be self-directed and retain creative control over one's craft. Full creative liberty. Being beholden to no one.

Not everyone decides these rewards justify the very real, tangible risks in an entrepreneurial role. But you did, consciously or subconsciously. You decided the rewards justified the risks, and you are willing to bear them, manage them, and work to minimize them by budgeting, building a cash reserve, and translating your goals into financial terms, all of which are discussed in the ensuing chapters.

In a way, this makes sense. Performance venues are increasingly dependent on fund-raising and ticket sales, and budgetary contingency plans often include scaling back performances by reducing the number of performers or the number of performances. This is

only effective as a cost-cutting measure if the performers are paid per performance rather than as company members. (That is, if the performers bear the risk.) Entrepreneurial artists are not slaves to this arrangement, however. They may embrace the risks and the associated freedoms to channel their own nonlinear, meandering paths through creative careers.

Noah's Dilemma

"I don't know what I'm supposed to do," Noah confesses, eyes downcast and lids blinking to hold back his tears.

"What do you mean?" his friend Elizabeth, a financier, asks.

Noah glances up to survey the scene around him. The tables in the coffee shop overflow with computers, tablets, and smartphones, outnumbering the people who use them. The hum of productivity fills the air: machines and gadgets whir, click, and beep around the room; glasses and plates clank; and voices carry through the air. The busy workday rolls on, despite Noah's panic.

"I did everything right," he replies. "I worked hard to finally get to this dream job. But now that I landed it, I hate it. It isn't what I thought it would be, but I don't feel like I can walk away. It is paying my bills, though, and I'm scared to try something else."

"But aren't you doing what you love?" Elizabeth asks. "Isn't that worth something? Even more than being a millionaire?"

"But I don't love it. So many aspects of this design firm are awful. I hate working on projects that are not fulfilling. I hate executing a design plan for a client with no taste. I hate having to sell more work. And besides, I'm not exactly getting rich," Noah exhales. "I never thought I'd be a millionaire, but I did think I'd be able to live comfortably and maybe even save a bit. I can pay my bills, but I can't get ahead."

Nonlinear Path

Tradeoffs between financial security and artistic freedom are ever present in life, and Noah continues to face them. He finds himself making ends meet, but not getting ahead financially, and feeling unfulfilled creatively. He thought he had traded a little creativity for a lot of financial stability, but he miscalculated.

Some of us may even romanticize the idea of trading in our stable jobs for a chance at creative fulfillment, as though financial strife is a precursor to brilliant artistic breakthroughs, with or without a satisfying product.

In romantic stories and legends, the choice between art and money is black or white: To attain creative brilliance you must live in poverty, or to achieve financial security you must sell your creativity to the highest bidder. As you can see from what I call the "happiness graph," this choice is perceived to be linear, with one end representing rich and miserable and the other end representing happy and poor. As one end rises, the other necessarily dips down. That's an unfortunate choice. But that's not really how it works anymore, especially not with the emergence of the creative class. The happiness graph is wrong.

Happiness Graph

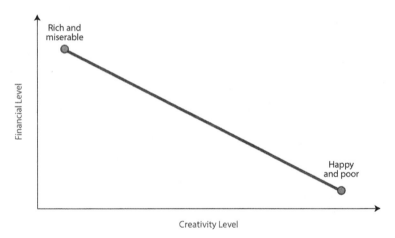

As an entrepreneur, you occupy and function within a massive, nonlinear gray area in the happiness graph. Noah, for example, is financially stable in that he is paying his bills, but he isn't getting ahead. He isn't saving and he is artistically miserable. He is especially unnerved because he did not foresee that a design career (which he initially loved) would lead him to question his future. He is neither rich nor happy, and his misery isn't justifying his financial existence.

Happiness Graph, with Nonlinear Gray Area

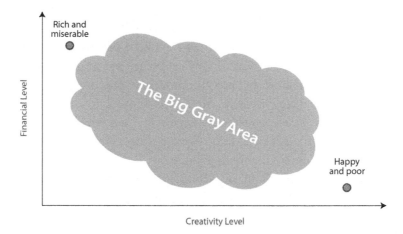

What's beautiful about this gray area is its inclusiveness. It recognizes that no one's shade of gray is exactly the same, there isn't only one linear trajectory, and anyone can find a shade that works. An entrepreneur's career course may vacillate, taking a meandering and unpredictable path. For example, take a fiercely independent 19-year-old optimist, absolute in her naïveté and determination. Her gray path can change over time as her professional and personal goals evolve.

Gray Area, with Meandering and Unpredictable Path

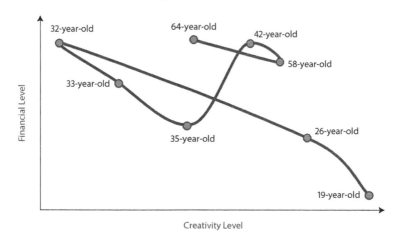

At 26, she is tired of sharing an apartment with many roommates and aches for more financial security. At 32, she is well positioned at a job that pays decently after advancing steadily in her industry and exhaustively building her resume for the first several years of her career. But she is bored professionally and stuck at a creative plateau. She wonders why she didn't pursue something practical with her life instead of something creative. She reads about mid-career professionals suffering from quarter-life crises, and her peers' sentiments echo her career restlessness and anxiety. She reinvents herself by getting a traditional, noncreative job.

At 33, she thinks about law school or pursuing an advanced administrative degree. She weighs her options, regretting her former career decisions and forgetting that her decisions were made with the best information she had at the time. She even considers accepting a job her 19-year-old self would have deemed excessively corporate in an effort to spice things up. At 35, she realizes her career pendulum swung too far, so she adjusts. She pursues a creative outlet, one with less financial security but professional and personal fulfillment.

Between these years, she decides to start a family, which she finds enriches her life in a completely novel way because it is something her younger self couldn't have contemplated. She exercises her creativity through various outlets and chooses to work less, trading professional ambition for personal ambition, at least for a while.

At 42 she returns to her focus on art. Her life experiences have molded her into the creative professional she always hoped to be, even though she couldn't possibly have predicted or mapped the route she followed in arriving at her dream destination. At 58, her personal needs change and shift again. She finds herself caring for a parent, supporting friends more deeply, or slowing the pace of her art to include her children's creativity in the process. At 64, she focuses more on herself and her art in a way she couldn't have imagined during her 30s and 40s.

This is her path. It is meandering and unpredictable but perfectly suited to a creative entrepreneur.

Unfortunately, Noah does not know about this gray area or its nonlinear paths. It didn't come up in his research as he learned his design craft, so he doesn't realize his career is not imploding but

merely unfolding in an unexpected way—a common phenomenon in a creative professional's life. He assumes—incorrectly—that because no one else is talking about unexpected twists, everyone else's lives are unfolding according to plan.

Noah's Relief

"Maybe you just need a change—something new to disrupt whatever pattern you've fallen into professionally," Elizabeth offers. "Because this doesn't seem to be working for you."

"I am at a complete loss," Noah admits. "I don't even know where to begin."

Elizabeth thinks for a while.

"What is everyone else doing? Do you ever talk to other designers—not just in a casual way but in an advisory way?" Elizabeth asks. "Do you talk about your career and its challenges?"

Noah doesn't. And because of that, he thinks he is the only one struggling with belatedly realizing that his dream job may not have been his actual dream job after all.

The next day, he signs up for a goal-setting seminar and bribes his friend Abby to attend as well. She isn't another designer, but she is a creative professional (a painter), so it is a step toward connecting with others in his field. He doesn't know if his goals need to be refined or rewritten altogether, but he knows he doesn't want to learn the answer alone.

Goal Setting

You may have already known that pursuing an entrepreneurial career would not be an easy road. But you may not have known how challenging it would truly be. After speaking to a group of entrepreneurial artists or creative entrepreneurs, I often get at least one request for more specific tips—not general advice on saving more money or budgeting appropriately, but a secret magic bullet to attaining financial stability that I neglected to divulge during my presentation. Believe me, if there were such a secret, I would proudly shout it from rooftops, post it online, and paint it in the sky.

The truth is, financial security is incredibly hard to attain, even for those with a steady source of income and great benefits. It's even harder for those with flexible income and a portfolio career.

There simply is no magic bullet.

What does ease this difficulty is setting personal and professional goals. Connect your choices to these goals. If you need to take on extra, unglamorous, less-than-ideal work from time to time (production assistance gigs, for example), do so in the interest of the long-term financial health of your portfolio career. But first, figure out your goals.

Caroline's Reluctance

"I can't believe I let you talk me into this," Caroline laments to Abby early one Saturday morning as they sip lukewarm cups of coffee and wait for the seminar to begin in a cold conference room.

"Why?" Abby says. "This will be great. Noah is going to be here, and this group organizes great programming for artists. Plus, I need to do a better job at setting goals for myself. I don't know what I'm doing."

"I already have goals," Caroline retorts. "I want a Pulitzer and a bigger checking account balance, just like everyone else."

Caroline is a mid-career writer whose dream of a freelancing profession is yet to be fulfilled. She juggles a full-time editing job for a major media company with small writing assignments on the side, but neither job leaves her

feeling fulfilled creatively. Both gigs pay for her rent, insurance, and other minor expenses, but not much else. And she feels mentally drained and emotionally exhausted all the time, so much so that when she isn't working she is unwilling and unable to pursue her true passion—storytelling.

"You won't leave here today with a Pulitzer or more money in the bank," Abby smiles. "But your account won't be smaller than when you came."

Caroline smiles mischievously at her cup. "Maybe this group's goal should be to serve better coffee."

Visualization

The first step to setting goals is visualization. Describe in detail where you are going currently and where you want to go in the future. Envision your future self by using the following prompts.

Visualization Guide

Prompts	Responses
Describe your physical location.	
➤ Is the future tomorrow? Is it several months from now? Is it years or decades from now? ➤ What country, state, city, province, or village do you live in? ➤ Are you inside or outside? ➤ Are you traveling or at home?	
Describe your home.	
➤ What does it look like? ➤ How is it decorated? ➤ Is it comfortable?	
Describe the people around you.	
➤ Who is with you? How are they related to you? ➤ What are they doing?	

Visualization Guide, *continued*

Prompts	Responses
Describe your occupation.	
➤ What are you doing? ➤ Is it a hobby or a profession? ➤ Do you enjoy it?	
Describe your daily routine.	
➤ What time do you get up? ➤ What do you do and where do you go during the day? Who do you see? ➤ Are you happy or content? Are you smiling? If not, what is bothering you?	

Now, for the second step, use the same prompts to compare your current reality (location, home, people, occupation, and daily routine) to your desired future self. Note the differences. Every difference now serves as a goal you can work toward—perhaps you'd like to live in a new city, get a more fulfilling job, follow a more exciting daily routine. Perhaps you'd like to increase your level of life and career satisfaction by carving out a new reality.

After you identify these goals, particularly those related to your professional pursuits, do the third step—prioritize them. List the most important at the top, followed by the less important. If the goals must happen in sequence, organize the list sequentially. The fourth and final step is to translate each goal into smaller steps and into financial terms; then, track your progress regularly. To help you with this final step, use the following goal worksheet. This worksheet reflects the correlation between each of your goals and finance, because pursuing each goal has some sort of cost.

Goal Worksheet

State your goal.	When do you hope to accomplish this goal?

What will you need?	How will you get it?	What will it cost?

Total cost $ _____

Number of periods remaining (months, weeks, years) _____

Amount toward goal each period $ _____

Status Updates			
Date	Progress (%)	Progress ($)	Revisions/Notes

Visualization Example

Consider this tangible example of visualization. The goal is to bake a cake, and this cake must be finished by 5 p.m. on Saturday (pretend today is Thursday).

List all the elements (even minor ones) involved in baking a cake:

1. *Recipe*
 - Find and follow a recipe; the recipe also dictates the requirements for the other steps. Cost: $0
2. *Ingredients:* flour, eggs, milk, sugar, butter
 - Search the kitchen, pantry, or refrigerator for the ingredients. Cost: $0
 - Purchase the missing ingredients. Cost: $15
3. *Supplies:* bowls, spatulas, cake pan, measuring cups
 - Search the kitchen or pantry for the supplies. Cost: $0
 - Purchase or borrow the missing supplies. Cost: $35
4. *Appliances:* mixer, oven, refrigerator
 - Check that the mixer, oven, and refrigerator exist or are working. Cost: $0
 - Purchase or borrow if appliance does not exist or is not working. Cost: $0–$1,000
5. *Schedule*
 - Reserve three to four hours of time to bake (either by trading shifts with a coworker or working around a freelance assignment). Cost: variable
 - Determine the best time to start baking. Cost: $0
 - Allow time for the cake to cool, the frosting to set, and the decoration to be complete. Cost: $0

Consider the funds needed to achieve this goal. What if there's no money to buy the ingredients, supplies, or appliances? The two options here are (1) earn the funds by working extra hours or solicit money from "investors" (either of which may delay the completion of the cake) or (2) reduce the total cost needed by buying cheaper ingredients or borrowing ingredients and supplies from a friend or neighbor (although borrowing implies returning or replacing the

items later, which means spending money is still involved). Here is the goal worksheet for this cake project:

Goal Worksheet for Cake Project

State your goal.	When do you hope to accomplish this goal?
To bake a cake.	5 p.m., Saturday

What will you need?	How will you get it?	What will it cost?
Ingredients: flour, eggs, milk, sugar, butter	Purchase them from the store	$15
Supplies: bowls, spatulas, cake pan, measuring cups	Existing inventory; borrow from friend or neighbor	$0
Appliance: mixer, oven, refrigerator	Existing inventory	$0
3–4 hours	Trade shifts with co-worker on Saturday	$0

Total cost	$ 15
Number of periods remaining (months, weeks, years)	3 days
Amount toward goal each period	$5 (i.e., replace $5 of savings each of the next three days)

Status Updates			
Date	Progress (%)	Progress ($)	Revisions/Notes
Thursday	25%	$0	Traded shifts
Thursday	50%	$10	Unable to borrow cake pan; will purchase it instead (additional $10)
Friday	75%	$25	Purchased ingredients ($15, as budgeted)
Saturday	100%	$25	Baked and completed cake!

The correlation between finances and goals is not perfect, but quantifying goals as much as possible enables the entrepreneur to be better positioned to achieve those goals. In this way, the entrepreneur can identify additional financial steps that may not be patently or initially obvious (such as borrowing instead of buying, in the case of the baking example).

Quantifying Goals

Quantifying a minimal $15 goal of baking a cake might seem ridiculous, but it is meant to illustrate the idea of quantifying a goal. Let's look at this in terms of the SMART (Specific, Measurable, Attainable, Relevant, Timely) mnemonic, a well-known goal-setting tool created by leadership consultant Paul Meyer.[13] While we are usually comfortable making our goals specific and measurable, we are not always *quantifying* what it takes to achieve a goal. In this section, I'll discuss how to relate the specificity, measurability, attainability, and timeliness of a goal to its quantification. (As for the relevance of a goal—I have yet to see a creative entrepreneur pursue a goal that isn't relevant, although relevance isn't always evident on the surface.)

Perhaps our goal is happiness, and we make the goal specific by defining happiness to be having a sustainable career centered on our starring role. It is measurable if we view "sustainable" as maintaining or increasing our bank account balances over time. But we can't take steps toward actually achieving our goal (happiness) until we have quantified it. To quantify such a goal, consider the cash reserves you'll need to protect yourself against cash flow shortages. Weigh the number of projects you can reasonably pursue and complete at any given time against your personal expenses to determine if solely supporting yourself from such projects is feasible. List and research the amount you'll need to invest to get your business up and running, both in terms of your personal qualifications (e.g., education, degrees, certificates) and the business itself (e.g., web hosting, advertising, office space).

A time-bound goal (the "T" from Meyer's SMART mnemonic) is meant to add to the specificity of the goal, but it also adds to its

quantification. By articulating the goal's time frame, you articulate how much you must save (or invest or earn) per period (e.g., month, year) to achieve the goal.

By looking at the quantification of the goal across a very specific time period, you are immediately able to ascertain whether the goal is attainable. You are also able to see how to attain it: Start saving or investing, even if that means committing to more production assistance work on a time-bound basis. Once you have quantified the goal, proceed without hesitation. You've justified the changes you will need to make to reach the goal, thus making them temporary choices instead of the necessary burdens of a creative existence.

Public Accountability

Declare your goal and deadline publicly, to impose external accountability and motivation. For example, if you send out a party invitation in which you note, "There will be homemade cake!" you not only inform guests but also set their expectations. The party attendees now hold you responsible for serving homemade cake. Public accountability is a powerful motivating tool for achieving goals, no matter how minor. This motivation can be both negative (e.g., inciting a fear of failure) and positive (e.g., aspiring to deliver only the best). And it is most effective when the audience (the group that received the announcement) is perceived by the goal-setter as competent, powerful, or influential [14] Inviting professional pastry chefs or dessert experts to your party may prove more motivational for you than inviting a group of diabetics. Declaring your creative career goals to a skeptical parent or mentor may prove more motivational than sharing them with your pet.

Tracking Progress

As the week (the time frame) progresses and you get closer toward your goal (baking a cake), track your progress. Update the status of your project by reducing the number of steps that remain, and assess your deadline to make sure it is still reasonable, based on the progress you've made. You might not know what will unfold later

in the week—you might get swamped with a big project, face unexpected travel, or be unable to locate a key ingredient. By tracking the status of your project, you'll be better able to deal with unexpected events—perhaps you could move the deadline or find an alternative ingredient as a substitute.

Presumably, an entrepreneur's goals are more complicated than the goal of baking a cake and stretch over a longer time frame than just a few days. But the process of tracking progress, much as the process of articulating and quantifying the goal itself, is the same in any case.

Abby's Goal

The seminar instructor encourages the participants to share their goals. Abby, a painter, is the first to volunteer.

She has always wanted to have a permanent home set on a lake not far from her current apartment. Her goal is clear: Purchase this home in 2 years. Next, the instructor encourages her to begin thinking about what she'll need to do to attain this goal, so they engage in a discussion.

First, she will need a down payment, but before she can quantify it she must do some research on home prices in the area she is targeting. Abby can peruse city appraisal data or real estate postings. If a home costs $300,000, for example, she'll need $60,000 (20 percent) as a down payment. Now, her goal is quantified: Save $60,000, or $2,500 per month, for 2 years. If that goal makes Abby squeamish, she has an option: Change the variables. Perhaps she could buy a house for $200,000 (instead of $300,000), which lowers her required monthly saving to $1,667 (instead of $2,500). (Abby reduced one variable: the purchase price.) Perhaps she could adjust her time frame from 2 years to 5 years. If she stretches the $60,000 goal over 5 years (instead of 2), she needs to save only $1,000 per month (instead of $2,500), which may be more attainable. (Abby changed another variable: the time frame.)

Second, Abby will need a strong credit rating to secure a mortgage loan. To strengthen her credit score, she has to pay all bills on time each month and she has to maintain (or start) a credit trail. Her name should be on her apartment lease, on utility and phone bills, and on a credit card or two (that she uses judiciously and pays off in full each month). Improving or starting credit does not cost anything, but it requires diligence and time.

Third, she will need to estimate her monthly mortgage payments according to the price of the home. Most banks offer free financial calculators on their websites. Abby should probably plan on paying between $1,500 and $2,000 (plus taxes) per month. This amount might be comparable to her current monthly rent, which makes planning easy. If the mortgage estimate is higher though, she must make plans to increase her monthly income or put away additional savings to accommodate her larger living expenses.

The instructor advises Abby to start a budget. While Abby ponders this, Caroline offers to share her goal.

Caroline's Goal

Despite her initial protestations, Caroline, a writer, finds herself enjoying the seminar. She seldom thinks through her goals and is generally content to let them float like shapeless and colorless balloons over her head. The idea of defining each of her goals seems daunting, but she raises her hand anyway to discuss a minor goal—maintain her yoga habit—although she isn't sure how it is tied to her bigger financial goals. The instructor helps her translate it into finance.

Caroline confesses to practicing yoga six days per week and spending, on average, $15 per class. She has paid membership fees and purchased class packages to pay for these sessions. This amount—totaling about $4,680 is already built into her annual budget, whether or not she realizes it (and she doesn't). Yet she still manages to attend without sacrificing food or rent money (so far). The instructor advises her that, going forward, her goal should be to break down this yearly total into a monthly yoga fund (about $390).

By setting aside a separate yoga fund, Caroline will never find herself in the position of sacrificing rent for yoga or incorrectly thinking that a financial hardship necessarily means curtailing personal pursuits. Yoga is important to Caroline (the only person who matters in this scenario) so planning or budgeting for the expenditures related to this activity is as much a priority to her as budgeting for other basic necessities. She should not assume a creative entrepreneur can't afford both rent and yoga or whatever personal expense she deems important. But she must budget for both.

Everyone has unique interests, hobbies, pursuits, and expense priorities, just as everyone has unique means of earning income to fund those interests. By recognizing these personal interests and planning to fund them, entrepreneurs can remove naysayers' ability to criticize their spending habits.

Noah's Goal

The final volunteer to share goals at the seminar is Noah, the designer. He takes a deep breath and timidly voices his goal: Sustain a design career without working for a firm. He wants to leave his current position within the year, a somewhat arbitrary time frame, but one he deemed reasonable for the sake of his aspirations and sanity.

He articulates what he thinks he needs: a diverse lineup of freelance design jobs that will help him build a strong portfolio and a good reputation to attract more clients. And he articulates how he plans to get these jobs: follow up with clients he has met during his time with the firm (without violating noncompete clauses), and pursue opportunities for short-term contract work through two separate channels. The instructor is encouraging but raises a valid point: "How will you manage the instability of your income as a freelancer, especially when compared to the relative stability of your salary with the firm?"

"Other people do it, so I think I'd be able to do it, too," Noah offers. "I guess if I have enough work, it won't be a problem."

"Maybe," the instructor says, smiling. "If I were you, I'd think about having a substantial amount of savings before embarking on your own. That way, if it takes a while for you to find more freelance work, if there is a slow period, or if a client doesn't pay you on time, you'll be able to use funds from your reserve to pay bills. Growing this fund should be part of your goal before you quit a steady paying job, and the reserve should cover about six months' worth of living expenses or more. Replenish the reserve if you dip into it so that you always maintain a comfortable amount."

"That's probably a huge amount," he replies. "How can I ever save that much?"

"Have you heard of compounding interest?" the instructor asks.

Disciplined Saving

It is never too late to start saving or to better manage finances; it's also never too early. This chapter delves into compounding interest, investments, and risks. It concludes with a brief reflection on the underlying bitterness that creative professionals sometimes exhibit, often to their financial detriment.

Elizabeth and Caroline—the Odd Couple

"What's wrong?" Elizabeth greets Caroline, who is slumped into her chair. "You look terrible."

Elizabeth and Caroline have been meeting at the same table at the same wine bar for four years now. They were once roommates, and their friendship has endured despite their opposite views, temperament, habits, and career choices.

"I went to this goal-setting seminar," Caroline reported, "and I thought I'd feel better about my career after I left, but I don't. I actually feel worse."

"Every goal I have is supposed to relate to numbers and finance in some way, which seems so implausible. If I wanted my goals to relate to finance, I wouldn't have become a writer."

Different Choices

Caroline is a writer who works as an editor for a living; her professed goal of writing full time makes her stomach turn with anxiety. Elizabeth is a financier who analyzes complicated trading strategies for Asian banks; she is practical and fearless—almost nothing makes her stomach turn.

In contrast, Caroline regards finance as a painful exercise that is indicative of her failures. Because of that view, she blissfully ignores all things financial, reasoning that a creative person cannot be bothered with such uncreative tasks. Elizabeth thinks Caroline's disdain for all things numeric makes her unique among other adults, but she is wrong. Caroline is not the only one who harbors this attitude and ignores financial matters.

Although Caroline has not suffered dire financial setbacks, she knows deep down that her credit score is less than desirable and her high credit-card debt must be paid off eventually. Instead, she admits to essentially living the life she wants, only on much less money than Elizabeth earns. She blames the financial disparity between them on their respective jobs. Elizabeth works in finance and is, therefore, wealthy; Caroline works as a writer and is, therefore, poor.

But Caroline's logic is faulty. The real reason for this disparity is that Elizabeth spends less than she earns and saves the difference. Elizabeth's salary is irrelevant. Plenty of high earners struggle financially because they spend more than they earn. Caroline, unlike Elizabeth, has a precarious situation—not because she is an artist, but because she spends at least as much as she earns during a given period. She puts the difference on a credit card.

Consider each woman's monetary assets:

Elizabeth and Caroline's Monetary Assets

Elizabeth		Caroline	
Cash (checking account)	$ 4,250	Cash (checking account)	$ 524
Cash (savings account)	$ 174,932	Cash (savings account)	$ 12,452
401(k)	$353,000	401(k)	$ -
Total	$ 532,182	Total	$ 12,976

As the table shows, Elizabeth takes advantage of her employer's generous 401(k) plan—exactly as she should. But why is the difference so large between the friends' checking and savings balances? Both women have been in the workforce the same number of years, both live in the same city, and both have comparable lifestyles.

Elizabeth's work pays her well, but she lives below her means. She occupies a modest apartment, socializes frequently but not excessively, and is conscientious about not wasting anything. Slowly her savings began to grow, until one day she had $12,000. She had never felt so rich in her life. Instead of buying more handbags, shoes, or clothing; moving to a nicer, bigger apartment; or going out more frequently, Elizabeth left her money in the bank, where today it continues to multiply—thanks to the compounding effect of interest.

Compounding Interest

When your money sits in a bank account, the bank pays you interest for its use of the cash. Banks are not simply storage facilities for cash; rather, bankers decide to keep a carefully calculated amount in reserve (in the vault) and lend the rest to the community (to potential homeowners, to businesses, to schools).[15] Those that borrow from the banks pay interest to the bank, and the interest earned by the bank is partially shared with its depositors. To illustrate the idea of a bank's reserve, recall George Bailey's plea to his bank's customers in *It's a Wonderful Life*. He asked them to withdraw only what they needed (rather than their full balances) to minimize the "run on the bank" (when the amount the bank holds in its vault isn't enough). And George Banks in *Mary Poppins* provided an explanation of the bank's value to the community when he told his son that his deposit would be part of building "railways through Africa, dams across the Nile, fleets of ocean greyhounds."[16] Of course, the son's deposit wouldn't fund any of those aspirations entirely; rather, the bank would use his deposit combined with the deposits of other account holders to fund such undertakings and share the rewards in the form of interest.

The interest rates earned and paid by banks (loosely tied to the federal funds rate) change over time and range from the very low (0.25 percent through April 25, 2012) to the very high (5.25 percent on June 29, 2006).[17] Interest, even a small amount, is better than none because, over time, the interest amount that accumulates on top of the principal begins to earn interest, too. To illustrate, take, for example, $1,000 invested in a long-term certificate of deposit (CD) that pays 1.75 percent interest[18] on January 1, 2010. This CD will be worth $1,189 on January 1, 2020, assuming the interest rate remains the same for the decade. Earning interest on the interest helps the balance grow. That's compounding.

Compounding is the same math that credit card companies use—only in reverse. Credit cards start off with low interest rates but eventually charge high rates, often to the shock of their users. Compounding is also the same math used to calculate the growth of 401(k) and other retirement investments over 30 or 40 years. The longer the time period, the more exponential the growth.

Investing

So how do you find exponential growth? At some point, the balance you have accumulated to fund your cash reserve and various goals you've articulated will grow large enough to make you think seriously about investment options—places to store money (with inherent risk) that yield higher returns (reward) than are possible with less risky alternatives, such as a savings account or a CD. There is no magic point when investment options make sense. But for many investors, the trigger is when they have a comfortable enough amount of cash set aside as a rainy day fund (say, 6 to 12 months of expenses) that they can tolerate losing additional money they invest. In other words, they invest only what they can afford to lose. They never invest the rainy day fund; they only invest extra savings.

The study of investments is specialized, and volumes have been written (and will continue to be written) about the best investment strategies. The bottom line for you is that investing isn't any scarier than creating a budget or mastering taxes, except that the consequences can be a bit more dire with investing. Money invested can be lost forever. Although over the long run (many decades), the value of many investments goes up, there is no short-term guarantee that the value will continue to appreciate. Even if the investment increases value over 40 years, it could lose value in any one (or more) of those years.

Risks

There is an inherent market tradeoff between risk and reward. This means the safer the investment is perceived to be, the lower its return. Conversely, the more risky the investment, the higher the return. An investor's tolerance for risk is informed by her time horizon, her overall volume of assets, and her appetite for uncertainty.

Time Horizon When considering her time horizon, the investor asks how long the funds will be invested. The longer an investor has before she needs to use the proceeds of her investment, the more risky she can afford to be. Generally speaking, younger investors have longer time horizons of investments than older investors, but

time horizon isn't simply dictated by retirement age. Instead, it is determined by when the investor needs to have access to the funds (e.g., to pay for college expenses, a down payment, or an extended professional leave).

Volume An investor's volume of assets also dictates how much she can afford to lose, and thus how risky she can afford to be. If she has a particularly large volume of assets (and of course, "large" is relative), she may be able to diversify sufficiently to absorb rather large (there's that relative word again!) losses. If she is more financially strained, she might not be able to risk quite as much, even in exchange for a higher reward. The greater an investor's volume of investment assets, the more risky she can choose to be.

Appetite for Uncertainty In addition to the previous two factors, which are relatively quantifiable in nature, an investor's appetite for uncertainty is simply qualitative. How comfortable is the investor with wild market swings and highly unpredictable future events? This factor ascertains the investor's comfort level with uncertainty and unpredictability. It is the investor's gut check. Someone with a low appetite for uncertainty would have a relatively low tolerance for investment risk.

Mitigating Risk

Diversification—investing in a variety of products—can help mitigate risk, but it isn't a perfect safeguard against investment risk. General portfolio management—allocating a percentage of resources to various investment types with relative risk levels that mirror the investor's financial goals and risk tolerance—is another. Neither diversification nor portfolio management is foolproof, however.

Know the risks of investing. Again, money (not just the interest but also the principal) can disappear, so education or advice from an investment professional is nearly always worth the time and money. A February 2012 survey by MFS Investment Management reported that one-third of the young investors who participated in the survey believed the information they could glean from the

Internet was as good as professional advice.[19] Forty percent of those polled felt that investment options were "too complicated," and the follow-up questions, designed to test the respondents' understanding of various investment options, confirmed that the respondents lacked a basic understanding of even relatively simple investment products. The respondents were correct to report that such products were "too complicated."

Investment Options

Investment options run the gamut, from CDs to mutual funds, from direct investments in stocks and bonds to hedge funds or private equity funds. Some investments are risky; some are relatively safe. Some carry heavy fees (which reduce the investment's potential profitability); others are relatively affordable. Investment advisors, certified financial planners, and brokerage firms may offer timely, relevant information and assistance to interested investors, and they often help investors ascertain their personal tolerance for risk. Soliciting advice from a professional in conjunction with the research you perform on your own is the best balance of diligence and competence.

And of course, the most important thing to understand is your comfort level and the tradeoff you face between risk (willingness to lose your assets) and reward (gains from investments), just like the tradeoff you face between entrepreneurial risk (lack of cash, potential lack of retirement, lack of insurance) and reward (creative fulfillment, empowerment, control).[20,21]

Controllable Factors

Elizabeth never worries about whether she hates her job. Of course, there are days when work is not appealing, but on balance, there are more good days than bad days in the office. And every day she chooses to go to work. She makes this choice not because she has to pay her rent (because of her healthy savings, she could easily cover rent and grocery bills for a few months if she loses her job) but because she is still working toward her professional goals. Having a comfortable cash reserve enables her to work for herself, for her

own reasons, rather than for someone else's. Elizabeth is an empowered professional.

Caroline can't say the same for herself. Often, she laments to Elizabeth that she is miserable professionally and stifled creatively. She can't afford to give up her full-time editing job, and her freelance writing gigs do pay but are uninspiring. Her writing assignments are about entertainment and fashion, subjects that she enjoys but that do not require Pulitzer-level journalism. She is on an endless cycle of doing unfulfilling work to maintain a lifestyle she can barely afford; instead, she needs to be following a plan that will eventually give her the financial freedom to pursue a life and career that are both professionally and creatively satisfying.

The main difference between Caroline and Elizabeth is not artistic temperament but control. In her mid-20s and into her early 30s, Elizabeth took control of her finances. She traded a few extra cocktails, designer handbags, and a luxurious apartment for a chance at financial security, entrepreneurial empowerment, and personal balance, which she now enjoys. That is the smartest move she could have ever made. Not only does she continue to live below her means and save any excess funds, but she also invests wisely and follows a budget (the topic of the next chapter).

Spending judiciously, saving fastidiously, investing realistically, choosing to make more money, and budgeting are just some financial things that you can control (as Elizabeth has done). Make that choice.

Abandoning Bitterness

The number of people who identify their primary job as "artist" has doubled in the past 30 years. The Internet not only has increased connectivity but also has added members to the creative profession. YouTube videos, blogs, and talent and reality shows have all produced instant celebrities and breakout talent. Although some artists churned out by web-based mediums, which have low barriers to entry, are truly exceptional, many others may be unworthy of the instant fame and fortune. This is a potential source of bitterness among some creative professionals who have spent their lives paying their dues, honing their craft, and building sustainable portfolio careers.

What must you, along with other entrepreneurs, do? Work harder. Here are specific tips:

➤ Earn the respect of experts in your field, professional mentors, and personal idols, rather than worrying about who is going viral online or who is becoming the new favorite artist.

➤ Cherish and seek the support of family and friends (as uninformed as they may be sometimes about your career choice).

➤ Keep a paying production assistance job as long as necessary to build up a savings safety net or to have a stable income or structured schedule. View these roles as stepping stones toward the ultimate goal; doing so puts these unpalatable gigs in context and limits their power. You've *chosen* to do them; you haven't been *forced* to do them. It is much easier to complete a job you'd rather not be doing if it is simply a means to an end and if its end is fixed, determinable, and in sight. (See Chapter 1 for a full discussion of production assistance roles.) Most importantly, don't view these jobs as the thing that defines you or your success or failure as an entrepreneur.

Another source of bitterness may be society's perceived value of art or the work of artists. People won't dream of paying merely $100 to a surgeon who performs a four-hour operation, but they have no problem offering the same measly amount to a classically trained musician who plays for four hours at a corporate event. Society should be more willing to fairly compensate high-quality work and content, and elected leaders should underscore the short-term and long-term positive influences of the arts on society. But until the world is perfect, complaining about these issues will get us nowhere—just as cradling bitterness about the state of the arts will accomplish nothing and will hurt entrepreneurs more than it will help. It fuels a cynical attitude or twisted justification for poor decisions, such as

➤ "I'll charge this expensive dinner on my credit card because I deserve it. If I lived somewhere else, I'd be eating here for free because my work would be recognized."

> "I must live in this luxury apartment because my talent is worth the price. I need a place that values my work."
> "I'm too good to serve coffee."

This bitterness is a major character flaw of the creative class. It manifests in Caroline's assumption that Elizabeth's financial success is a byproduct of her career in finance rather than the result of savvy financial practices. This burning bitterness pulses through the Achilles' heel of every great creative entrepreneur, serving as the lone point of weakness in an otherwise strong and protected individual.

After reviewing the findings of his well-known 1972 study with toddlers, Stanford psychology professor Walter Mischel commented, "We can't control the world, but we can control how we think about it."[22] This observation can serve as a call for you to change your mindset about your financial present and future if you find yourself harboring bitterness. Remember that those who achieve and sustain their success aren't necessarily those who didn't experience failure early on, or those who attended the best schools, or those who met the right people. They aren't even those who come from wealthy or connected families. Successful people are realistic about and committed to their goals. They accept their flaws (including the bitterness they feel) and overcome them through hard work, diligence, tears, trials, and sacrifice. With their commitment comes humor, humility, and a willingness to rise above their ego to do whatever is necessary (even if it means waiting tables on occasion).

Caroline's Realization

"I guess I have to make a budget," Caroline sighs. "This makes me feel like such a failure. I never wanted to live on a budget!"

"It's not so bad," Elizabeth reassures her. "Besides, I budget."

Caroline's eyes widen. "You do? I thought you were doing so well!"

"I am," Elizabeth agrees. "Probably because I budget."

Caroline ponders that statement. It is consistent with what she learned at the goal-setting seminar she attended with Abby.

Elizabeth continues with a smile, "And I even enjoy it."

Practical Budgeting

Budgeting plays a supporting role to something much more exciting. It makes your craft better—be it art, performance, technology, law, or accounting—not in the artistic sense, but in a way that sustains your practice. Having good financial health (just like having good physical and mental health) provides you with peace of mind. Peace of mind then leads to productivity and creativity. Ergo, budgeting leads to creativity.

There's no magical formula to budgeting, there's not a secret budgeting class that finance majors ace, and there's no global conspiracy to keep financial success away from creative people. Budgets can be long or short, complex or simple. There's no wrong budget, and (short of not budgeting at all) there's no wrong way to do it. So get started already.

Abby's Resolve

Abby is inspired after she leaves the goal-setting seminar. She is convinced she can master budgeting and get closer to her dream home. But first, she wants to have a better handle on her professional work and seize every opportunity to become more business savvy.

Budgeting Basics

Budgeting used to be a dirty word—a gauche, déclassé word that successful entrepreneurs didn't dare utter. It implied being cheap or reducing cost and quality, so the understanding was that those who had truly "made it" had no need to budget (just look back to Chapter 4 to see how Caroline reacts to Elizabeth's confession that she budgets). In modern times, the reverse is true. Thomas Stanley and William Danko popularized the notion of "the millionaire next

door" in their 1996 book of the same name. They found that the wealthy among us budget fastidiously and live below their means.[23]

Here's an updated definition of budgeting: to plan to operate within available means, regardless of the number of zeros included in those means. A budget is the slightly larger version of quantifying financial goals (discussed in Chapter 3). It captures not just each individual goal but also each individual goal's financial implications. At its simplest, a budget is a list of expenses for a project or a period and an estimated amount of each item. That's it. It isn't a wish list of things (although it can include the savings needed to fulfill that wish list), and it isn't a delusional exercise in optimism (in which, say, a blogger plans to be paid $1 per word for her compositions and musings).[24]

The next layer added to a budget is the income section, which is essentially a list of jobs for the same project or period and estimates of the earnings from each. The list should include the starring role, supporting cast roles, and production assistance jobs. Obtain income estimates by talking to peers about prevailing rates, recalling past experiences about fees, and perusing job postings or websites that aggregate salary information.

Actual results are different from the budgeted amount because it is impossible to make exact predictions about the future. A budget is filled with educated guesses about expenses that may occur (e.g., rent, groceries, computer repairs) and income that may come through (e.g., payment for freelance or contract gigs, advertising revenue from blog posts or a website, a book deal advance). Building in a contingency to the expense side of the budget is also advisable to cover miscellaneous needs, such as a replacement computer or iPad, new software program, or course to expand your credentials. If your phone is lost or stolen, for example, you're going to need a new one immediately. Period. Not having connectivity is not an option, at least not if you plan to continue running your business. Planning for contingency ensures that you can pay for necessary items without delay or without using a credit card. Things will *not* always sort themselves out eventually, so budget appropriately.

Budgeting Steps

It is unnervingly easy to say, "I will start budgeting," and even make an effort by attending a class or skimming a book. But even the best intentions fall short when more interesting tasks come along or when daily life gets hectic. Recommit to the idea of budgeting by breaking the budgeting process down into these five simple steps and doing each:

- ➤ Define the budget parameters.
- ➤ List the expenses.
- ➤ Estimate the expenses.
- ➤ Fund the expenses.
- ➤ Make it work.

Define the Budget Parameters

Instead of just thinking about budgeting in general or trying to budget for every conceivable aspect of life, define the budget parameters. Ask yourself these questions: What is the budget for? A specific project? The first year of operating a future business? A current business? Personal use? What is the period the budget should cover? In other words, state the specific purpose and the specific period or span of time. This is the first and most important step in creating a useful budget because it informs the rest of the steps. Expenses that don't relate to the parameters (e.g., personal expenses in a project budget) don't belong in the budget (although they may belong in a different budget). Defining the parameters is akin to stating the budget's goal, and articulating the framework (timing, scope, purpose) for reaching the goal. At the outset of the process, the parameters must be specific, but, as we'll address in the final step of budgeting, they are inherently flexible as well.

List the Expenses

List every single expense associated with the budget parameters. Then walk away and do something else. Come back to the list later to add other expenses that you forgot the first time. Allowing for ample time to complete this list helps ensure that no relevant expenditures

are left out. If you've done a budget before, you know the types of expenses to include. If you've never budgeted before, review recent credit card or bank statements to get a sense of your expenditures.

The Internal Revenue Service is a good resource for understanding expense categories. The agency issues publications related to artist-specific expenses (especially for performing artists) and includes an expenses list on Schedule C of Form 1040. The following table is a listing of expenses and their categories; some items are relevant for work purposes, while others are applicable to personal budgets. Pick and choose the expenses and categories (and write your own) that relate to your budget parameters.

Expenses and Expense Categories

Category	Example	Application to Creative Professionals
Taxes and benefits	➤ Payroll tax ➤ Health/dental insurance ➤ Disability insurance ➤ Workers' compensation ➤ Pension and retirement	If you are an employee, your employer likely covers your payroll taxes and benefits. But if you are an entrepreneur, you'll have to pay some or all of these for yourself.
Professional	➤ Accounting ➤ Bank fees ➤ Interest expense ➤ Investment fees ➤ Legal fees ➤ Other professional fees	No matter your income level, a professional accountant can help keep your finances on track. Bank fees include ATM fees, overdraft fees, and minimum balance fees; interest expenses include interest on short-term loans and credit cards.
Indirect professional	➤ Catering and hospitality ➤ Dues and subscriptions ➤ Professional development ➤ Conferences and meetings	Every entrepreneur should invest in memberships, meetings, and professional development opportunities judiciously. Learning and education do not end just because formal education does.

Expenses and Expense Categories, continued

Category	Example	Application to Creative Professionals
Facilities and equipment	➤ Equipment rental ➤ Repairs and maintenance ➤ Rent ➤ Utilities	Even if you don't own real estate or major assets, plan to spend a substantial part of your budget (i.e., 20 to 50 percent depending on geography) on rent, utilities, and repairs and maintenance. If your work requires the use or rental of a major piece of equipment (e.g., a potter's wheel, an instrument), include that expense as well.
Technology	➤ Internet access ➤ Website design and maintenance ➤ Telephone	Technology investment can be the great equalizer between an established service provider and an entrepreneur.
Administrative	➤ Office expenses ➤ Postage and shipping ➤ Printing ➤ Supplies ➤ Insurance	Even fully green businesses should plan to spend some amount on supplies, postage, and printing. Professional liability insurance is usually available through professional organizations, and it may be required for entrepreneurs working with certain clients.
Advertising and marketing	➤ Advertising and marketing ➤ Public relations	Advertising and marketing expenses may be embedded in website costs or in postage and printing costs (for printed materials), but purchasing banner ads is a cost that belongs in this category.
Travel	➤ Lodging and meals ➤ Touring ➤ Local travel	Plan on this not only for specific artistic applications (e.g., attending shows) but also for conferences and local travel to meetings.

Expenses and Expense Categories, continued

Category	Example	Application to Creative Professionals
Fund-raising	➤ Fund-raising expenses ➤ Fund-raising professionals	This category only applies to entrepreneurs who pursue grants, fellowships, or crowdsourcing.
Artistic	➤ Artist commission fees ➤ Artist consignments ➤ Artists and performers (nonsalaried) ➤ Collections conservation ➤ Collections management ➤ Production and exhibition costs ➤ Program expenses ➤ Recording and broadcast costs ➤ Royalties ➤ Rights and reproductions ➤ Sales commission fees ➤ Cost of sales	This category is intentionally broad to account for the unique professional fees an entrepreneur may encounter. Include whatever artistic expenses you have in this category. Cost of sales includes supplies used to create a particular work that is then sold or held in an artist's inventory.

You can identify holes in your own expense lists by talking to peers, mentors, and those who work in your industry. In addition, check various online budgeting tools and templates to supplement your budget expense list. Last, remember that an entrepreneur is a small business. Scanning the US Small Business Administration's website (www.sba.gov) may trigger expense ideas, as may perusing small business publications published by the IRS that deal with home offices, small businesses, and sole proprietorships. For more discussion on enumerating and estimating specific expenses, see the appendix at the end of this book.

In the first two steps of budgeting—define the budget parameters and list the expenses—words are infinitely more important than numbers, because words articulate what the budget is trying to accomplish. You can look at these two steps and know what questions to ask and what answers are available. But the numbers come next.

Estimate the Expenses

This is the step when numbers become important. Review the list of expenses category by category and line by line, and then estimate the cost of each item for the defined parameters (e.g., project or time span). Some expenses may be fairly easy to estimate, while others may be wildly unpredictable. Relax—these numbers are just educated guesses—and it's not the end of the world if they are completely wrong. Budgeting is an art, not a science, and practice does make perfect. If you still feel completely stuck, peruse the appendix for research advice about common line items.

Fund the Expenses

Now, list the income that can fund the expenses. Include every possible source of income, such as a full-time or part-time job, freelance or contract work, grants, fellowships, sales of goods, ticket sales, advertising revenue, honorariums, and stipends. Allow ample time to complete this list, and feel free to come back to it at different times to add sources you accidentally omitted or forgot the first time.

Be creative in finding sources of income, and be open to pursuing those that might not be obvious. For example, you could plan to sell eight paintings for the year, but beyond that you could license paintings to various websites or publishing companies. In addition, you could accept commission work (even if it isn't exactly what you'd like to do), apply for various fellowships and grants, or become a resident teacher for an arts-in-education nonprofit. Working a flexible or temporary gig may also be an option for earning extra cash. Listing sources of income beautifully illustrates the idea behind a portfolio career, which represents the growth and evolution of the creative class economy and a major shift in the US workforce. No longer do individuals, households, and small businesses have to build budgets

around one straightforward source of income but around multiple, diverse (related and unrelated to one's craft) jobs.

With your sources of income identified (in words), estimate the potential earnings for each source (in numbers). This is one of the hardest parts of budgeting for an entrepreneur, especially in the early stages of the business. If it were easy to make an educated guess about how much money an entrepreneurial effort would earn or raise, then everyone would become an entrepreneur. But it's not.

Much like expenses, some earnings are easier to estimate than others. Salary from a traditional job, for example, is easy to jot down because the amount is fixed for the year and the taxes are already withheld from the amount that appears on the check stub. In contrast, freelancing income or sales of artwork are difficult to estimate, especially for those just starting out.

Building a client base, and learning the rate each client offers or agrees to pay for services, takes time because cultivating clients is an art, not a science (like budgeting!). As a result, estimating an average income for the year can be challenging. It may be helpful, however, to think in broad categories or "buckets" of clients. For example, say 1 or 2 "big fish" clients pay $7,500 each per year for your work; 8 "medium fish" clients pay $1,000 each per year; and 20 "little fish" clients pay $500 each per year. If your business model is to serve only the big fish, plan on landing 8 projects for them (8 × $7,500 = $60,000). You won't know who these clients will be exactly, but you'll know which broad category each client may fulfill. If your business model is to serve a mixture of small fish and medium fish, plan on landing 50 projects for small clients (50 × $500 = $25,000) and 25 projects for medium clients (25 × $1,000 = $25,000). If your goal is to build a client portfolio comprising a mixture of big, medium, and small clients and to sustain these relationships to justify leaving a steady job, budget the income on paper before you take any action. It's a lot easier to work this out in theory (e.g., specific number of clients needed, specific individuals or groups that will hire and support the business, specific rates or fees for the work performed) than get a sobering reality check later. If your business model relies on completing 50 projects for small clients, but there are only 2 potential clients that fit into the "small client" category, you have a potential problem.

If receiving a fellowship or grant is part of your income plan, research the foundations or groups that award these funds. Study the specific organization (e.g., XYZ Arts Foundation) and its requirements and deadlines. Hoping for funding is not enough, especially given today's precarious economic climate; you must search for and pursue the funding assertively. If fellowships and grants are on the income list, estimate their amounts conservatively—at least before you abandon all other sources of income.

If your business involves the sale of goods (artwork, for example) instead of services, you must determine the appropriate selling price for each work. Pricing your work appropriately is one of the biggest challenges an entrepreneurial artist faces. The price an artist sets for her work is informed by the cost of the input items (supplies), the artist's time spent creating the work, and the market for the work.

The cost of input items is relatively easy to calculate (although tracking such costs can be administratively burdensome). See the discussion on inventory systems in Chapter 12 for more information. An artist should never set the sales price of a work below the cost of supplies used to create the work; otherwise, the artist is in effect "donating" not only her services in creating the work, but also the supplies used to create the work. That only makes sense if the artist receives some really amazing intangible (noncash) benefits to justify the deep discount (donation).

The relationship between the amount of time an artist spends creating a work and the price she sets for the work isn't always clear or linear. Some works may take relatively little time to create and sell for extraordinarily high prices, while other works may be very labor intensive and yet sell for relatively low prices. However, an artist should be aware of the time and effort she exerted in creating a work, and should consider that, along with the cost of supplies used in the work and the market for the work, as she sets the price for the work.

Determining the market for the work is another complicating factor that an artist must consider in pricing her work. Understanding the market for a work of art is based on research of selling prices of comparable works and experience. Comparable works don't have to be exactly the same, and in an artistic context, they won't be; they simply must be similar enough to be comparable. Research may

include simply observing what pricing models other artists use, it may include initiating conversations with knowledgeable participants in the industry (e.g., gallery directors, administrators, educators), and it may include reading about industry trends. Research informs the starting point, but experience and trial and error are the best instructors of the market's idiosyncrasies, and they inform the artist's long-term pricing strategies.

Much as someone who provides services to clients may create broad categories of clients based on the level of revenue each may generate, an artist who sells goods may create broad categories ("buckets") of inventory items, based on whatever logical groupings make sense in the context of the artist's work: perhaps size, quality of supplies, complexity, or medium. Creating such groupings helps an artist distinguish among her creations and helps her articulate to potential customers the reasons behind certain price points.

Make It Work

A budget "works" when income equals or exceeds expenses. It also works when you invested in the process of drafting and then following it. Despite your best intentions and careful planning, however, a budget almost never works right away. More often than not, expenses exceed income, because people, in general, tend to be conservative when budgeting income and aggressive when budgeting expenses. That is just how we work.

To make a budget work, you can reduce expenses, increase income, or change the parameters. As an entrepreneur, your life is full of tradeoffs, and having everything all at once is not always possible. Therefore, you may need to postpone nonessential expenses until you can find a source of income to cover them. Or, in a larger context, you may need to keep a stable job (production assistance) until your business (especially the starring role or supporting cast roles) can sustain enough income to cover all your expenses.

By making budgetary trades (expanding the time horizon, reducing the scope of a project, curtailing expenses, or maintaining an income source for a bit longer), you exploit the amazing flexibility of budgeting. Instead of using a budget to dash your dream of full-time

freelancing, acknowledge that the budget illustrates that the answer isn't "no." Rather, it is often "not yet." Modifying the budget parameters—the timing and scope of the budget—is the easiest way to make a budget work. But this is not to say changing a budget's parameters is akin to accounting voodoo. It is not simply adding a rosy filter to an otherwise dire budget. Rather, it is deciding (as an empowered creative entrepreneur) to do something smaller (reduce the scope) or to postpone a project (change the timing) until the necessary assumptions, such as the number of clients you'll have, are realistic. The exercise itself, the understanding of the process, and the willingness to be flexible with defined parameters is much more important than budgetary perfection. If the budget still doesn't work once you've exhausted the parameters, consider reducing expenses.

Expenses are more controllable than income, given that you can weigh wants versus needs and prioritize expenses with more ease than you can confirm additional gigs, find new clients, or land more assignments. This means, to the extent possible, spend less or spend later.

How to Spend Less Divide expenses into wants and needs, and accept that not all wants are affordable—at least not all at once. Tough luck. Don't regret the choice of becoming an independent entrepreneur, however, if the biggest downside is traveling more modestly, eating fewer meals at restaurants, or splurging less on luxury items. Being an entrepreneur is a really good choice to make, despite the material tradeoffs.

Spend wisely on everything, and invest in quality over quantity to maintain the integrity of your hard-earned cash. Part with it if you must—but do it for a worthwhile reason.

How to Negotiate Another way to reduce spending is to negotiate. Businesses have an incredible amount of negotiating freedom, and they can extend that to customers who ask. Cable and Internet service, gym membership, cell phone plan, admission to events, and even rent are all negotiable. Given how finicky consumers have become and the availability of great deals online, most companies are open to negotiations and prefer to keep a customer paying 90

percent than to lose that customer completely. Nearly everything is negotiable.

Negotiation comprises two basic concepts: **sunk costs** and **walk-away prices**. Sunk costs are those already incurred for any particular project or deal; they are "sunk" because they have already been spent (the cash has left the coffers, so to speak). A sunk cost cannot be recovered; it is gone permanently. As such, it should no longer factor into an equation to determine whether a deal makes sense going forward. Walk-away prices, on the other hand, establish the deal-breaking parameters upfront. A walk-away price is the minimum amount of consideration a party to a negotiation must attain to reach an agreement. It is akin to the seller's minimum price required to part with her home, or an art auction's reserve price. It isn't what someone hopes to be paid; it is the minimum amount he *must* be paid for a deal to close. If consideration is less than the walk-away price, the artist should walk away from the deal. Walk-away prices aren't advertised. Only the artist knows what his walk-away price is, and the walk-away price should never be the starting point in a negotiation. It might, however, be an end point. A walk-away price can be made up of both tangible (cash) and intangible (experience or exposure) consideration, but an artist must clearly articulate the value for his time and work. These concepts come up again in Chapter 10, where the idea of masochistic volunteering is addressed.

The best negotiators tell their story well. They tend to be nice and likeable, especially when they are asking for a favor from customer service representatives (who might themselves be entrepreneurial artists filling production assistance roles to earn extra cash), so a little kindness can go a long way. Plus, there are always special introductory deals for new customers, and most companies give employees discretion in extending the deals to "special" existing customers (read: the nice ones). Don't be shy about asking for a better deal. The worst that could happen is that the other party would say no (because of the walk-away price), and that's not exactly embarrassing.

As an entrepreneur, you know about negotiation better than anyone does. Would you do a project for 80 percent of your normal fee if you deem it good for your portfolio or if the process enables you to meet people who could give you more business in the future?

Of course you would. Sometimes doing something for less than the asking price makes sense, and companies agree. Many businesses, especially creative businesses, are flexible and negotiable, and you should adopt those traits as well. You should be comfortable saying, "My normal fee for an engagement like this is $500, but I'd be willing to offer you a preferential rate of $300." The other party should know it is getting a good deal and, as a result, may subconsciously respect your work more because of your flexibility (a product of the delightful psychology of finance). Plus, the perceived value of your work increases from $300 to $500.

Remember, though, that once both parties have agreed on an amount, the conversation is over. The business that gave a special deal should not remind you (as the customer) of the one-time favor it extended each time you call the company. Likewise, you (as the entrepreneur) should not bring up the price reduction on a specific project you gave to a client. Doing so is petty and unprofessional. If you undersold your services, consider that a lesson learned (a sunk cost) and strike a better deal next time.

When negotiating, make it personal—that is, personal for the other person but impersonal for you. For example, a landlord who knows your story (e.g., you are writing the next great play) may be willing to cut you a break on the rent, not increase it as much or at all every year, or allow you a small extension on payment. To establish this connection with a landlord, strike up a conversation, invite him and his family to a production of your play, or give him a few complimentary tickets. But remember, get the landlord to figuratively invest in your story, not the other way around. Don't volunteer or promise to pay more because you learned that his daughter is going to college. Worry only about reducing your expenses. Make the negotiation personal for the landlord, but keep it impersonal for you.

Abby's Festival Budget

With Noah's encouragement, Abby begins to build a budget. She defines her parameters (i.e., budgeting for several trips to art festivals) and starts making two lists—one for her expenses and one for her income—and estimating the amounts for each item.

In part because of the success of her recent gallery show, Abby has taken a yearlong residency in Ohio. During the year, she plans on taking three or four trips to sell her work at art festivals around the state. She estimates that she'll be able to drive to each one, stay two nights for each trip, and spend no more than $30 per day on food. She is not planning on renting a trailer to transport her paintings. Her expense budget looks like this:

Abby's Expense Budget

Destination	Transportation	Lodging	Meals	Total
TBD; estimated entrance fee: $300	Car, no trailer; 250 miles @ $0.55 per mile: $137.50	2 nights @ $80 per night: $160	3 days @ $30 per day: $90	$687.50 per trip
4 trips per year:				**$2,750**

She estimates that she'll sell between three and eight paintings per festival, and she determines the average price per painting based on information she learned from her recent gallery show and from advice she received from her residency director. Her income budget looks like this:

Abby's Income Budget

	Three Sales	Five Sales	Eight Sales
Average price per painting: $450	$1,350	$2,250	$3,600
Expenses per festival	$687.50	$687.50	$687.50
Projected profit per festival	$662.50	$1,562.50	$2,912.50

Abby knows that selling eight paintings is better than selling three, but she also knows that the average cost per festival ($687.50) is more than the sale price of one painting ($450).

She hopes to sell at least two paintings at each festival so that she can fund her expenses for the trip and pocket some money. Her break-even point is the sale of two paintings. (See Chapter 13 for a discussion of break-even points.)

This budget doesn't look like it was prepared by an accountant, and it doesn't have to follow any particular set of rules. It simply states Abby's parameters, the associated expenses, and the projected earnings.

What-If Analysis

Sixty-four percent of US residents surveyed by the National Foundation for Credit Counseling in 2011 reported they had less than $1,000 saved in an emergency fund.[25] This is consistent with (and in fact worse than) the unscientific findings from Monster.com's 2009 survey, which found 34 percent of US workers who participated reported that if they lost their job (e.g., laid off without severance pay) they would only have enough money to cover their expenses for one week.[26] These findings are not at all surprising. Many of us know we're not great at saving for catastrophes, and many of us are too optimistic and too likely to focus on short-term certainties rather than distant possibilities.

Creating a budget is important. It is an amazing accomplishment and a great first step to saving for unexpected events. A budget becomes an even more useful tool, however, when you add a what-if analysis, the subject of this chapter.

Caroline's Budget

"You're never going to believe it," Caroline says as she tosses her coat and handbag onto the empty chair next to Elizabeth. "I made a budget!"

"You did what?" Elizabeth asks, her eyes widening as she clears space for Caroline at the table.

"I made a budget—for my job, my writing projects, my expenses, everything!" she exclaims. "And you know what? I kind of get now how excited you are by all this finance stuff. It's kind of like Scrabble. You're dealt certain letters, some of which you'd never choose, and you have to figure out how to make them work."

"Caroline, I'm ecstatic for you," Elizabeth laughs. "Congratulations! What changed? I thought everything was going fine without a budget."

"The instructor at the goal-setting seminar was talking about it, Noah was talking about it, Abby was talking about it. Then you just told me you also do it. Finally, I figured if you guys could do it, I could too—or at least try it. Do you want to see it?"

Caroline slides a sheet of paper across the table to Elizabeth.

Caroline's Budget

Income		Notes
XYZ Media Company	$ 37,800	Net paycheck every 2 weeks of $1,575
Freelance Writing	$ 6,000	Write 1 article (1,000 words) per month, $500 each
Taxes	$ (1,800)	Assume 30% tax rate
Net Freelance Writing Income	$ 4,200	
Total Income	**$ 42,000**	
Savings	$ (5,120)	Goal: Save about 12% of income
Income after Savings	**$ 36,880**	

Expenses		
Living Expenses:		
Rent	$ 12,000	
Car payment	$ 5,880	
Utilities (gas/electricity)	$ 1,080	
Phone	$ 1,320	
TV/Cable/Internet	$ 1,320	
Social	$ 2,400	$200 per month
Yoga classes	$ 4,680	$15 per class, 6 days per week
Food	$ 2,880	$240 per month
Total Living Expenses	$ 31,560	
Creative Expenses:		
Books	$ 600	
Supplies	$ 2,400	
Total Creative Expenses	$ 3,000	
Business Expenses:		
Web hosting	$ 100	$200 host contract over 2 years
Promotions/advertising	$ 250	Average per year
Printing, computer repairs	$ 600	Average per year
Meetings (coffee, meals)	$ 480	One per month (3 coffees @ $5, one lunch @ $25)
Memberships	$ 150	Average per year
Insurance	$ 140	Annual rate
Networking events	$ 600	One per month
Total Business Expenses	$ 2,320	
Total Expenses	**$ 36,880**	
Net Income (Loss)	**$ -**	

"It's beautiful! You even handwrote it and used fancy paper. You can use Excel for this; you know that, right?" Elizabeth asks.

"Of course," Caroline shrugs. "And maybe I will eventually, but you know me. I write everything by hand at first and type it up in later drafts. Why should I change my process just for budgeting? That's what the instructor said. I don't have to be an accountant. I can do one that works for me and make it feel like it's mine."

"I understand," Elizabeth replies, still looking at the budget admiringly. "You should frame this. It looks like a piece of art—seriously!"

"I'll give it to you to hang in your office," Caroline jokes.

"What happens if something changes? If you lose your job?" Elizabeth asks after noticing that the biggest source of income is XYZ Media Company, Caroline's full-time employer.

"I won't," she replies breezily. "If anything I'll get a promotion now that I can budget. But if I get fired or laid off, I'll just find another job."

"Okay, then what if your freelance clients stop giving you assignments? What if they close shop? What if they change their focus—to science fiction or something?" Elizabeth pushes on.

"What are you talking about? No, they wouldn't!" Caroline retorts a little defensively.

"Relax, nothing like that will probably happen. But what if your neighbor's apartment catches on fire, and what if the fire damages your place and you need to move out for three months?"

"Stop scaring me!" Caroline raises her voice. "If that happened, couldn't I stay with you? And wouldn't the building's insurance cover everything?"

"They might eventually, or your renter's insurance might pay. But how are you going to live for the weeks or months before the insurance check arrives? How are you going to replace everything you lost? Your computer? Your clothes? You can't borrow those things eternally."

"I should probably get renter's insurance," Caroline sighs as she bites off a piece of bread.

"Yes, probably," Elizabeth says, smiling. "But that's not my point. I was just trying to get you to do a what-if analysis."

"A what-what?" Caroline asks.

"A what-if analysis. It's an exercise for thinking through hypothetical worst-case scenarios so that you can be ready with solutions before something bad actually happens."

What Is a What-If Analysis?

Part of making a budget work is thinking about how it might work under different—usually bad—circumstances. As you balance income and expenses, you're already thinking about continuing or increasing income sources while reducing nonessential expenses. The **what-if analysis** is an exercise that takes your thinking one step further. It pushes you to plan for the unpleasant unexpected events now, so that you are prepared to make informed decisions and adjustments if those events become a reality. The goal of a what-if analysis is to minimize surprises and shocks and prepare for unexpected circumstances analytically instead of emotionally.

You never want to be fired from a job or learn that one of your biggest clients cannot hire or pay you anymore. The beauty of the what-if analysis is that it gives you a chance to put yourself in those situations and to formulate answers to hypothetical questions without becoming emotionally involved. These financial answers are easier to work out on a budget spreadsheet than during the height of a crisis.

What-if questions can be anything, but usually they relate to the potential vulnerabilities in a budget—specifically, the biggest source of income and the biggest expense item. Changes to these items often have the biggest impact on the bottom line and aren't always easy to anticipate or fix quickly. Examples of what-if questions include the following:

> ➤ What if you lose your job (through a termination, a mass layoff, or another reason)?
> ➤ What if three of your biggest clients declare bankruptcy and can't pay you?
> ➤ What if your computer crashes and you have to buy a new one?
> ➤ What if your apartment floods or catches fire?
> ➤ What if you absolutely must increase your income by 20 percent; how would you do it?
> ➤ What if you absolutely must cut your expenses by 20 percent; how would you find the savings?

What-if questions can be used for good scenarios as well:

> What if your painting sells for twice the amount you expected; what would you do with the surplus?
> What if you get a promotion and an 8 percent raise? Would you move? Save the excess? Go out to eat more?

Those are wonderful questions to answer, but positive circumstances can be just as troubling as negative ones. We humans tend to overemphasize the positive and minimize the negative, which is usually a good thing. But this tendency may work against our favor when it comes to income, because we're prone to spending extra money several times over. For example, if your painting sells for $1,000 instead of $500, you may treat yourself to some new supplies (because you have that extra $500 to spend). Or you may go out to dinner with friends a few times (because you have that extra $500 to spend). Or you may take cabs home rather than subway rides (because you have that extra $500 to spend). Maybe you'll get a new phone, even if you don't need one (because you have that extra $500 to spend). Before you know it, you will have spent $150 on supplies, $200 on dinners at restaurants, $65 on cab fares, and $300 on a new phone—for a total of $715, which is $215 more than the initial extra $500. If this occurs, you have an optimism problem, which is an emotional response. You overemphasize the positive impact of earning more and ignore the fact that the surplus can quickly turn into a problem if you don't manage it appropriately. If you do a what-if analysis without emotions (before you feel like you "deserve" an immediate reward for your efforts, even if you really do), then you can plan for a reward that is longer lasting than a couple of expensive dinners, cab rides, or a new phone.

The answers to what-if questions have to be specific and not generic. You can't simply say, "I'll find a new job if I lose my current one," "I'll replace my clients if they no longer need my services," or "If I have a surplus I'll save it." All of these statements may be true, but they completely ignore the reality that it may be really hard to find a new job, harder to replace three big-fish clients, and hardest to save extra funds (especially in a tight economy).

The Internet offers a seemingly infinite number of financial literacy resources. These websites aim to help people develop solid

savings habits to combat the consequences of scenarios identified by a what-if analysis. The Advertising Council and the American Institute of Certified Public Accountants (AICPA) collaborated to create Feed the Pig (www.feedthepig.org), an interactive site that provides financial tips, tricks, tools, advice, and educational quizzes. Its goal is to encourage everyone, especially young professionals, to save money. Users can tailor the features to their needs, preferences, and personality types (based on the "Me Save?" avatars) and can share and interact with other users through Facebook and Google. The tips and status checks can be shared via email and text or on the site. AICPA created a partner site called "360 Degrees of Financial Literacy" (www.360financialliteracy.org), which aims to help people understand their financial situations at various stages of life, from teenage years through retirement. No matter what online resource you use, you should understand that it is never too early or too late to begin saving as a strategy to combat whatever financial scenario you encounter.[27,28]

Decision-Making Tool

What-if analysis can serve as a decision-making tool as well. It can translate options into financial terms; simply add the cost for each option. For example:

> - What if I moved to a larger, more expensive apartment ($2,000 per month in rent) instead of the modest, cheaper apartment ($1,000 per month in rent)?
> - What if I pursued a graduate degree (a 2011 MBA from Harvard cost $121,220)[29] or completed a continuing education class (graduate classes in Harvard's extension program cost $1,950 each in 2012)?[30]
> - What if I moved to California instead of Georgia (in 2012, a $50,000 salary in Atlanta was comparable to $83,607 in San Francisco)?[31]
> - What if I had children now ($250,000 over 17 years)[32] instead of waiting ($250,000—or more—later) or opted not to have children ($0)?

By posing these what-if questions and identifying the cost of each option, you can better understand the financial implications of your decisions on your budget (or any hypothetical budget). As you can see, these questions are phrased in such a way that the answer isn't a simple "yes" or "no," and the questions aren't posed as baseline hurdles to clear. Rather, they force you to decide whether the financial consequences justify the decision. The answer to an option can't always be "yes," even if we really want it to be so. Sometimes the answer is "not yet;" rarely is it an emphatic "no." Viewing the options through a financial prism helps illustrate the difference (the cost, if you will) between answering "yes" and answering "not yet."

But for what it is worth, finances are only part of the decision equation. It may be perfectly reasonable for you to analyze an option by crunching the associated numbers but then ignore those numbers in favor of basing your decision on intuition. That's fine. Finances shouldn't be the only factor that influences a decision. But make a deliberate attempt to at least look at the finances (even if you end up ignoring them altogether) because they are part of the decision-making process.

Example What-if Questions and Answers

Question: What if I lose my three biggest clients?
Answer: My three biggest clients represent $50,000 of my income per year. Eventually, I'll replace these clients, but doing so will probably take between 6 and 18 months. In the interim, I'll increase my focus on getting work from mid-level clients and on soliciting new business with the help of the recommendations from past and present clients; this may yield an estimated $12,000 per year. I'll contact my former employers to notify them that I'm available to do some work on a short-term basis; this may yield an estimated $3,000 per year. I'll arrange to teach two yoga classes per week and fill in as a substitute when needed, which may yield an estimated $3,000 per year. I'll ask existing yoga students for the names of friends I could contact to offer my teaching services, which may yield an estimated $1,500 per year. I'll cancel my cable to save $30 per month, for a $360 savings per year. I'll suspend my subscriptions to journals and

magazines and read them at the library instead, for a $400 savings per year. I'll forgo two of the three conferences I planned on attending, for an $8,000 savings per year. I'll spend up to $10,000 of my savings to get back on track. If after six months I still haven't replaced the clients I've lost, I'll let go of my intern and reduce my assistant's hours, for a $12,000 savings per year. I'll register with a temp agency, which will serve as a bridge source of income.

Question: What if I incur a surplus?
Answer: I'll deposit any surplus income into an emergency fund account. I'll keep it separate from my regular bank account so that I'm not tempted to use it. I'll start building my reserve to use if something goes really wrong. My goal is to save enough to fund six months' worth of expenses (rent, utilities, food) so that if I do lose my job or if some catastrophic event happens, I'll have a cash safety net to use until I find a new job.

Question: What if I spend my surplus on paying off debt?
Answer: I'll use any unexpected surplus to make additional credit card payments. The payments will be more than I budgeted so that I can make real progress in reducing my debt. By doing this, for every $1,000 I pay per year, I'll save $180 in interest and fees and I'll pay off the balance earlier.

Notice that these answers are specific, with estimated time frames and amounts. Although there are no right answers, failing to think about and answer the questions is definitely wrong.

Caroline's What-Ifs

"Okay, so tell me more about this what-if analysis. What hypothetical questions should I be asking? How will I know if my answers are right?" Caroline prods.

"There aren't any right answers, I promise," Elizabeth assures her. "It's not about being right. It's about preparing you to handle difficult financial situations so that if they happen you can keep your budget instead of throwing it out the window because it didn't turn out like you planned. The what-if exercise is just a reminder that we don't know what is going to happen. But it's also a reminder that we don't *have* to know what's going to happen; we just have to make our budget work to fit a lot of different circumstances."

"That sounds doable," Caroline says. "Like in Scrabble when you're at the end of the game and you're still holding a Q and an X but no vowel. You can't give up; you wait to draw a vowel or for the board to open up. You have to make the letters you have fit the board and play out different word combinations in your head, asking yourself 'what if I do this?' or 'what if that doesn't happen?'"

"Exactly," Elizabeth nods her head. "Only in Scrabble, you know instinctively how to handle tough letters because you've been playing forever. And in Scrabble, your bank account is not affected if you fail to plan for the unexpected or to ask the what-ifs."

CHAPTER 7

Budget Variances

Creating a well-reasoned, workable budget and performing a what-if analysis are only the first two parts of the budgeting process. The third is doing a comparison between the actual financial results (what happened) and the budgeted amounts (what you thought would happen). If you don't assess this budget variance (or figure out if the budget works), you may as well not budget.

Caroline's Disappointment

"My budget!" Caroline wails over the phone. "It's completely wrong. I can't believe how wrong it is. What was I thinking when I made it?"

"It can't be that bad," Elizabeth says. "You made your best guess about each budget item with the information you knew at the time, and didn't you save quite a bit this year?"

"I did save almost $3,000, and that is pretty fantastic," Caroline agrees. "But still, some of my budget figures were laughably low—so far away from the actual numbers!"

"Who cares?" Elizabeth replies. "Next time, it will be a little better. Just jot down notes and costs now so that you'll remember to budget more closely for next year."

"I wonder how Abby did," Caroline muses. "She did a budget for traveling to a bunch of different festivals. I wonder if her actual numbers turned out better than mine?"

Comparing Actual versus Budget

After going through the exhaustive exercise of building a budget from scratch and figuring out how to make it work for the realities and uncertainties of your life, career, and goals, you may be tempted to file it away and then forget about it. You're done! You may now raise your hand when you attend a financial planning seminar and

the speaker asks who in the room has a budget. You can brag about it to your money-savvy friends and colleagues.

Except you're never quite done with a budget. You must regularly revisit it to check if the budgeted amounts are on track with the actual results. If you don't do this, you are not alone, according to a survey. In 2009, Harris Interactive conducted a survey on behalf of the National Foundation for Credit Counseling and reported that only 42 percent of adults who participated in the poll "keep close track of their spending."[33] This percentage was essentially unchanged in the 2012 survey by the same group; only 43 percent of the participants said they have a budget and track their expenditures.[34] The easiest way to monitor a budget is to use the exact same format you created and add columns for actual figures. Ideally, enter amounts monthly, but quarterly or even biannual updates are better than none at all.

Monitoring Variances

Monitoring a budget is how you ensure that a budget works. Typically, a budget is reviewed at the end of the year to compare the differences between what earnings and expenses you expected and the earnings and expenses that actually occurred. Also review your assumptions at this point, noting which assumptions were realistic and which ones were too idealistic (even delusional). Understand what (if any) unexpected events happened to wreak havoc on the budget and what fixes you applied to remedy each situation. But looking back at the end of the year is the bare minimum requirement. Ideally, a budget should be reviewed at specific points during the year. Halfway through the year (six months into the budget year) is a great starting period. At this time, about half of the expenses have materialized, but it is not too late to cut back on expenses for the coming months to ensure that the year ends on track or with a surplus.

Caroline's Monthly Updates

Caroline monitors her budget by tracking her expenses each month. The first three months of the year are shown below.

Caroline's Budget, with January, February, and March Actuals

Income	Budget	January	February	March
XYZ Media Company	$ 37,800	$ 4,725	$ 3,150	$ 3,150
Freelance Writing	$ 6,000	$ 500	$ 500	$ 500
Taxes	$ (1,800)	$ (150)	$ (150)	$ (150)
Net Freelance Writing Income	$ 4,200	$ 350	$ 350	$ 350
Total Income	**$ 42,000**	**$ 5,075**	**$ 3,500**	**$ 3,500**
Savings	$ (5,120)	$ -	$ -	$ -
Income after Savings	**$ 36,880**	**$ 5,075**	**$ 3,500**	**$ 3,500**
Expenses				
Living Expenses:				
Rent	$ 12,000	$ 1,000	$ 1,000	$ 1,000
Car payment	$ 5,880	$ 490	$ 490	$ 490
Utilities (gas/electricity)	$ 1,080	$ 109	$ 104	$ 87
Phone	$ 1,320	$ 117	$ 117	$ 121
TV/Cable/Internet	$ 1,320	$ 109	$ 109	$ 109
Social	$ 2,400	$ 172	$ 154	$ 282
Yoga classes	$ 4,680	$ 250	$ 250	$ 250
Food	$ 2,880	$ 330	$ 298	$ 310
Total Living Expenses	$ 31,560	$ 2,577	$ 2,522	$ 2,649
Creative Expenses:				
Books	$ 600	$ -	$ -	$ -
Supplies	$ 2,400	$ 24	$ -	$ -
Total Creative Expenses	$ 3,000	$ 24	$ -	$ -
Business Expenses:				
Web hosting	$ 100	$ -	$ -	$ -
Promotions/advertising	$ 250	$ -	$ -	$ -
Printing, computer repairs	$ 600	$ 1,488	$ -	$ -
Meetings (coffee, meals)	$ 480	$ -	$ -	$ -
Memberships	$ 150	$ -	$ -	$ 75
Insurance	$ 140	$ 140	$ -	$ -
Networking events	$ 600	$ -	$ -	$ 100
Total Business Expenses	$ 2,320	$ 1,628	$ -	$ 175
Total Expenses	**$ 36,880**	**$ 4,229**	**$ 2,522**	**$ 2,824**
Net Income (Loss)	**$ -**	**$ 846**	**$ 978**	**$ 676**

The deviations between actual and budgeted amounts are called **variances**. Variances can be positive (favorable) or negative (unfavorable). Favorable income variances indicate actual income is higher than the budgeted amount; negative income variances indicate the opposite. Favorable expense variances indicate an expense item is less than what was budgeted; unfavorable expense variances indicate the expense exceeded its budget.

Periodic monitoring of these variances can teach you a lot about the budgeting process. It shows you the correct or incorrect assumptions you made regarding income and expenses. It shows you the damage or disruption that an unexpected fund or expenditure can create. What you learn from the current budget (what worked and what didn't work) will make your future budgets better and more accurate. Part of this learning is to identify why there are variances, not simply that variances exist.

To figure this out, ask yourself: Did you stumble upon an amazing opportunity that was too good to resist? Did a personal catastrophe happen that caused you to travel more than you had planned? Did you lose or damage a computer or instrument and have to replace it? Did your most reliable client suddenly become less than reliable? Did you find certain projects to be not as fulfilling as they had been previously? Did you make a conscious decision to pursue a more fulfilling but less lucrative project?

Those are all reasonable justifications for having a variance. Variances are completely fine, as budgets (like life) aren't supposed to be perfect but rather reflect our best expectations about what may happen. Understanding variances, however, allows you to make better assumptions for future budgeting processes. To further understand this concept, let's examine the variances in Caroline's and Abby's budgets.

Caroline's Budget Variances

At the end of the year, Caroline compares her actual results to her budget, and the variances aren't major.

Caroline's Budget, with Actuals and Variances

Income	Budget	Actual	Variance	Notes
XYZ Media Company	$ 37,800	$ 37,800	$ -	Net paycheck every two weeks of $1,575
Freelance Writing	$ 6,000	$ 5,100	$ (900)	Instead of 12 articles, wrote 10 (none in July/August)
Taxes	$(1,800)	$(1,530)	$ 270	
Net Freelance Writing Income	$ 4,200	$ 3,570	$ (630)	
Total Income	**$42,000**	**$41,370**	**$ (630)**	
Savings	$(5,120)	$(2,819)	$ 2,301	Saved less than goal—but still nearly $3,000!
Income after Savings	**$36,880**	**$38,551**	**$ 1,671**	
Expenses				
Living Expenses:				
Rent	$ 12,000	$ 12,000	$ -	Lease signed—no variance
Car payment	$ 5,880	$ 5,880	$ -	Car payments fixed—no variance
Utilities (gas/electricity)	$ 1,080	$ 1,200	$ 120	
Phone	$ 1,320	$ 1,440	$ 120	
TV/Cable/Internet	$ 1,320	$ 780	$ (540)	Eliminated cable starting in April
Renter's insurance		$ 984	$ 984	Forgot to budget for this
Social	$ 2,400	$ 2,180	$ (220)	Fewer outings? Maybe social counted as networking
Yoga classes	$ 4,680	$ 4,280	$ (400)	Unlimited passes
Food	$ 2,880	$ 3,092	$ 212	
Total Living Expenses	$ 31,560	$ 31,836	$ 276	
Creative Expenses:				
Books	$ 600	$ 2,750	$ 2,150	Needed a lot more books!
Supplies	$ 2,400	$ 490	$ (1,910)	Saved a bit on supplies because I spent more on books
Total Creative Expenses	$ 3,000	$ 3,240	$ 240	
Business Expenses:				
Web hosting	$ 100	$ 100	$ -	
Promotions/advertising	$ 250	$ -	$ (250)	Didn't do any promotions
Printing, computer repairs	$ 600	$ 1,488	$ 888	Expensive repair to computer
Meetings (coffee, meals)	$ 480	$ -	$ (480)	Most meetings counted as networking events
Memberships	$ 150	$ 275	$ 125	Membership fees higher than expected
Insurance	$ 140	$ 140	$ -	
Networking events	$ 600	$ 1,472	$ 872	Counted some social as networking
Total Business Expenses	$ 2,320	$ 3,475	$ 1,155	
Total Expenses	**$36,880**	**$38,551**	**$ 1,671**	
Net Income (Loss)	**$ -**	**$ -**	**$ -**	

In some cases, there are no differences between the actual and budgeted numbers. Her rent and car payments are just as she expected. And the variances in some areas can be easily explained. For example, instead of writing 12 articles during the year (the budget), she completed only 10 (the actual); this decreased her freelance income (a negative or unfavorable variance). She curtailed her cable expense in April, so at the end of the year she shows a favorable budget variance in that category (that is, she spent less than she planned). In other areas, she adjusted. Because she purchased more books than she budgeted for, she consciously bought fewer supplies. By adjusting, she turned a $2,150 budget problem (what she overspent on books) into a $240 budget problem (what she overspent less what she saved on supplies).

Other variances are harder to explain. Caroline underspent on social expenses, but she now realizes that some of her networking activities should have counted as social expenses. This is a possible source of the variance, and she plans to pay closer attention to this expense in the future. Because she didn't budget for renter's insurance, that category shows a large variance. Now that she knows better, she will budget for that expense in the future.

Note the amount Caroline saved. Although she didn't meet her savings goal for the year, she saved nearly $3,000—no small accomplishment. She should be proud and celebrate that fact rather than punish herself for the shortfall. Thinking optimistically (but not unrealistically) is important when budgeting.

Abby's Budget Variances

Recall Abby's budget (see Chapter 5). She created a budget to travel to four art festivals in an attempt to sell her paintings during her yearlong residency in Ohio. She estimated that the cost to attend each festival would be about $690 and the income to sell three paintings at each festival would be $1,350.

Abby's budget turns out pretty well. She selected four festivals to attend. She actually earned more income than she expected (a positive variance) at the first three festivals because she sold a number of low-priced, smaller paintings. Although she didn't plan on selling those works, she quickly realized that the festival attendees preferred them, especially because of their low price. In addition, her expenses per festival exceeded her budget. To adjust for that variance and save money, Abby decided her fourth festival should be local, thus allowing her to save tremendously on travel expenses. The local festival wasn't Abby's first choice, but she was mindful of her expenses.

Now that Abby is examining her budget, she finds the following variances for each trip:

Abby's Budget, with Actual and Variances

CLEVELAND ARTS FESTIVAL			
July 1 – July 3 (3 days, 2 nights)			
Actual Festival Income		Travel Budget	Over (Under)
Sales Income			
Painting #406	$ 325.00		
Painting #522	$ 575.00		
Small paintings (14 @ $55)	$ 770.00		
Total Income—Cleveland Arts Festival	$1,670.00	$ 1,350.00	$ 320.00
Actual Festival Expenses		Travel Budget	(Over) Under
Entrance Fee			
Flat fee to purchase booth space	$ 300.00	$ 300.00	$ -
Transportation			
Car (no trailer)			
Miles	294.00		
IRS Rate	$ 0.55		
Total Transportation	$ 161.70	$ 137.50	$ (24.20)
Lodging			
Nights in hotel near festival	2.00		
Cost per night	$ 104.50		
Total Lodging	$ 209.00	$ 160.00	$ (49.00)
Meals			
7/1 Breakfast	$ 3.50		
7/1 Lunch	$ 5.75		
7/1 Dinner	$ 18.00		
7/2 Breakfast (in hotel)	$ -		
7/2 Lunch	$ 8.75		
7/2 Dinner (official festival dinner)	$ 35.00		
7/3 Breakfast (in hotel)	$ -		
7/3 Lunch	$ 8.75		
7/3 Dinner	$ 12.75		
Total Meals	$ 92.50	$ 90.00	$ (2.50)
Total Cost—Cleveland Arts Festival	$763.20	$ 687.50	$ (75.70)
Net Income (Loss)—Cleveland Arts Festival	$906.80	$ 662.50	$ 244.30

Abby's Budget, with Actual and Variances, continued

LEXINGTON ARTS FESTIVAL			
June 14 – June 15 (2 days, 1 night)			
Actual Festival Income		**Travel Budget**	**Over (Under)**
Sales Income			
Painting #323	$ 325.00		
Painting #328	$ 575.00		
Painting #334	$ 575.00		
Painting #521	$ 475.00		
Painting # 523	$ 475.00		
Small paintings (8 @ $55)	$440.00		
Total Income—Lexington Arts Festival	**$2,865.00**	**$1,350.00**	**$ 1,515.00**
Actual Festival Expenses		**Travel Budget**	**(Over) Under**
Entrance Fee			
Flat fee to purchase booth space	$450.00	$ 300.00	$ (150.00)
Transportation			
Car (with trailer)			
Miles	382.00		
IRS Rate	$ 0.55		
Trailer rental ($55 per day)	$ 110.00		
Total Transportation	$320.10	$ 137.50	$ (182.60)
Lodging			
Nights with friend in Lexington	1.00		
Cost per night	$ -		
Total Lodging	$ -	$ 160.00	$ 160.00
Meals			
6/14 Breakfast	$ 3.50		
6/14 Lunch	$ 5.75		
6/14 Dinner (with friend)	$ 45.00		
6/15 Breakfast (at friend's house)	$ -		
6/15 Lunch	$ 5.75		
6/15 Dinner (with festival organizer)	$ -		
Total Meals	$ 60.00	$ 90.00	$ 30.00
Total Cost—Lexington Arts Festival	**$830.10**	**$ 687.50**	**$ (142.60)**
Net Income (Loss)—Lexington Arts Festival			
	$2,034.90	**$ 662.50**	**$ 1,372.40**

Abby's Budget, with Actual and Variances, continued

SLU ARTS			
October 21 – October 24 (4 days, 3 nights)			
Actual Festival Income		Travel Budget	Over (Under)
Sales Income			
Painting #201	$650.00		
Painting #724	$425.00		
Painting #572	$600.00		
Small paintings (18 @ $55)	$990.00		
Total Income—SLU ARTS	$2,665.00	$1,350.00	$ 1,315.00
Actual Festival Expenses		Travel Budget	(Over) Under
Entrance Fee			
Flat fee to purchase booth space	$ 350.00	$ 300.00	$ (50.00)
Transportation			
Car (no trailer)			
Miles	834.00		
IRS Rate	$ 0.55		
Total Transportation	$ 458.70	$ 137.50	$ (321.20)
Lodging			
Nights with friend in St. Louis	3.00		
Cost per night	$ -		
Total Lodging	$ -	$ 160.00	$ 160.00
Meals			
10/21 Breakfast	$ 1.90		
10/21 Lunch	$ 5.75		
10/21 Dinner	$ 8.50		
10/22 Breakfast	$ 1.90		
10/22 Lunch	$ 5.75		
10/22 Dinner	$ 15.80		
10/23 Breakfast	$ 3.50		
10/23 Lunch	$ 5.75		
10/23 Dinner (with friends)	$ 45.00		
10/24 Breakfast	$ 3.50		
10/24 Lunch	$ 5.75		
10/24 Dinner	$ 15.75		
Total Meals	$ 118.85	$ 90.00	$ (28.85)
Total Cost—SLU ARTS	$ 927.55	$ 687.50	$ (240.05)
Net Income (Loss)—SLU ARTS	$1,737.45	$ 662.50	$ 1,074.95

Abby's Budget, with Actual and Variances, continued

COLUMBUS LABOR DAY FESTIVAL			
September 3 – September 4 (2 days, 1 night)			
Actual Festival Income		Travel Budget	Over (Under)
Sales Income			
Painting #197	$ 575.00		
Painting #400	$ 375.00		
Small paintings (3 @ $55)	$ 165.00		
Total Income—Columbus Labor Day Festival	$1,115.00	$ 1,350.00	$ (235.00)
Actual Festival Expenses		Travel Budget	(Over) Under
Entrance Fee			
Flat fee to purchase booth space	$ 275.00	$ 300.00	$ 25
Transportation			
Car (no trailer)			
Miles	12.00		
IRS Rate	$ 0.55		
Total Transportation	$ 6.60	$ 137.50	$ 130.90
Lodging			
No lodging (home)	-		
Cost per night	$ -		
Total Lodging	$	$ 160.00	$ 160.00
Meals			
9/3 Lunch	$ 5.75		
9/3 Dinner (at festival)	$ 25.00		
9/4 Lunch	$ 5.75		
Total Meals	$ 36.50	$ 90.00	$ 53.50
Total Cost—Columbus Labor Day Festival	$ 318.10	$ 687.50	$ 369.40
Net Income (Loss)—Columbus Labor Day Festival	$796.90	$ 662.50	$ 134.40

Abby's Budget, with Actual and Variances, continued

Actual Festival Income & Expenses		Travel Budget	Over (Under)
Total Travel Income	$ 8,315.00	$ 5,400.00	$ 2,915.00
Average per Trip	$ 2,078.75	$ 1,350.00	$ 728.75
Painting Sales (12 total)	$ 495.83	$ 450.00	$ 45.83
Small Sales (43 total)	$ 55.00	$ -	$ 55.00
Total Travel Expenses	$ 2,838.95	$ 2,750.00	$ (88.95)
Average per Trip	$ 709.74	$ 687.50	$ (22.24)
Average Entrance Fees	$ 343.75	$ 300.00	$ (43.75)
Average Transportation	$ 236.78	$ 137.50	$ (99.28)
Average Lodging	$ 52.25	$ 160.00	$ 107.75
Average Meals	$ 76.96	$ 90.00	$ 13.04

Sales of Major Works (#)	12
Average Selling Price	$ 495.83
Sales of Small Works (#)	43
Average Selling Price	$ 55.00

When comparing the budgeted from the actual numbers, Abby realizes that her expense figures aren't that far off. On average, each festival's actual cost was $709.74, compared with the budget of $687.50. However, the actual amount could have been higher if Abby had not chosen to attend a nearby festival (her fourth festival) instead of one that required traveling. The three festivals she did attend were pricey (anywhere from $75 to $240 over budget). In future budgets, Abby may plan to spend about $840 per festival instead of the more modest $687.50. She computes the higher average cost on the basis of the three nonlocal festivals, which provides a more accurate estimate of nonlocal festival costs.

Abby underestimated her income. She ended up making $2,915 more than she budgeted. No matter how she analyzes that variance, it is good news for her bottom line. She sold 12 major works and 43 small paintings during the course of the festivals, which was more optimistic than her most conservative budget (which assumed she would sell three major works per festival). The average selling price for each major work was $495, which exceeded the average price she budgeted ($450). Note the way Abby records her sales for each festival by painting. We'll address inventory systems and cost of sales along with the recordkeeping discussion in Chapter 12.

Creating a budget, performing a what-if analysis to prepare for uncertainties, and monitoring the budget for variances between the actual and the budgeted amounts are important tasks for a creative entrepreneur to remain informed (and empowered) financially. But then what?

The only reason we do any of this is to help us achieve our goals, whether they are financial, creative, or personal in nature. Budgeting (and budget analysis) is the first step toward our goals, but it isn't enough. We must translate our budget (and its results) into personal financial statements to see the ultimate impact on our goals.

Personal Financial Statements

Personal financial statements, two in particular, illustrate your financial position, much as an artist statement articulates your artistic position. Personal financial statements outline the path from your budget to your goals. For our purposes, we'll focus on the personal profit and loss statement and the personal balance sheet. The actual figures from your budget morph into your personal profit and loss statement for the year, and the result of that statement affects your personal balance sheet. Ultimately, it is the net worth from your personal balance sheet that funds your goals.

Path from Budget to Goals

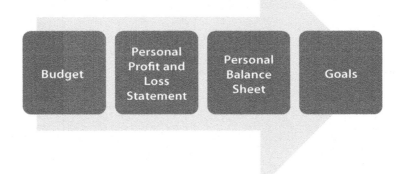

Creative entrepreneurs should produce a personal profit and loss statement and a personal balance sheet at least once a year, using the templates in this chapter. You can coordinate the information with the budget and goal worksheets from previous chapters.

We'll begin the discussion of personal financial statements by focusing on the technicalities of the statements, and then spend

time illustrating how personal financial statements connect a creative entrepreneur's budget to his or her goals.

Personal Profit and Loss Statement

The actual results shown in the budget become the foundation for a profit and loss (or P&L) statement. A P&L is an ongoing record of income and expenses (called "activity") for one period (a year, generally). Companies create P&L statements, which show the income earned and expenses incurred during the year and the net amount of the two at the bottom. A personal P&L works the same way, and it mirrors your budget, although usually with less detail. The net amount at the bottom (hence the term "bottom line") is important for goal-achieving purposes, while the rest of the statement is important for budgeting purposes.

A positive net income or profit exists when income exceeds expenses for the year, and it brings you closer to achieving your financial goals. A negative net income or loss exists when expenses exceed income, and it prolongs the achievement of your financial goals. Your net income amount for a period or span of time increases or decreases your personal balance sheet, the second type of personal financial statement.

Sample Personal P&L Statement Format

Profit & Loss Statement For the period _____		
Income		Expenses
Total Income	$	Total Expenses $

Net Income (income minus expenses) $ _____

Personal Balance Sheet

A balance sheet is a snapshot (akin to a photograph) of your financial health at one moment in time, on one day. It differs from the P&L, which captures income and expenses for an entire period (one year) and is analogous to a movie instead of a photograph.

Your balance sheet shows what you have (called "assets"), what you owe (called "liabilities"), and the difference between the two (called "net worth" for our purposes). Companies call this difference either "equity" or "net assets."

As you progress toward your goals, you increase asset balances on your balance sheet. Increases in asset balances come from the net income on the P&L statement.

In simple terms, assets are good and liabilities are bad (although it is never quite that simple). When you have more assets than liabilities, you have positive net worth; when you have less, you have negative net worth. Positive net worth is good, because the excess can fund your goals. Negative net worth is bad, because the shortfalls defer your goals.

Connecting the Balance Sheet to Goals

Once you know your net worth (regardless of the number of zeros it contains), divide it into different buckets—one bucket per goal. This is theoretical dividing; I'm not suggesting you open a different bank account for each goal, but it is useful to track progress toward each individual goal.

Assign one bucket as a "rainy day" fund—like emergency money or a cash reserve. This fund should be able to cover (at least) six months of expenses, but a year's worth is even better. Replace any part of the fund that gets depleted (as it may likely be throughout the year). The remaining buckets are reserved for your other goals. You've already established the nature, amount, and timing of your goals. As other goals appear or disappear, adjust the buckets accordingly. By giving each goal its own separate bucket, you're doing a few things.

First, you are clarifying what you are saving for (e.g., down payment on a house, vacation, retirement), how much you need to save toward that singular purpose, and how much can go toward

other pursuits. This way, you ensure that you aren't double saving; that is, you aren't mentally allocating money to fund multiple goals. For example, you have $60,000 in your bank account. You allocate $50,000 to your rainy day bucket. Now that you know you have only $10,000 ($60,000 − $50,000) left, you won't be tempted to spend $20,000 on a new car (a different bucket). Only $10,000 is available to fund a new car.

Second, you are making each goal accessible and measurable. It is daunting to imagine the total amount you may need to save to achieve all your goals. Having to save a (presumably) large amount is a discouraging thought and might hinder your progress. If your goals are articulated in small financial chunks or buckets, each appears more manageable, even if the total amount you must save remains unchanged. You have tricked yourself into being optimistic.

Third, you are developing a system for tracking your progress toward achieving each goal. Everyone likes to feel that they are moving forward, closer to their intended objective, rather than simply floating without direction. As you watch the savings balance grow in each bucket, you're more likely to continue adding money or cutting expenses (healthy financial habits) to see that balance increase even more. It absolutely works.

Sample Personal Balance Sheet

Balance Sheet Date: _____			
Assets		**Liabilities**	
Total Assets	$	Total Liabilities	$

Net Assets (assets minus liabilities) $ _____

Net Asset Segments					
Rainy Day Fund	Goal	Goal	Goal	Goal	Goal
$	$	$	$	$	$

Segment choices (Goals)
- ➤ Rainy day fund/cash reserve/emergency money
- ➤ Down payment on a house
- ➤ Retirement
- ➤ Vacation

Caroline's Financial Statements

The actual results of Caroline's budget feed directly into her P&L statement for the year.

Caroline's Profit & Loss Statement

Profit & Loss Statement For the period: 2012			
Income		Expenses	
XYZ Media Company	$ 37,800	Living expenses	$ 31,836
Freelance writing	$ 3,570	Creative expenses	$ 3,240
		Business expenses	$ 3,475
Total Income	$ 41,370	Total Expenses	$ 38,551

Net Income (income minus expenses)	$ 2,819

Caroline had positive net income for the year of nearly $3,000. (Note that this is the amount she put toward savings on her final budget, with actual results.)

Caroline's personal balance sheet looks like this at the beginning of the year:

Caroline's January 1 Balance Sheet

Balance Sheet Date: 1/1/12			
Assets		Liabilities	
Cash (checking account)	$ 524	Car loan	$ 20,000
Cash (savings account)	$ 12,452	Apartment lease	$ 12,000
401(k)	$ -	Credit card debt	$ 8,000
Car	$ 25,000		
Computer	$ 2,000		
Supplies	$ 500		
Total Assets	$ 40,476	Total Liabilities	$ 40,000

Net Assets (assets minus liabilities)	$ 476

Net Asset Segments					
Rainy Day Fund	Goal: TBD	Goal: TBD	Goal: TBD	Goal: TBD	Goal: TBD
$ 476	$ -	$ -	$ -	$ -	$ -

Caroline's Assets and Liabilities

As Caroline's balance sheet illustrates, sometimes the things we have represent both assets and liabilities. In Caroline's case, such an asset (and liability!) is her car. The car appears on both the assets and liabilities sides, because although it is a valuable property it is hindered by a debt. To purchase the car (which cost $25,000), she put down $5,000 in cash (which decreased her cash in the bank) and took out a car loan to finance the rest of the amount ($20,000). The full value of the car ($25,000) is her asset. The financed portion of the car ($20,000) is her liability. She traded $5,000 and a promise to pay $20,000 for a $25,000 car. The transaction balances ($5,000 + $20,000 = $25,000). (This transaction doesn't show up on her balance sheet, but rather it would have been reflected on her personal profit and loss statement for the year she purchased the car.)

As Caroline pays the bank a portion of her car loan each month, her cash balance decreases and her liability goes down (because she is paying the debt). The value of the car itself ($25,000) doesn't change. Once she pays off this loan, the liability will be reduced completely from her balance sheet, and the money she typically allots monthly on a car payment can go toward something else.

Caroline's net worth on this January 1 balance sheet is $476. That is the amount she will have if she sells all her assets and pays off all her debts. It is important to understand this net worth number, rather than simply her cash balance, which is considerably higher. The cash balance isn't fully Caroline's because she has promised to give some of it to her landlord (in the form of rent), some to the credit card companies (in the form of a credit card payment), and some to the bank that financed her car (in the form of a car payment). Only the amount that remains—her net worth—directly relates to her goals. By the end of the year, after she has earned her income and paid her expenses (listed on her P&L statement), the positive net income amount shows up on her balance sheet.

The net income (Caroline's savings for the year) is added to her checking account balance. She uses some of the cash in her savings account ($5,880) to make car payments and reduce her car loan from $20,000 to $14,120. Assume the rest of the amounts remain unchanged (she does not purchase a new computer, she replenishes

her supplies, she signs another apartment lease for the next year for the same amount, and she makes no progress in paying off her credit card debt). Her December 31 balance sheet is now as follows:

Caroline's December 31 Balance Sheet

Balance Sheet Date: 12/31/12			
Assets		**Liabilities**	
Cash (checking account) $ 3,343		Car loan	$ 14,120
Cash (savings account) $ 6,572		Apartment lease	$ 12,000
401(k) $ -		Credit card debt	$ 8,000
Car $ 25,000			
Computer $ 2,000			
Supplies $ 500			
Total Assets $ 37,415		Total Liabilities	$ 34,120

Net Assets (assets minus liabilities) $ 3,295

Net Asset Segments					
Rainy Day Fund	Goal: TBD	Goal: TBD	Goal: TBD	Goal: TBD	Goal: TBD
$ 3,295	$ -	$ -	$ -	$ -	$ -

Caroline's new net worth is $3,295 (this is the net worth from her January 1 balance sheet [$476] plus the net income she earned for the year [$2,819]). She allocates the full amount toward her rainy day fund.

The Connection between Financial Statements and Goals

Again, the most important part of the personal P&L statement is the bottom line—the amount of net income. (Analyzing income and expenses is important during the budgeting phase; once you've moved into creating personal financial statements for a year, the P&L's bottom line is what affects your goals.)

Positive net income increases assets on the balance sheet. (Think about it: When you make more money than you spend, you have more cash; cash is an asset on the balance sheet.) Conversely, negative net income increases liabilities on the balance sheet. (Again, think about

it: When you spend more money than you make, you can't cover all your expenses and thus need additional funds—likely from either a credit card or a loan. Such debt is a liability on the balance sheet.)

If you have savings or a reserve fund, negative net income may decrease your assets instead of increasing your liabilities. (Arguably, this is "better" from a financial perspective, although the results are just as bad from a goal-setting perspective.) If you spend more money than you make for a certain period of time, the money you use may come from your cash reserve. That means your cash balance (an asset) goes down. Here's an illustration:

Connecting Financial Statements to Goals

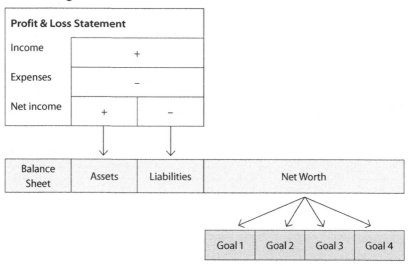

Positive net income increases assets, which builds net worth, which then accelerates financial progress toward your goals. On the other hand, negative net income (i.e., losses) decreases assets or increases liabilities, either of which lowers net worth, which then defers financial progress toward your goals. Consider the following examples.

Example 1

At the beginning of the year, Entrepreneur A's assets are $12,000 and his liabilities are $3,000, so his net worth is $9,000, which he divides into three goals. He earns $8,000 in net income for the year,

which increases his assets and thus the amount he has devoted to each goal. Here's an illustration of his financial statements:

Example 1

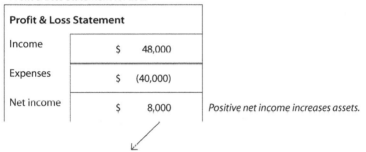

1/1/2012 Balance Sheet

	Assets	Liabilities	Net Worth
Balance Sheet	$ 12,000	$ 3,000	$ 9,000

$ 6,000	$ 2,000	$ 1,000	$ -

Profit & Loss Statement for 2012

Profit & Loss Statement	
Income	$ 48,000
Expenses	$ (40,000)
Net income	$ 8,000

Positive net income increases assets.

12/31/2012 Balance Sheet

	Assets	Liabilities	Net Worth
Balance Sheet	$ 20,000	$ 3,000	$ 17,000

$ 8,000	$ 4,000	$ 3,000	$ 2,000

An increase in assets increases progress toward goals.

Example 2

If instead Entrepreneur A loses $4,000 during the year (a negative net income), he may use his existing cash (stored in his rainy day fund) to cover the shortfall. Here's an illustration:

Example 2

1/1/2012 Balance Sheet

	Assets	Liabilities	Net Worth
Balance Sheet	$ 12,000	$ 3,000	$ 9,000

$ 6,000	$ 2,000	$ 1,000	$ -

Profit & Loss Statement for 2012

Profit & Loss Statement	
Income	$ 38,000
Expenses	$ (42,000)
Net income	$ (4,000)

Negative net income decreases assets.

12/31/2012 Balance Sheet

	Assets	Liabilities	Net Worth
Balance Sheet	$ 8,000	$ 3,000	$ 5,000

$ 3,000	$ 2,000	$ -	$ -

A decrease in assets decreases progress toward goals.

Example 3

Alternatively, Entrepreneur A may use his credit card to cover his shortfall for the year. Instead of decreasing his assets, he increases

his liabilities. Either way, his net worth decreases, and his progress toward his goals is hindered. Here's an illustration:

Example 3

1/1/2012 Balance Sheet

	Assets	Liabilities	Net Worth
Balance Sheet	$ 12,000	$ 3,000	$ 9,000

$ 6,000	$ 2,000	$ 1,000	$ -

Profit & Loss Statement for 2012

Profit & Loss Statement	
Income	$ 38,000
Expenses	$ (42,000)
Net income	$ (4,000)

Negative net income may increase liabilities.

12/31/2012 Balance Sheet

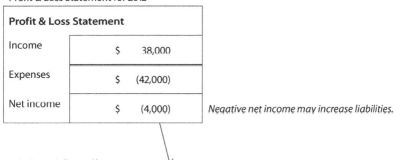

	Assets	Liabilities	Net Worth
Balance Sheet	$ 12,000	$ 7,000	$ 5,000

$ 3,000	$ 2,000	$ -	$ -

An increase in liabilities decreases progress toward goals.

Caroline's situation is akin to Example 1. A positive net income for the year increases her assets, which in turn raises the amount she allocates toward her goals.

Practice, Rinse, Repeat

Budgets and personal financial statements get easier to create and understand with practice and repetition. These financial exercises aren't one-time tasks; rather, they are ongoing activities that complement a creative professional's skill set and business interests. Just as basic knowledge of marketing, social media, public relations, business, technology, and customer service is essential to an entrepreneur's career and longevity, so is a basic understanding of finance. No savvy entrepreneur ignores an opportunity to attract and retain clients, remain relevant in the field, and learn new strategies, so why should the same professional avoid financial matters that can affect business viability and sustainability?

Because budgets and financial statements cover specific parameters of time and purpose, they are only applicable within those defined parameters. This is good, because it gives you reason to create a new budget and another set of financial statements, enabling you to practice and repeat the processes. Establish new parameters. Expand the time frames. But don't start from scratch because that is a colossal waste of time. Use the ending balance sheet as the starting balance sheet for the next year, or build on previous budgets and financial statements. Take into consideration whatever lessons you learned in your previous attempts.

This financial process is like diagramming sentences or practicing scales. It's not fun; it's not exciting; it's not what brings prestige, fame, and fortune to a craft. But it is an essential part of building a successful business ... and life.

True creative and financial empowerment will follow suit once you've mastered (through practice and repetition) the steps of managing your income and expenses. You'll find your own nonlinear path in that massive gray area occupied by creative professionals (see the happiness graph discussion in Chapter 2). Whether that path leads toward financial security or toward creative liberty or is nestled comfortably in between is up to you.

Cash Challenges

As an entrepreneur, you may face one major, overarching hurdle related to cash: You don't always know when it's coming. Because your income varies and is paid at irregular intervals, you may have cash flow timing problems (which result when cash must be spent [outflow] before cash is received [inflow]).

There are two solutions to this problem:

➤ Build up cash reserves to use during lean, unpaid times to fund ongoing expenses.

➤ Anticipate the timing of cash flows to better understand the necessary reserve amount and adjust flexible expenses.

Logan's Cash

Logan squints as he scans the restaurant to look for his friends Abby and Caroline. He finally spots them at a table near the back and rushes toward them.

"You're not going to believe this," he says by way of hurried greeting. "They paid me in cash tonight! What am I going to do with all of this?" gesturing to his back pocket as he takes a seat.

"Dinner's on you," Caroline retorts. "And who are 'they'?"

"They are this really cool, artsy place that hosted the acting workshop I led tonight," Logan explains. "The clientele there is interesting—performance artists, actors, playwrights, even some famous people. It's relatively new, but it already has so much cachet. It hosts these master classes that are well attended and heavily promoted. So I said yes!"

"What was the catch?" Abby asks.

"Instead of paying my normal flat fee, they offered to split the proceeds with me," Logan continues. "So if no one showed up, I wouldn't get paid. I figured out that to earn what I would normally be paid for a gig like that, at least 27 people had to show up."

"That's a big gamble," Abby offered.

"It was, but more than 40 people showed up," Logan reported. "The class

was awesome and I made some incredible connections. The venue even wants me to come back next year!"

"That's amazing, but why did it pay in cash?" Caroline wonders.

"Isn't that crazy? As I was leaving, the manager came up to me, shook my hand, and handed me a wad of cash," Logan says. "Of course, I took it. But getting a check is so much easier. It is just paper and I can deposit it right away, even though it's real money. With cash I get tempted to spend it more quickly and on things that aren't in my budget."

"Like this dinner!" Abby jokes.

Cash Flow

Logan is exactly right: It is easier to track checks than cash. Because of that, **cash flow** problems can occur. "Cash flow" sounds like an intimidating accounting phrase, but all it means is balancing the timing of cash inflows with the timing of cash outflows.

For a professional in a traditional salaried job like Elizabeth, cash flow is straightforward. Every two weeks, she receives a predictable, flat salary. This take-home amount (out of which appropriate taxes, social security contributions, health insurance premiums, and retirement-fund contributions have been deducted) comes in the form of a check and is directly deposited into her checking account. She knows when she gets paid, how much she gets paid, when the check posts to her account, and when the money is available to pay her expenses.

For an entrepreneurial artist like Logan, cash flow is uncertain. He doesn't always know when he will get paid, how much he will get paid, or what form the payment may take (cash or check). But he knows when he must pay his bills. He has a potential timing issue because his income is less predictable than his expenses. But he can change his financial habits to improve his cash flow, despite the unpredictability of his income. However, before we discuss unpredictability, let's talk about cash itself.

Cash Recordkeeping

What should Logan (or you) do the next time he receives cash instead of a check? The answer is to treat the cash as if it were a check. Here's a step-by-step guideline:

> ➤ Go directly to the bank (an ATM works fine); do not pass go; do not enter the fancy restaurant.
> ➤ Pretend the cash is a check, and deposit it immediately.
> ➤ On the deposit receipt, write the title of the class, the name of the venue, and any other note that would serve as a reminder of the source of the money.
> ➤ At home, record the cash as if it were payment from an invoice. (This "contemporaneous documentation" is important, and we'll talk more about recordkeeping for tax purposes in Chapter 11.)

Sure, getting a check is easier, as the check is imprinted with the payer's name and other information, payee's invoice number, and payment amount. The deposit receipt for the check could include a printed image of it, making the check easier to remember months later. But this guideline, especially the recordkeeping part, works just as well.

Cash is fungible, meaning it is impossible to tell if a $20 bill in your wallet came from a teaching gig or a tip or an ATM withdrawal from your salary. One $20 bill looks just like another. Because your cash isn't labeled, recordkeeping for cash is much more important than it is for checks and other forms of payment. Correcting a recording or depositing mistake is easier with a check than with cash. This is why recordkeeping for the cash income you receive is crucial.

And even though cash you earn is fungible, it must be treated exactly the same as other income would. You still have to pay taxes on it, you still have to record it, and you still have to include it in your budget and financial statements. Even if you spend it right away and then forget about it, it still counts as income.

Sometimes, companies or businesses track payments (even if they are in cash) to independent contractors (like Logan). They issue a Form 1099 to each contractor at the end of the year; the form

is a record of how much a contractor earned or received in total from the company for that year. The form is also submitted to the IRS, so the IRS is aware that the company paid the contractor a specific income that should show up on the contractor's tax filing. But even if you don't receive a Form 1099 from the entity that hired you for a project (either because the entity paid you less than the reportable amount—$600 in 2012—or the business didn't keep a record of cash or check payments) you must report that income to the IRS. You have an obligation to pay taxes on income you earned, even fungible cash income.

The Unpredictability of Income

You and I, as creative entrepreneurs, would love to know when to expect gigs and payment with precision. But we rarely have the luxury of predictability. Some months are lucrative, with consulting engagements, deadlines for ongoing and incoming projects, performances and showings, or teaching seminars all competing for space in the calendar. These are months when hours pass in moments, sleep is happily forgone, and productivity is at its peak. And with great productivity often comes great financial rewards. Payment typically follows busy months of work and could mean celebrating with a few drinks, a fancy dinner out, a short trip out of town, a new instrument or equipment, or a long session in the recording studio.

But reality is always looming. Not every month is a great month. Unfortunately, while you are not working (and thus not getting paid) you still have to pay rent; buy groceries and basic necessities; keep the utilities turned on; and make a student loan, credit card, or car payment. All of these bills can be difficult or nearly impossible to settle without income or at least a possibility of an incoming gig. Not only is this a cash flow problem, but it also causes sleepless nights and stifles creativity tremendously, which in turn may make bouncing back hard when the not-so-great months are over. Being financially poor and creatively unhappy is a bad spot on the happiness graph; don't find yourself there.

The Unhappy Spot on the Happiness Graph

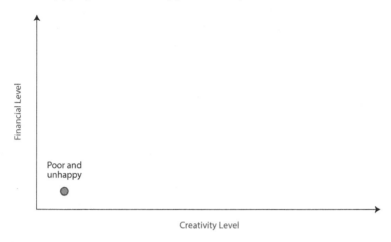

Real Solution 1: Using Cash Reserves

What's a solution to this cash flow problem caused by unpredictability? A common solution that many entrepreneurs employ during lean months is to use a credit card to pay for expenses, casually ignoring what is happening beneath the surface. Unfortunately, this practice leads to another common recurring problem for too many entrepreneurial artists and creative entrepreneurs: massive amounts of credit card debt that costs many times more to repay than the original expenses themselves.

Chapter 4 discusses how compounding works in the context of earning interest on savings. Credit card compounding works the same way, but instead of customers reaping the benefits of compounding, they suffer its burden. After the low introductory rates (offered for the first couple of months or even a year to lure people into applying for and using the credit card) lapse, the credit card company increases the rates steeply to 12 percent, 18 percent, or even 26 percent per year. Entrepreneurs are smart; they know this credit card math deep down.

Instead of using credit cards, think about a real solution to cash unpredictability. Start and maintain a reserve fund—cash savings that you can use as a bridge between the months you are not

earning an income and the months you are inundated with paid work. Accumulating this reserve should be your number one priority, and this pot should never be subjected to investment risk or used as a celebration fund.

The Tangibility of Cash

Touching cash makes the income tangible. It is a powerful feeling that leads you in opposite directions. When you're paid in cash, you feel rich. You either want to spend it right away or hold on to it more carefully to prolong that feeling. Because you do have bills and expenses, you also want to ensure that every dollar is spent wisely so that the landlord gets the rent, the food pile is replenished, the creditors are paid, and so on. This is managing your tangible cash, and for this there's an effective tool called the **envelope method**.

The Envelope Method

The envelope method is simple:

- ➤ Label one envelope for each expense category on your budget. One is called "rent," one is "groceries," one is "cell phone," one is "social outings," one is "credit card"—you get the idea. Use as many envelopes as there are expense lines on your budget.
- ➤ Fill each envelope with enough cash to fund the separate expense for the period (e.g., a month, a week).
- ➤ Use the cash (and only cash) to pay for your expenses as they occur.

But here's the catch: To make the envelope method work, you have to commit to two things. First, use only cash during the entire budget period. That week or month, you can't buy groceries with a credit card and be excited that you still have cash left in the "groceries" envelope. Even if there is still cash in the envelope, the grocery budget is either gone or reduced, eaten up by the credit card charge. Second, do not spend more than what each envelope contains. You created your budget; you chose the amounts to fill each envelope. If you don't have enough cash in the "social outings" envelope, you

must literally take cash from another envelope to fund excessive social expenses. Maybe you choose to deplete the grocery envelope; maybe you choose the clothing envelope, or maybe you choose the supply envelope. It doesn't matter which one you choose, but the cash you use has to come from one. But you've created a domino cash flow problem, and you'll eventually run out of envelopes to take cash from, which might result in one expense not getting paid (and that could mean interest or penalties).

The Modified Envelope Method

Given the convenience of online bill payment systems and the financial benefits offered by some creditors to customers who use automatic payments (e.g., some student loan providers reduce the interest rates for those enrolled in their electronic payment program), the idea of putting cash in an envelope and delivering it to a landlord or a cell phone provider is ludicrous. Most people don't even know the physical locations of their various creditors. The modified envelope method is an acknowledgment of the availability of technology-based transmissions, helping people manage their tangible cash as well as their electronic funds.

Here's the basic premise: Use cash for small or daily transactions that happen in person, and pay electronically for the rest. Keep envelopes for items that you will pay in cash, just as you did for the envelope method. But toss the envelopes for expenses that you will pay electronically. For example, pay with cash at the grocery store, movie theater, or pharmacy; in bars, restaurants, and coffee shops; for lunches and bus, train, or cab fares; and for other incidentals. Reserve online bill payments, checks, and debit cards for monthly, recurring, or fixed-amount expenses, like rent, utilities, and loans. Set aside enough money in your checking account each month to cover the electronic bills.

Debit cards may be a preferable electronic payment method because the expense is removed from your bank account immediately, which provides some level of tangibility to the expense (unlike a credit card). But for maintaining the highest possible tangible connection to your expenses, use cash. The most important rule of

the envelope method applies to this modified version as well: Stay within the budget, and only use whatever cash is in the envelope or whatever electronic fund is allocated for a bill. Once the cash is gone, it's gone. If you overspent in any category (funded by cash or electronic transfers of cash), you must borrow from other categories to make up the difference.

The Virtual Envelope Method

Not surprisingly, several tools are available on the Internet that mirror the envelope method. Here are a few options:

- ➤ "Budget" by Snowmint Creative Solutions: http://www.snowmintcs.com
- ➤ Bank of America Money Management: http://learn.bankofamerica.com/articles/money-management
- ➤ Citi Finacial Tools: https://online.citibank.com
- ➤ Mvelopes: http://www.mvelopes.com

These are known as virtual envelopes. Think of these virtual envelopes as sub-bank accounts. Cash isn't leaving your bank account when you put it in a virtual envelope; it is simply partitioned off in an "envelope" within the account, and the system provides a visual representation of your budget in envelope form. But generally speaking, your money doesn't physically go anywhere.

Using virtual envelopes offers some advantages, such as the convenience of creating envelopes online and the rewards (e.g., discounts, points, miles, cash back, reduced interest) offered by banks or credit card companies for electronic transactions. The biggest drawback to virtual envelopes is that they don't give users the physical connection to the cash they are inserting into or pulling out of the envelopes. Moving pictures of cash from envelope to envelope is not as satisfying as the tangible act itself, something that is unique to the envelope method.

Weaning off the Envelope Method

If the envelope method works for you, that's great. Continue using it for as long as you want. But know that once you have a deep understanding of its purpose (spending within your means or budget) and what your expenses look like in cash terms, you should consider transitioning from using just cash. You'll reap more rewards or benefits if you pay electronically, by check, or by debit card, and such forms of payment are more convenient, faster, and easier to track than cash payments (despite their lack of physical form). Maybe you could graduate to using virtual envelopes, debit cards, or even credit cards (as long as you pay the balance off in full each month).

But do pay attention—always. If you find yourself overspending or losing track of your budget, return to the cash-only system. The benefits of electronic or noncash transactions (no matter how good they are) cannot outweigh an over-budget problem.

Real Solution 2: Anticipate the Timing of a Cash Shortage

The other solution to a cash flow problem is to anticipate the timing of a cash shortage so that you may replenish your cash reserves. Potential cash shortages, however, aren't evident by simply examining your budget or P&L statement. Because these tools show income and expenses over a long period (e.g., one year), they aren't suited for cash planning in the short term (on a week-by-week or month-by-month basis). Instead of using the wrong tool to answer the question, "When might I face a cash shortage?" you can reframe the data used in those tools to answer the question.

For example, review your P&L statement and translate the data into cash terms on a month-by-month basis. Here's a form for doing just that:

Personal Cash Flow Statement

Cash Flow Statement For the period _____			
	Cash In (Income)	Cash Out (Expenses)	Net Cash
January			
February			
March			
April			
May			
June			
July			
August			
September			
October			
November			
December			
	Total Income	Total Expenses	

Net Income (income minus expenses) $ _____

The total income and total expenses will remain the same for purposes of the P&L statement and the cash flow statement. But by dividing the total income by timing (month by month) instead of type (teaching income, acting income), you'll identify periods where you might have a cash shortfall. By so doing, you'll be better able to plan for them by building up a reserve (in the approximate amount you'll need) or deferring expenses that are not time sensitive.

Logan's Cash Flow Model

Logan uses his budget for the year as the starting point for his cash flow model. For 2012, Logan prepared the following budget.

Logan's 2012 Budget

Income			
Starring role	Acting income	$ 20,000	*Estimated based on prior year's workload*
Supporting cast	Workshop teaching fees	$ 2,000	*$500 per workshop, one per quarter*
	Reading fees	$ 1,000	*Estimated $100 per reading, ten per year*
	Coaching fees	$ 2,500	*$50 per week*
Production assistance	Bartending income	$ 10,000	*Amount needed to make budget work—pick up hours as necessary*
	Total Income	**$ 35,500**	
Quarterly	Taxes	$ (8,875)	*25% of income for the year*
Flexible	Savings	$ (1,775)	*5% of income for the year*
	Income after Savings	**$ 24,850**	
Expenses			
Monthly	Rent	$ 10,200	
	Utilities	$ 900	
	Phone	$ 1,200	
Quarterly	Management fee	$ 4,000	*Payment to agent*
Flexible	Travel	$ 1,100	
Monthly	Social/food	$ 4,800	
One-time	Health insurance	$ 1,500	*Estimated based on quotes received*
	Renter's insurance	$ 150	*Prior year's insurance amount*
	Memberships	$ 1,000	
	Total Expenses	**$ 24,850**	
Net Income		**$ -**	

He is thrilled that he'll be able to cover his expenses for the year, plus save a little bit ($1,775), based on the roles, workshops, and bartending work he plans to do throughout 2012.

But Logan knows he will not realistically earn his income evenly throughout the year, even though his expenses occur on fairly regular intervals (monthly or quarterly, in most cases). So he prepares a cash flow model to understand at what points in the year he might have trouble paying his expenses. Once he knows when those points will likely be, Logan can save for them accordingly.

Logan's Cash Income Model

	Cash Flow Statement For the period: 2012					
	Cash In (Income)					
Month	Acting income	Workshop teaching fees	Reading fees	Coaching fees	Bartending income	Total Income per Month
January			100	200	2,000	$ 2,300
February		500		200		$ 700
March	4,000			200		$ 4,200
April	8,000			200		$ 8,200
May			400	250	1,000	$ 1,650
June		500		200	1,000	$ 1,700
July				150	2,000	$ 2,150
August		500		150	1,000	$ 1,650
September	4,000		100	350		$ 4,450
October	4,000	500	400	200		$ 5,100
November				200	1,000	$ 1,200
December				200	2,000	$ 2,200
Total	**$ 20,000**	**$ 2,000**	**$ 1,000**	**$ 2,500**	**$ 10,000**	**$ 35,500**

Logan categorizes the type of income he expects to receive, and the total amounts in each category ($20,000 of acting income, for example), match what he budgets for the year. But because his income occurs at irregular intervals, the total income per month Logan expects varies throughout the year from the low point in February ($700) to the high point in April ($8,200). He knows based on his production schedules when his acting income will likely occur, and he knows from previous experience when opportunities to earn reading fees and workshop teaching fees will be most likely. He also knows from previous experience when he'll be able to have some extra hours tending the bar (and when he'll be able to spend the time doing that during the summer months when he isn't scheduled to shoot).

Logan prepares a similar model for his expenses, based on when he expects to pay each.

Logan's Cash Expense Model

Cash Flow Statement
For the period: 2012

Month	Taxes	Savings	Rent	Utilities	Phone	Mgmt. fee	Travel	Social/ food	Health insurance	Renter's insurance	Member- ships	Total Expenses per Month
January			850	75	100	1,000		400				$ 2,425
February			850	75	100			400				$ 1,425
March			850	75	100		300	400				$ 1,725
April	2,219	1,775	850	75	100	1,000	200	400				$ 6,619
May			850	75	100			400				$ 1,425
June	2,219		850	75	100			400				$ 3,644
July			850	75	100	1,000	200	400				$ 2,625
August			850	75	100			400				$ 1,425
September	2,219		850	75	100	1,000	200	400				$ 3,844
October			850	75	100	1,000		400			300	$ 2,925
November			850	75	100			400	1,500	150	300	$ 3,375
December	2,218		850	75	100			400			400	$ 4,043
Total	$ 8,875	$ 1,775	$10,200	$ 900	$ 1,200	$ 4,000	$ 1,100	$4,800	$ 1,500	$ 150	$ 1,000	$ 35,500

Many of Logan's expenses occur monthly, for example rent, utilities, and phone. Others occur quarterly (his tax payments, for example, or his management fee). Still others (like insurance and membership fees) occur only once during the year. Logan has some flexibility with respect to these annual expenses because they happen only once per year, so if necessary, he may be able to defer them (assuming he gets the go-ahead from the insurance company or membership groups). He has considerably less flexibility to adjust the timing of monthly and quarterly expenses; they are due when they are due.

Again, the total expenses in each of Logan's categories match the total expenses on his budget. His tax expense for the year is still $8,875 in total; his social/food expense is still $4,800. Logan has simply presented the information by time (i.e., monthly) to understand how much he must spend in cash each month.

So how does Logan's monthly cash inflow compare with is monthly cash outflow? He summarizes his cash flow model to find out.

Logan's Cash Flow Model

Cash Flow Statement For the period: 2012			
Month	Cash In (Income) Total Income per Month	Cash Out (Expenses) Total Expenses per Month	Net Cash
January	$ 2,300	$ 2,425	$ (125)
February	$ 700	$ 1,425	$ (725)
March	$ 4,200	$ 1,725	$ 2,475
April	$ 8,200	$ 6,619	$ 1,581
May	$ 1,650	$ 1,425	$ 225
June	$ 1,700	$ 3,644	$ (1,944)
July	$ 2,150	$ 2,625	$ (475)
August	$ 1,650	$ 1,425	$ 225
September	$ 4,450	$ 3,844	$ 606
October	$ 5,100	$ 2,925	$ 2,175
November	$ 1,200	$ 3,375	$ (2,175)
December	$ 2,200	$ 4,043	$ (1,843)
Total	$ 35,500	$ 35,500	$ -

By looking at his income and expenses by time (i.e., by month) instead of by type (e.g., acting income or rent expense), Logan can see which months will present cash flow challenges.

Logan knows he must begin the year with at least $850 in savings to cover the cash flow shortage he'll have in January ($125) and February ($725). Because he expects to be paid a hefty sum in March, he can replenish the $850 he used of his reserve. This is where Logan might get into trouble. Because he will likely have a lot of cash income in March, he may feel wealthier, and more "entitled" to lavish dinners out, extra indulgences, or other personal rewards that aren't part of his budget. If he "rewards" himself in March, his cash situation will be more dire in future months (especially June, November, and December, when Logan will need his cash reserve to fund future shortfalls).

Logan uses his cash flow model to understand the cash reserve he must have on hand (at least $850 to start the year, almost $2,500 going into June and July, and $4,000 by November and December), and to anticipate cash flow timing issues. He may combat the timing issues by increasing his reserve (again, by saving the excess in March instead of spending it) or by adjusting the timing of his flexible expenses. Perhaps Logan may pay his annual health insurance premium in October (when he has the cash) instead of November (when it is due). Such planning and adjusting help Logan balance the cash timing challenges creative entrepreneurs face.

Liberation from Cash Flow Problems

Despite the cash challenges that come with being an entrepreneur, you likely value your freedom and independence more than the luxury of predictable income. You've done the math—intentionally or unintentionally—and determined that freedom outweighs predictability every time. You realize that you could combat unpredictability in income and irregular cash flows by planning better (i.e., building up and using cash reserves and anticipating the timing of a cash shortage). A well-balanced cash reserve—one that grows a little bit each month—provides more security to an entrepreneur than a traditional job might. And with security comes peace of mind, and with peace of mind comes incredible innovation and creativity.

The Savings–Creativity Cycle

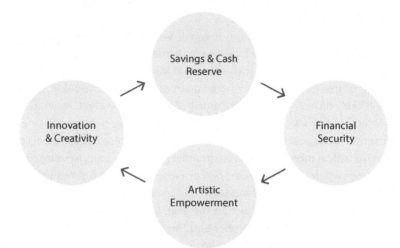

Logan's Envelopes

Logan was initially skeptical of using and receiving cash, but he found the modified envelope method helps him visualize when he needs to take on additional production assistance work (bartending in his case) to complete or replenish the amounts in the envelopes. It also helped him maintain a more tangible sense of his discretionary expenses (particularly social expenses and food).

At the end of every month, Logan deposits any leftover cash from each envelope into a savings account and promptly forgets about it. He doesn't need it, after all, because the cash he adds to various envelopes at the start of each month covers all his expenses. In lean months, he does take money from the savings account to fill his envelopes, but he always replaces the money as soon as the acting or teaching gigs start rolling in again, and as a result, the balance in the account is steadily growing. With a healthy cash reserve, he can choose to reduce and eliminate his production assistance work. He doesn't need it to be his bridge source of income (as we'll discuss next in Chapter 10); he is his own bridge.

More starring and supporting cast roles and less production assistance jobs make for a very happy, at-peace Logan. His roommate, Evelyn, though, isn't as lucky with managing her career or her money. She is having a different sort of cash problem.

Make More Money

It sounds so simple: Make more money. Clearly that is the ideal solution to a cash flow problem, but how does one make more money when the opportunities available are so fleeting and the market so competitive? You have two (noncompeting) choices: Find a bridge source of income and stop masochistic volunteering.

Evelyn Struggles

"Ev, when you have a second, can you write a check for this month's rent?" Logan says to his roommate. "I'll drop it off with the landlord on my way to work."

Evelyn gulps. She just checked her bank balance, and it has dwindled to $503, not enough to cover her half of the rent. Again.

"I hate to say this, Logan, but I don't have it," she confesses gravely. "I'm really, really sorry."

"What do you mean?" he replies, surprised. "You've been working so much lately."

Evelyn's shoulders slump. "Yeah, but I actually haven't gotten paid for most of that work," she says. "None of the choreography projects have paid yet, and I haven't had any income from the dance supply store in a few months. I thought I had enough saved before I stopped working there—at least three months' worth of expenses. But everything seems to cost more than I expected. My last teaching gig went really well, and that paid for last month's rent. But now I'm stuck waiting for checks in the mail and hoping for other work."

"I can cover your half this month," Logan offers. "But do figure something out—and quick. We still have to pay electric and gas, not to mention your other bills."

"I don't know what to do anymore," Evelyn admits. "I cannot spend any less. I already live on a shoestring and I don't buy anything unnecessary. I have to eat; I have to live somewhere; we have to have lights. I have already reduced my expenses as far—farther actually—than they should ever have to go."

"So you can't spend less, I get it," Logan replies sympathetically. "But if you can't spend less, maybe you can … make more?"

Bridge Sources of Income

The first step to earning more money is to find other sources of income. This is where having a portfolio career really shines. Recall from Chapter 1 that a portfolio career consists of three types of work: a starring role (the main craft or passion), supporting cast roles (work related to the craft but is not itself the craft), and production assistance roles (work that has nothing to do with the craft). These supporting cast and production assistance jobs provide (what I call) a **bridge source of income**—work that funds expenses or fills money gaps when the starring role is insufficiently lucrative; when it isn't enough.

Supporting cast roles could vary, from freelancing to teaching to being an assistant—all within the person's discipline or field of study, and all to gain experience, professional credibility, industry involvement, and financial compensation. Increasing the time devoted to these gigs can yield a considerable flow of income—but often on a short-term or part-time basis only. The drawback of having supporting cast jobs is that they may be temporary. They also might be harder to leave, given their close industry connection to the person's starring role and the intangible benefits from connections and experience. Supporting roles may expand (accidentally or intentionally) to fill otherwise available hours, depleting time from the staring role.

If the supporting cast work fails or doesn't provide a steady enough source of income, production assistance work is always an alternative. These jobs may not be desirable, glamorous, or creatively fulfilling, but they are sources of quick cash. And they help to build up the cache of occupations to which a true portfolio careerist can turn during financially lean times or when creatively fulfilling pursuits are not lucrative. If you find yourself oscillating between "portfolio" and "striving" you might need more time in the "striving" category (i.e., with more production assistance roles) to really build up a cash reserve to sustain the portfolio part of your career.

That's a tough sentence to read, and it's even more difficult to accept that sometimes careers move forward and sometimes they move backward. No one wants to move backward because doing so

feels like a failure. Entrepreneurs must acknowledge that moving strategically (forward or backward) is sometimes the only way to progress. A setback only means we need to recalibrate our path and change our own perception of the value of the work we do. In practical terms, pursuing a craft while still holding another job to pay the bills may not be ideal, but if pursuing a craft exclusively without having another source of income is not a viable, sustainable option, then it's better to address this situation head on. (See the discussion about this in Chapter 1.) The cash reserve you can build up as a striver can help you get through the inevitable lean times.

All the concepts we've discussed in the book thus far are tied together. Understanding your entrepreneurial career in a creative class economy, needing to set goals and create and follow a budget or plan for your money, and overcoming cash flow problems are all part of being a creative entrepreneur. You became one because you aren't satisfied with relinquishing or deferring control and working toward someone else's interest. So view your need to *choose* to perform production assistance gigs as taking control. Choose to manage your portfolio career like a savvy professional who understands the realities of trade-offs. A portfolio career is full of tough choices, and making more money is one of those choices. If you are able to extend your bridge source of income to build a sufficient cash reserve to support yourself, then choose to do that to support your entrepreneurial life.

Typically after you identify (and land) a bridge source of income, you start to relax and achieve peace of mind. And that's when your creativity starts flowing again.

Evelyn Takes Control

Evelyn feels lost and overwhelmed. She follows a budget, and she saved before she left her job at the dance supply store (which can be classified as both a supporting cast role and a production assistance gig). It was stable, predictable work, even though she didn't love the monotony of restocking the shelves or cleaning up after customers haphazardly flipped through the stacks in search of an item. She didn't love that her schedule changed every

week and that she couldn't always reschedule her shifts to accommodate her need to go to classes, rehearsals, auditions, or important meetings with choreographers and other dancers. But borrowing money from Logan is even more disdainful to her than the tedium and inflexibility of her old job. And she hates watching her savings disappear as she waits for gigs and offers.

Evelyn thinks about what Logan says about making more money. So she swallows her pride and calls her former manager at the dance store.

"Really? Oh thank you so much! Twenty-five hours a week to start will be perfect. I'll be there this Saturday and for as long as you'll have me," she says happily ending the call. She dials Logan's number next.

"Hey! Guess who's going back to work at the dance store?!" she exclaims. "It's temporary, and it will still be boring and infuriating at times. But I'm not going to dwell on that. I'm going to focus on paying you and my bills. Then, I'm going to focus on pursuing projects that I can actually get paid for."

"Excellent news! What about those checks you've been waiting for?" Logan asks.

"Ugh, nothing. I have to follow up again. They have budgeted enough to pay me, but they essentially treat me like a volunteer, so I end up doing the work first and get paid—maybe never? That's not what we agreed to," Evelyn declares.

"Good for you! You sound rejuvenated again," Logan says.

"I am," Evelyn agreed. "I feel a lot better about taking control."

Masochistic Volunteering

Sometimes you may be offered an opportunity that is fulfilling artistically or professionally but doesn't come with any compensation. Sometimes you may be offered an opportunity that provides incredible experience or exposure but comes with less compensation than you'd otherwise prefer. If the intangible benefits of either opportunity truly outweigh the financial cost to you (i.e., not getting paid), then go for it.

All professionals have a responsibility—moral, ethical, social, and professional—to volunteer in their own capacities, in their own fields. Volunteering yields plenty of benefits. It is emotionally and mentally rewarding, contributes to an individual's personal development (self-actualization), and helps forward a cause or an initiative. It also has trickle-down and trickle-across effects on the economy because the recipients of the volunteer services or goods

benefit without incurring financial hardships. The benefits multiply without multiplying the costs. Artists are not exempt from these rewards. They, too, can gain the benefits associated with volunteering, perhaps by offering occasional classes or demonstrations to those who otherwise wouldn't be able to attend an art class. Plus, such opportunities enhance professional fulfillment and expand the artist's network and experience.

But unlike other professionals (e.g., attorneys, accountants, advisors), who view volunteering as the exception not the norm, entrepreneurial artists often find themselves stuck in a spiral of volunteerism. Often, artists value the output (e.g., painting, performance, music composition, book) more than they value their input of process, effort, and time. They tend to compromise their fee or income for the sake of the art (the end product). As a result, volunteering can become their norm rather than their exception, and the intangible benefits slowly diminish or expire completely. That's when the otherwise positive idea of volunteering becomes (what I call) **masochistic volunteering**.

Example 1: The Art Donation

Consider a new artist's opportunity to contribute a sculpture to a local show. The hosts offer exposure to a large audience and the experience of participating in a juried show, but no compensation. The artist agrees to participate enthusiastically.

A massage therapist who sees the artist's work asks him to donate a piece to her office space. The office has no budget to purchase a piece, but many clients visit the office space, and the exposure for the artist could be compelling. The artist agrees, somewhat reluctantly, glad that the show led to another project (even if it was unpaid).

One client, in fact, visited the office, learned the artist donated his sculpture, and contacted the artist. He tells the artist about a contest that the newspaper he works for is hosting. There is no compensation for creating the work, but the artist would get a show and some great press in exchange for his contribution. The newspaper client thought the artist would be interested since he was willing to do pro bono work. The artist agrees to participate, very reluctantly.

A choreographer reads the great write-up about the artist in the paper and contacts him about creating a set piece for her next production. Her dance company is a nonprofit so funds are limited, but she offers to pay for his supplies and reminds him about the great exposure he'll receive among patrons of the show. The artist agrees, and starts to wonder (finally!) whether he can call himself a professional if he isn't getting paid. Let's look at a visual representation of his work.

Masochistic Volunteer Projects

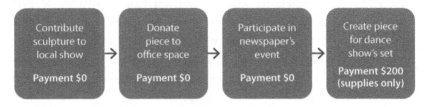

Volunteering became the artist's norm, and he found himself unable to break out of the volunteerism spiral. The intangible benefits diminished (did he really need more exposure?), but he kept volunteering. It became masochistic.

Why We Volunteer Masochistically

The psychological reasons behind this phenomenon are complicated. Perhaps artists are unwilling to walk away from an interesting project regardless of its parameters. Perhaps they fear another project won't be forthcoming, and they would rather be busy (even the unpaid type of busy) than idle. Perhaps they subconsciously fear that society or the invisible hand of the economy won't value their output as highly as they do, so they underprice their work to protect their egos. Perhaps they fear being labeled a "sellout" for attaching a price to their time and effort. The thought process, whatever it is, is not important in the macro sense because entrepreneurs—artists and professionals alike—all have their unique personal reasons for developing pricing structures. What does matter in the larger scheme of things is for entrepreneurs to develop a strong sense of

good deal/bad deal balance and the willingness to walk away, no matter what, when a deal sours. Making a distinction between good and bad deals and walking away from the bad deals are something those in the business world practice regularly. And so should artists.

Recall the discussion in Chapter 5 about sunk costs and walk-away prices. Sunk costs are the unrecoverable, spent costs of a deal or an agreement. A walk-away price, meanwhile, is the absolute minimum compensation parties to a negotiation must attain to reach an agreement. To illustrate these concepts, let's examine the consequences of Evelyn's masochistic volunteering.

Cutting Your Losses

Part of Evelyn's cash flow problem stems from an engagement she has with an emerging dance company. It all started well. The company hired her to choreograph an upcoming show and promised to pay her $5,000 in two installments—the first would be paid one month into the project (assuming she met the required milestones) and the second would be paid five months later, after the show premieres.

Evelyn was ecstatic, of course. She spent countless hours developing and directing several pieces, attending castings, collaborating with the performers, editing the accompanying music for each piece, holding rehearsals, and so on. When the first payment didn't come after the end of the first month, she called the executive director, who assured her the check was in the mail. A few weeks later, it still was not in her hand, which prompted her to ask again and again. She heard variations of the same response: "It's en route; we're working on it." Not wanting to be a bother, she continued working. Besides, she didn't want to fall behind schedule on such an important project.

Evelyn's Sunk Costs Evelyn entered a seemingly benign agreement. After a point, assuming the nonpayment trend continues, she may find it necessary to cease work on the project. If she does end her work with the company, the time and energy—not to mention the expense of showing up to work every day—she has invested are sunk costs (in accounting terms). She can't get those back, no

matter how long she sticks around hoping the dance company will eventually get around to paying her.

Sunk costs aren't always time related, although arguably time is the best kind of sunk cost because by putting in time something creative does emerge (in her case, a piece of choreography), so the engagement isn't a total loss. Assuming the contract she signed permits her to retain ownership of her work, the dance company would be in breach of contract if it uses the work without her permission. She, on the other hand, can draw on her work for future choreography projects.

When we think of the worst kind of sunk costs, we usually think of something monetary. Let's say Evelyn wanted access to a mirrored room for use during rehearsals, so she booked a space for six months and paid in advance (cost: $3,000). If by the second month of her engagement she decides to walk away from the project, the money she has already spent on the studio rental shouldn't affect her decision making. She may be tempted to say, "I can't leave because I already spent $3,000 on the studio rental, and I need to get that back at least." That money is gone, and continuing to hold up her end of a bad bargain won't change the fact that she has spent $3,000 of her own money. Even if the company eventually pays her the agreed total amount of $5,000, her $3,000 is still gone. It's a sunk cost, so it should have no bearing on her future decisions.

Evelyn's Walk-Away Price By negotiating the timing, amount, and conditions of her fee in advance and signing a contract, Evelyn already inherently practices the idea of a walk-away price. She knew what she was willing to be paid for her work, and she negotiated with the dance company to reach an acceptable amount (hopefully an amount higher than her walk-away price). If the tangible or intangible benefits she received in exchange for her work didn't exceed her own personal walk-away price, Evelyn wouldn't have agreed to the project.

A walk-away price is the absolute minimum amount one party to an agreement is willing to accept. The person would prefer to earn more than the walk-away price, but she'll never accept less.

Graceful Exits

Money matters can get awkward, no matter who is involved. The lesson here is to do as much due diligence as possible beforehand to minimize or prevent an awkward situation later. The contract Evelyn and the dance company signed should have included language that protects both parties—something along the lines of "The artist will cease work on the agreed-upon project if payment on said payment schedule is not timely met." Here, the terms "project," "payment schedule" and "timely" should be defined. Alternatively, the wording could be, "Payment shall be deemed 'delinquent' when it has not been received by the artist within ten (10) business days of the payment date, at which point the artist will cease work on the agreed-upon project."[35]

The purpose of such a clause is not to find the organization at fault or in default, as it may not "force" an organization to keep its end of the bargain; after all, an organization that is dysfunctional and unprofessional enough to fail to meet ordinary payroll obligations cannot be expected to abide by language in a contract. Rather, the purpose of this clause is to give the entrepreneur or independent contractor a professional, dignified way to walk away from a bad deal. If Evelyn's contract has this language, she can refer to the contract stipulation and inform the company (preferably in writing) that because she has not received payment within the agreed-upon schedule, she must suspend further work until the payment is received. This way, the contract is the bad guy, not her.

If her notice influences the company to make a payment, then she can complete the project, which she finds personally and professionally fulfilling. If not, then she can move on to the next project, explaining simply (if asked) that her previous project ended because the company breached a contract. Period. No scandal, no drama, no gossip.

Beyond contract protection, the key to walking away gracefully is to be unwaveringly professional and respectful. This is an important lesson in severing masochistic volunteering experiences. Every performer knows how to exit the stage gracefully, and the honest ones may admit to failing to do so on occasion. A graceful exit is

an art form that requires infinite patience to master, and for entrepreneurs who want to continue doing business in their field it is mandatory. No matter what.

Being professional means behaving in an appropriate, civil, and kind manner that begins with respect. For example, you respect your profession enough to not devalue it with improper or unethical behavior. You respect your client enough to not make any dispute petty or personal. You respect your craft enough to not overshadow it with conflict or distraction.

A bridge burned is a lost opportunity, and given the speed with which news travels in this age of social media, a bitter separation or sour experience could mean many lost opportunities. Admittedly, some opportunities (bad deals) are worth losing, but that determination should be your own to make, not one made for you because a previous client (advertently or inadvertently, accurately or exaggeratedly) damaged your reputation. Being a freelancer, an independent contractor, or a creative entrepreneur is difficult enough as it is, so why make it harder by burning bridges or walking away gracelessly? Give people (fellow entrepreneurs or not) a break, and be nicer than you think you should be (without being a pushover whom colleagues and clients can take advantage of or coerce into masochistic volunteer projects). Not only will you sleep better at night, but you will also cement a reputation as a respectful, decent, and pleasant professional. Then, your craft and work won't be overshadowed by unnecessary drama.

Increasing the Perceived Value of Your Work

Some creative entrepreneurs (e.g., accountants, lawyers, marketers, fund-raisers) have an easier time setting rates and asking for payment. Traditionally, there are established markets for the services these professionals provide, and these entrepreneurs base their hourly or flat fees on experience, existing competition, and what their respective market can bear. Entrepreneurial artists, on the other hand, cannot always say the same. Their markets may be less well defined, and their services or performance rates and the price of their products vary widely.

Perhaps the accepted societal view is that the services or goods an artist provides (e.g., ballet performance, stage play, musical performances) are worth less than the services or goods an accountant or a lawyer provides (e.g., tax return preparation, legal representation). Perhaps the perception is that an artist is more willing to negotiate than a business professional. Perhaps the dirty little secret about an artist's tendency to engage in masochistic volunteer work has gotten out, and the public feels entitled to exploit that. Perhaps the starving artist trope has made people think that artists are more likely to accept any amount of payment out of desperation to make ends meet. If that is the case, then is it possible that the idea of a starving artist is actually creating more starving artists? Is it possible that we are all guilty of masochistically volunteering ourselves into starvation and an unsustainable professional career?

Whatever the collective perception or misconception about the value of the work of artists, it won't change immediately—even if the entire creative class banded together to refuse to continue masochistic volunteering, which further devalues and undermines artists' work. These embedded thoughts take a long time to change, and that's okay. What can you do, though, to help raise (even a bit, even gradually) the perceived value of your work as well as the work of entrepreneurial artists everywhere? Treat your own input (not just your output) as what it is—highly valuable. Stop masochistic volunteering and start negotiating for a fair compensation for your work.

Example 2: Effective Volunteering

Consider our sculptor from earlier in the chapter, who found himself volunteering masochistically. How would he convert that masochism to effective volunteering?

His first volunteer opportunity wouldn't change. He enthusiastically agreed to contribute a sculpture to a local show in exchange for exposure and experience (but no money). But when the office asked him to donate a piece, he could have amended his response. Instead of simply agreeing to the contribution and hoping for exposure, he could have agreed, but explained to the office that such

a commission would normally cost $2,000, and asked the office to host an unveiling event where they invited clients to meet the artist and casually socialize. He still wouldn't get any cash, but he would fix the price for his work ($2,000) and secure some intangible compensation in the form of a networking event.

Then, when the newspaper employee calls, he might already know the general price range for the sculptor's commissioned work, so instead of telling him about an opportunity to volunteer, he might prefer instead to interview him about the work. The artist still gets press coverage, but without masochistic volunteering.

The choreographer might read the article and call the artist, but instead of offering only to cover his supplies, she might happily report that one of the company's board members has agreed to underwrite his $2,000 fee to create a piece for the set.

Effective Volunteer Projects

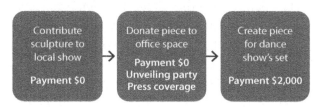

Instead of creating four pieces for $200 to cover (some) supplies, the artist creates three pieces for $2,000. He has volunteered effectively, rather than masochistically.

Share Your Story

Frame your our own story as a way to promote and elevate the perceived value of your work—not in a manipulative way but in a realistic manner. For example, the next time a client approaches you to give a deep discount on your artwork, know that you have a choice. You can accept it without saying anything, but curse him later for his ignorance. You can accept it, but remind him that his offer perpetuates the starving artist idea, which makes him a hypocrite and likely not a repeat customer. Or you can explain the story behind the work.

What were you thinking when you created the painting? Which artists influenced you? What inspired you to become an artist? When you share your story, you add an intangible value to the work. And that personalization may change the perceived value of the art in the client's mind, and maybe even the price you receive for it.

Alternatively, you can sell the work at a reduced rate and tell the client he is getting a good deal. You can suggest that maybe next time, he'll pay the full price. You may request that he host a party to show off his new purchase to friends (and potential future clients). This is how you can extract some intangible value from the transaction to make up for the loss of tangible payment. Your walk-away price hasn't changed, but what you receive is part tangible (cash) and part intangible (exposure, networking, goodwill).

Assert Yourself

You—in fact, anyone who works independently—may struggle to find the right balance between assertiveness and humility. Sometimes the process or product is so personal that putting a price tag on it seems like an impossible task, and negotiating a price for such a personal work may feel like negotiating for a human soul. This sentiment (no matter how sincerely felt) puts you at an extreme disadvantage because the counterparty doesn't feel the same way, can sense your unease, and may exploit your sentiment in the negotiation. The other party is focused on one thing: acquiring your good or service for the lowest cost. Period. So get equally focused, stand by the value of your craft, and demand to get paid fairly.

Being assertive (i.e., stipulating fair or appropriate payment) in the face of humility (i.e., recognizing the disinterested point of view of the counterparty) is a work in progress. You, just like every other entrepreneur, will likely mess up this balance at least a few times. But with practice and each wrong, awkward move made during a negotiation, you learn a little more and get a little better.

What if you have no power to negotiate a price? That is a keen reality for plenty of entrepreneurs. For example, you are asked to complete a project for a particular fee ($500) and schedule (3 weeks), without any room for negotiation. You can agree to take the assignment, or you can politely decline. It's up to you. If you accept, even

if you think the work is extraordinarily underpaid, you've subconsciously decided on two other things.

First, the intangible benefits of the project (e.g., working with a renowned expert or the possibility of future work) make up for the low pay. Share that with the client—in a nice, respectful, professional way, of course—to help the client change her perceived value of the time and effort you are about to put into this project specifically as well as the value of your work generally. (If you don't try to change this perception, no one else will.) Sharing it once is educational, but sharing it repeatedly—no matter how true it is— reflects poorly on your professionalism. (This is akin to constantly reminding someone that he got a good deal, long after the deal has closed—see Chapter 5 for that discussion.)

Second, you'll figure out how to make the low pay and lengthy schedule work somehow. This is a subconscious decision you won't realize you've made until the rent and other bills are due and you're panicking that you cannot cover them (see Evelyn's story). If you make a conscious decision upfront to make the assignment work, then you can plan to take some production assistance work while working on the project. Or you can pick up a few supporting cast gigs. Again, articulate that to the client; explain that because you've agreed to do the work for less than your regular rates, you cannot be available on, say, a Thursday night because you have to teach a yoga class to make ends meet.

Chances are you won't go into a negotiation with a script based on the ideas discussed in this chapter. But do let these ideas float in your mind so that when a negotiation conversation arises, you'll know what to expect. Tailor the conversation according to your circumstance and what you've learned about changing someone else's perception of the value of your work. The next time, change it a bit; and the time after that, change it a bit more; and so on—until you see the perception actually transform in your favor.

Evelyn's Future Steps

Taking advantage of Evelyn's new resolve, Logan tries to get her to adopt the envelope method he uses to manage his cash. But it finally dawns on him that she doesn't need such a system. Managing her expenses isn't the problem; she struggles with the revenue or income side. Instead of tracking expenses, she must learn to find starring roles (and bridge sources of income) that don't devolve into masochistic volunteer opportunities. She also needs to negotiate better terms for her projects, sign contracts that protect her interests—artistically and financially—let go of the psychological ties of sunk costs, and walk away from bad deals professionally and respectfully but firmly. Easy, right?

Just as there aren't rules that govern budgeting, there aren't mandatory practices for making more money and negotiating fair payments. Like Evelyn, you have the responsibility—in fact, the obligation—to assess your own financial strengths and weaknesses and then adopt practices that work within the real confines of your craft, the industry norms, and your habits and preferences.

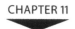

Understanding Taxes

They are complicated. They are mundane. They inspire fear and loathing in equal proportions. Taxes are—to paraphrase Benjamin Franklin—one of only two things certain to happen in life (the other one being death).

Derek's Tax Appointment

Derek runs up the stairs, taking two steps at a time. Breathless, he bursts into the office, announcing, "I have a 10 o'clock with Paul O'Brien."

The receptionist glares at him and then points to the clock behind him, which reads 10:17. "I'll tell him you're here," she mumbles and then saunters down the hall. Derek immediately despises her.

Derek sits in the waiting room on a straight-backed wooden chair that feels as narrow as it looks. He eyes the magazine rack stuffed with copies of the *Journal of Accountancy,* the *Economist, BusinessWeek,* and *Time.* This is going to be painful, he thinks.

"Derek!" a voice bellows from behind the receptionist desk. A stout, red-faced Irishman stands there, smiling at him. "Great to meet you!" he exclaims in a heavy brogue. "Follow me to my office."

"Mr. O'Brien, I'm … " Derek says as they walk down the hallway.

"Paul, Paul, call me Paul," Paul interrupts as he opens the door to his office, motions for Derek to take a seat, and slumps in his chair.

"Paul," Derek says. "I'm so sorry I'm late. I wasn't quite sure where this office was."

"Who cares?!" Paul replies, waving his hand. "You're here now, and that's the important thing. What can I do for you?"

"I need help with my taxes," Derek says as he pulls papers, folders, and envelopes from his satchel. "For this year and last year and maybe the year before that. I've never made much money, so I haven't filed in a while. I'm sorry."

"You apologize too much," Paul notes. "Let's see what you've got."

Derek hands Paul the big stack and watches in awe as Paul flips through the pages quickly. Paul nods, smiles, and sits back in his chair. "Tell me about yourself," he says.

Assorted Sources of Income

Derek is a saxophonist who cobbles together a variety of live gigs, teaching engagements, recording jobs, and a part-time office job. He works 30 hours per week at a recording company, which pays him a salary, less withholdings for taxes and benefits, and issues him a Form W-2 every year. It is an administrative job, but it keeps him connected to the industry and gives his weeks a bit of structure.

His teaching engagements include a fellowship for the state. As a fellow, he teaches music classes in three middle schools per week during the school year. For this work, he receives a lump sum from the state and a form that itemizes his income. Derek also gives weekly private saxophone lessons to two students; their parents pay him in cash, so he does not have tax forms for that income.

Derek is part of a chamber group, which recorded a soundtrack for a four-part miniseries. For this work, he received a Form 1099 from the production company. The clubs and bars where he plays live gigs pay him in cash, and the amounts vary according to the venue's take for the night. Derek doesn't have any record of this income, although he estimates it to be $3,500 for the year.

After a few more questions, several hours, and two coffee breaks, Paul is finished assembling Derek's tax returns. Derek is relieved, and he rubs his hands together as he waits for Paul to reveal a refund amount. He has already earmarked the expected refund. He will pay off some of his credit card debt and then treat himself to a fancy dinner.

"You owe $1,154," Paul announces matter-of-factly, unaware that Derek expected a vastly different conclusion.

"What? Why?! I barely make any money. How can that be?" Derek says, his hands now rubbing his temples. "I'm sorry, but maybe you missed some numbers? Maybe there are tax breaks you didn't include. I can wait if you need time to go through these again."

But no one—not Paul, not the recording company, not the state, not the production company—has made a mistake. Except maybe Derek himself.

When Derek started working for the agency, he completed a Form W-4: Employee's Withholding Allowance Certificate. This form tells the employer how much to withhold from an employee's paycheck at every pay period; this withholding is remitted to the IRS, along with a matching portion from the employer. On his W-4, Derek claims two allowances, which may be the right number if he earns no other income during the year. But he also earns income as an independent contractor, and such income has no withholdings. For example, when he gets paid $4,000 for a recording gig, that $4,000 is the

actual earning; no other amounts are withheld or taken from that total for tax purposes. He is responsible for remitting a percentage of that $4,000 to the IRS in tax form. In short, as an entrepreneur, Derek is his own employer and an employee so he is responsible for paying employment and income taxes on his freelance income.

In Good Company

Derek is in "good" company among entrepreneurial artists, unfortunately. In 2012, *Accounting Today* reported that the IRS was seeking more than $1 million in back taxes (from 2002 through 2009) from rapper Lil' Kim.[36] In 2010, actor Wesley Snipes began his three-year prison sentence for failing to file any tax returns for at least a decade; he owed more than $2.7 million in taxes from 1999 through 2001.[37] Richard Hatch, the winner of the reality competition *Survivor's* inaugural season was awarded his $1 million prize in full, without tax withholdings taken by CBS. He was convicted of tax evasion and sentenced to four years and three months in federal prison in 2006 (although he was released in 2009).[38] Finally, there's Willie Nelson. He released an album titled *The IRS Tapes: Who'll Buy My Memories* to fund part of his 1990 invoice from the IRS for unpaid back taxes and fines totaling $16.7 million.[39]

But Derek isn't Willie Nelson; he has no desire to send the proceeds from his creative output directly to the IRS. He is no Richard Hatch either, who at least had the benefit of his $1 million winnings to fund his tax bill.

Now saddled by an IRS bill, Derek gets to work. He asks his landlord for a one-month extension on his rent and his father for a six-month loan. He picks up extra live gigs at the clubs and overtime hours at the recording company. Paul also agrees to let Derek pay for tax services after six months instead of the normal thirty days. After all this, Derek manages to scrape together the $1,154 he owes. But he is miserable and a little humiliated by the process.

Tax Basics

This chapter covers tax basics, including self-employment tax, estimated tax, and recordkeeping requirements. More so than any other, this chapter discusses laws that are revised on a regular basis, so always consult the latest IRS publications or guidance on new regulations applicable to your specific circumstances. A discussion about taxes can get arduous, so let's use Derek's story as a frame for these concepts.

Self-Employment Tax

Paul offers Derek some tax advice so that he never has to face an unexpected tax bill again. These tips are applicable to you, too.

- ➤ *Change the withholding amount.* By overwithholding on his salaried income from the recording company, Derek may pay less in estimated taxes throughout the year. He is essentially using "extra" withholdings from his salary to pay taxes on his freelance income, which relieves part of Derek's administrative burden.
- ➤ *Treat the craft as a formal business, not just something that brings in extra money.* To do this, Derek doesn't have to create a corporation or any other business entity to be an entrepreneur (although he may choose to). It is perfectly acceptable to be self-employed, but with that comes a bit of tax responsibility. Sole proprietors (which include self-employed entrepreneurs) are required to pay both income tax and self-employment tax (generally Social Security and Medicare).

In 2012, the income amount that created a tax liability was $400. That means self-employed individuals who earned more than $400 (or less if they met certain other filing requirements) were required to file an income tax return (see Chapter 1, page 6 of *IRS Publication 334: Tax Guide for Small Businesses*).[40] They also had to make estimated tax payments throughout the year if they expected to owe $1,000 or more upon filing their tax return (see Chapter 1, page 8 and Chapter 10, page 41 of *IRS Publication 334*). The self-employed tax for 2012

was 13.3 percent on the first $110,100 of net income earned. This 13.3 percent comprised both Social Security tax (10.4 percent) and Medicare tax (2.9 percent). Any earnings in excess of $110,100 were subject to only the 2.9 percent Medicare tax for self-employment purposes. Self-employment taxes are paid on Form 1040: Schedule SE. (Know that for 2013, self-employment tax rates increased because the payroll tax holiday ended on December 31, 2012.)

Self-Employment Tax Breakdown

Self-employment business income includes all earnings received from any sources. In Derek's case, it includes the cash from performing in gigs, the cash from giving private music lessons, the checks from his state fellowship, and the check from the production company.

Income may also include goods received. Say Derek performs at a friend's wedding (for which he normally charges $500). His friend, Abby (a painter), has a limited wedding budget, so instead of paying Derek $500, she gives him two small paintings (each of which normally sells for $250 at an art festival). With this exchange, Derek technically earns $500 from the wedding gig. In the eyes of the IRS, earnings from a barter exchange count as income (see Chapter 5, pages 20–21 of *IRS Publication 334*).[41]

Remember, as a self-employed entrepreneur, you owe not just self-employment taxes but also income taxes to the federal government and to the state (and maybe even the city) in which you operate your business.

Estimated Tax

The IRS produces an estimated tax worksheet each year. It is meant to help filers determine whether to pay estimated taxes and, if they do, how much to pay. The worksheet is usually part of the *Form 1040-ES Tax Package*, which contains the estimated tax forms, instructions, and pertinent guidelines and worksheets.

Here is a very simplified version of the estimated tax calculation (see page 7 of the *Form 1040-ES Tax Package*):

➤ Estimate your adjusted gross income for the year. A good starting point is the adjusted gross income from your previous year's tax return.

➤ Subtract the standard deduction amount (or an estimate of itemized deductions if you plan to itemize) and the amount of personal exemptions you will claim. Again, use your previous year's tax return as a guide to estimate the amount of your deduction (probably the standard amount) and the number of exemptions you claimed (probably one for yourself, one for your spouse, and one for each of your dependents—if any).

➤ Calculate the approximate tax you'll owe on the net amount. The IRS always publishes a tax table along with the instructions to Form 1040-ES to help with this calculation.

➤ Add your self-employment tax. In 2012, this was 13.3 percent of what you earned during the year. Adjust for a bunch of other things, which may not apply, such as alternative minimum tax (AMT). The AMT is an alternate set of rules certain taxpayers must use to calculate their tax liabilities. In theory, the AMT ensures all taxpayers (particularly those who benefit from certain tax preference items) pay a minimum amount of tax. (The IRS

created a tool, AMT Assistant, to help taxpayers determine if they are subject to AMT in 2012: http://www.irs.gov/Businesses/Small-Businesses-&-Self-Employed/Alternative-Minimum-Tax-%28AMT%29-Assistant-for-Individuals.)

➤ Subtract withholdings from your employer (if any). To estimate this, look at your most recent paycheck and figure out what was withheld and then multiply that number by 12 (if you are paid monthly) or 24 (if you are paid biweekly). You can also look at what was withheld on your previous tax form or on the last pay stub you received for that year. Alternatively, you may ask your employer's payroll or human resources staff.

If the "answer" to these calculations is more than $1,000, then expect to pay estimated taxes for the year. Divide that number by four, and pay that amount to the IRS quarterly.

Estimated tax payments are due in April, June, September, and the following January of a given year—generally on the 15th of each month. Each payment should be 25 percent of the total tax due for the year after subtracting withholdings and any credits (i.e., the "answer" you got by using the worksheet). Alternatively, you may pay 100 percent of the previous year's tax liability (assuming the previous year covered 12 full months) without incurring a penalty (see pages 1 and 3 of the *Form 1040-ES Tax Package*).

Confused yet? Let's look at how all this applies to Derek's situation.

Derek's Estimated Tax With Paul's help, Derek works through a simplified version of the estimated tax worksheet. Although he knows it is a conservative calculation (meaning he would likely pay more in estimated taxes than he will ultimately owe), Derek prefers that to owing nearly $1,200 again in the future. Paul lectures him repeatedly about giving an interest-free loan to the government (by paying more than he might owe throughout the year and collecting it back in the form of a refund), but Derek is resolute in his conservative approach. He reasons that as his business grows and his cash situation

improves, he can afford to be more aggressive in estimating his tax liability. Of course by then, he will have a greater understanding of the whole tax process. Derek plans to pay $288.75 to the IRS four times per year, based on his calculations using the simplified estimated tax worksheet.

Derek's Estimated Tax Worksheet

Simple Estimated Tax Worksheet		Notes
Expected AGI:		
Income from working at the recording company	$ 30,800	Prior year's earnings (net of withholdings)
Fellowship	7,500	Three-year amount
Teaching students	5,250	$35 per lesson for 3 students per week for 50 weeks per year
Gigs	3,500	Estimated based on prior year estimate
Total AGI	$ 47,050	
Standard deduction (2012 amount)	(5,950)	
Exemptions (2012 amount)	(3,800)	
Taxable income	$ 37,300	
Tax (from IRS tax table in Form 1040-ES)	5,355	$4,867.50 plus 25% of the amount over $35,350
Withholdings from agency	(4,200)	$35,000 earned; $30,800 paid
Estimated tax	$ 1,155	
Quarterly payments	$ 288.75	Estimated tax divided by 4

Recordkeeping for Tax Purposes

Paul's final tip to Derek is this: Keep records of all your income—from cash and check payments to business-related expenses (even if these items are paid in cash).

Derek's business expenses are the current operating costs of running his business as a musician. According to page 9 of *IRS*

Publication 583: Starting a Business and Keeping Records, business expenses that are ordinary ("common and accepted in a field of business, trade, or profession") and necessary ("helpful and appropriate for the business, trade, or profession" but not necessarily "indispensable") are deductible for tax purposes.[42] His lack of records is probably why Derek could not deduct expenses that would have reduced his tax burden.

Recordkeeping may be bad news for those who tend to misplace or toss receipts or paperwork. But the good news is that there is no IRS mandate for the specific recordkeeping system to use. You can devise a system that meets both the baseline IRS requirement and your organizing ability. All you need to do is track "business transactions"—that is, every single business income amount from all sources and every single expenditure related to the business (see page 11 of *IRS Publication 583: Starting a Business and Keeping Records*).

Your system doesn't have to be (but it could be, if you prefer) an old-fashioned accounting ledger, in which you handwrite transaction details and add or subtract figures manually. The IRS permits the use of an electronic system or record, as long as it "provides a complete and accurate record of data that is accessible" and in "legible format" (page 11 of *IRS Publication 583: Starting a Business and Keeping Records*). Transactions recorded in a suitable system must be supported by evidence, which the IRS calls "supporting documents."

Supporting Documents

Invoices, bank deposit slips, and check stubs are examples of supporting documents for business income. Receipts, credit card statements, and cancelled checks are acceptable documentations of business expenses.

Regardless of the form these supporting documents take, each document should show the date, the amount, and the nature of the income or expenditure (which may require notes). For example, if Derek receives $300 in cash for playing a gig on a Saturday night, he should deposit the cash into his business bank account and make a note of the source of the money on the deposit receipt (which shows only the date and that a deposit of $300 in cash

has been made but not much else). Similarly, his business bank statement will show that he paid $35 to a restaurant, but the statement will not show the business purpose for that expense (or if it were breakfast, lunch, or dinner and whom he shared the meal with). If the lunch was with a music collaborator or a potential client interested in hiring him for an upcoming performance or project, then the lunch is a valid business expense. If, instead, the lunch was with a friend and for purely social reasons, then the lunch wouldn't be considered a valid business expense. Derek should note the purpose of and the attendees to the lunch on the restaurant receipt.

Business Bank Account and Basic Accounting

Both of the previous examples (depositing cash and purchasing lunch) presume that Derek has a separate bank account for all his business transactions. He should, and so should you. The simplest business checking account (which does not pay interest or impose limits on the number of transactions each month) is generally free. The account also comes with a debit card. Business income and expenses should be separated from personal income and expenses.

The idea of separating business and personal income and expenses can get a little muddled if your business income is your only income (as may likely be the case for an entrepreneurial artist with a portfolio career). You'll need this income to pay for rent and groceries, even though these are personal—not business—expenses. The best way to address this problem is to pay yourself a salary from the business account. Your salary, transferred from your business account to your personal account periodically, funds your personal expenses. Excess earnings (the portion you don't transfer to your personal account) are reinvested in the business.

However, getting to a point when there is excess income is tough. Alternatively, you can consider segregating each check you receive into a personal portion and a business portion based on the budget you created. Look at the expenses on your budget to determine the approximate split between business and personal expenses. A typical breakdown might look like this:

> ➤ 30 percent taxes (set this amount aside immediately)
> ➤ 40 percent personal expenses (rent, groceries, social expenses)
> ➤ 20 percent business expenses (advertising, printing, supplies)
> ➤ 10 percent savings

Using the percentages outlined above, an artist who receives a check for $2,000 would deposit half of it ($1,000) in his business checking account (30 percent, or $600, to cover the taxes, plus 20 percent, or $400, for business expenses). He would deposit the other half ($1,000) into his personal checking account to cover personal expenses (40 percent, or $800) and savings (10 percent, or $200). By splitting each check into business and personal portions, entrepreneurs no longer have to worry about building a reserve to fund ongoing salary payments to themselves.

Reconciliations

Each month, Derek should review his business bank statement to ensure he has listed in his recordkeeping system all the income earned and all expenses paid for the month. This way, the statement and the system are reconciled. It's also a good idea to review the business bank account activity regularly (e.g., monthly) to ensure there are no wayward transactions, especially those that may indicate identity theft, or charges incurred that wouldn't normally show up on Derek's radar (this can be done online as well). For example, a client may want to transfer money to his account via wire instead of writing a check. Derek may discover that his bank charged a minimal fee for receiving the wire transfer. This may not be a big deal, given that Derek would rather incur the charge and get paid than not be paid at all. Going forward, he may ask clients who wire money to pay for the extra charge so that he can receive the full payment amount. But Derek can only fix this issue if he finds out about it, which is why reviewing bank activity is important. Derek probably knows that extra fees are charged for certain transactions only when he sees

the fees on his statement; this is common among bank customers, because banks' fees policies are notoriously opaque.

For recordkeeping purposes, download your statements from the bank's website because they won't be available online forever. Store them on your computer's hard drive (which, incidentally, you should back up regularly to ensure the data aren't lost).

Reconciling records and basic accounting can be done simply (using a general ledger book or a database such as Excel or Numbers) or with help from a software system (such as QuickBooks or Quicken). The advantage of using software tools is their consistency and ease of use. Most of the functionality is already developed for the user. Some software even includes budgeting functions (predesigned budget templates) and tax filing assistance (they can "talk" to tax preparation software such as TurboTax). The disadvantage is their price. You, like many entrepreneurs, may want to start out using a basic database system (which is free but has limited and manual functionality) and then graduate to the complicated software once your business is more established with more discretionary income.

When using any system, you should put in place proper controls to maintain the integrity of your data. For example, use strong passwords to limit access to your accounts. Plus, if you hire an assistant, devise a working arrangement that minimizes or eliminates the opportunity for embezzlement or other damaging activity. Say Derek hires an assistant. He could limit the assistant's duties to scheduling gigs and making and distributing promotional material, and he could prevent her from opening his mail or depositing his checks. If the assistant has access to his bank accounts, credit cards, petty cash, and other forms of money, she is given the opportunity to steal (see pages 11–15 of *IRS Publication 583: Starting a Business and Keeping Records*). Not that an assistant (yours or Derek's) would do such a thing, but the point is to keep your data and finances safe and secured from any real or potential threats.

Length of Time to Keep Records

Whether records are kept in hard copy or electronic form, they must be maintained for as long as necessary to support the income

and expenses reported on the tax return. For tax purposes, this is the statute of limitations—that is, the length of time during which the IRS is allowed to audit the return or during which the tax filer is allowed to amend the return. If you omit income from your return, for example, the statute of limitations is three or six years, depending on the size of the omission. That means for a 2000 tax return (presumably filed on April 15, 2001), the IRS may have until April 15, 2007—six years after you *filed*, but seven years after you earned the income—to audit you. If a fraudulent tax return is filed, or no tax return is filed at all, the statute of limitations never ends.

Seven years tends to be the "normal" required time to retain records for tax purposes, but other purposes (e.g., insurance, investments) may dictate other periods of limitations (see page 15 of *IRS Publication 583: Starting a Business and Keeping Records*).

In addition to IRS publications, which give clear explanations of the agency's various requirements as well as examples of recordkeeping systems, the US Small Business Administration provides counseling, training, and consulting for small business owners who are beginning, expanding, or improving their businesses. The SBA also offers a library of resources available both online and at various small business information centers (see http://www.sbaonline.sba.gov).

Derek the Professional

"Feel better?" Paul asks as he passes a folder to Derek.

"I am now a musician with a business, not just a gig, my friend," Derek sighs. "Remember the first time we met? I was so lost and terrified of the taxman. Now, thanks to you, I have a business bank account and a database and my receipts are not crumpled in pockets of dirty jeans anymore. They are now neatly filed away in a cabinet. I feel like a real professional!"

"You look and sound like a new man. Should I call you *Mr.* Derek now?" Paul laughs as he shakes Derek's hand.

Financial Management Systems

You are busy—extremely busy. Not only are you producing works of art, completing projects, and attending or holding events and performances, but you are also running a business. The biggest misconception about creative entrepreneurship is that these professionals can do whatever they want with their time. In reality, you and I know that working independently means you are working all the time. After all, you are your own business administrator, human resources department, marketing and public relations manager, booking agent, fund-raiser, and chief financial officer.

Streamlining your business processes to make them as efficient as possible should be your top priority. The less time you spend tending to the business, the more time you can dedicate to the work itself.

Alison's Technology Wish

"It's been forever since I've seen you!" Allson declares, embracing her friend Elizabeth in a tight hug.

"You've been so incredibly busy!" Elizabeth says, squeezing Alison back.

"I know. I'm sorry. Business is booming. I can't complain. How are you?" Alison replies, pulling Elizabeth down to sit next to her chair.

"I'm fine, just so glad to see you," Elizabeth says.

"Before we say anything else—and I want to hear everything that's going on with you—let me thank you from the bottom of my heart for all the referrals you've sent my way. The power of word-of-mouth is so compelling, and it's very different from my normal advertising strategies. So thank you a million times over," Alison gushes.

"You've earned it," Elizabeth replies. "I wouldn't keep recommending you if you didn't consistently do a great job. Some of my clients do email just to tell me how fantastic you are at teaching them office best practices, at clarifying HR policies and procedures, and at giving them advice so that they don't get sued by their employees. Frankly, I am so sick of hearing about how good you are."

"Aww, that's nice to hear," Alison replies. "Now if only I can focus my

energy on just that part of my job—that part when I consult with clients—I'd be on cloud nine."

"What do you mean?" Elizabeth asks, confused.

"There's always business stuff. Paying bills, tracking the budget, following up on late payments, entering and monitoring expenses, so on and so forth. I've hired an assistant, but he can't run my business alone. I still have to do much of the work," Alison confesses. "What I really need is an automated recordkeeping system—one with all the bells and whistles and customer support and trainers. Then I can delegate a lot of the busy tasks to my assistant, and I am left to consult to my heart's content."

"My company uses a system like that, but it's proprietary—designed for our firm specifically. I can find out the name of the firm that designed it, and maybe you can contact them to help you out," Elizabeth offers.

"Oh, that would be great," Alison exclaims. "I'm not even sure where to start."

Finding the Right Financial Management System

Alison owns a successful human resources consulting practice. Although she isn't an artist, she fits Richard Florida's expanded definition of the creative class—business professionals who "engage in creative problem-solving, drawing on complex bodies of knowledge to solve specific problems."[43] She and Elizabeth have built thriving careers on the strength of their knowledge, skills, and ambition, and their friendship dates back to their days pursuing graduate degrees together. They are professionally fulfilled because they are able to exercise their creativity, even within their traditionally noncreative industries. As a financier with clients in Asia, Elizabeth is able to connect Alison to Asian bank executives who are planning to or are in the process of opening branches or headquarters in the United States. In fact, the majority of Alison's clients have been referrals from Elizabeth.

As a busy creative entrepreneur, Alison has learned to become efficient. The idea of spending countless hours a month on the administrative side of her business makes no sense to her, although she knows managing the business is critical to her success. Now that she has landed more accounts, she is looking to automate her bookkeeping, invoicing, bill paying, and budgeting tasks to save her time

and effort. She knows the wonders of technology will save her, but she doesn't know how yet.

Many software, programs, or applications are available in the market. They range in price, user-friendliness, reliability, and features/functionalities. To find the right financial management system, an entrepreneur (you and Alison included) has to ask five questions of each option:

- ➤ What does it cost?
- ➤ Does it look backward, forward, at the present, or all of the above?
- ➤ How well does it communicate with the boss?
- ➤ Do the users actually use it?
- ➤ How will it improve my financial situation?

The answers to these questions are helpful as you explore your own financial management efficiency.

What Does It Cost?

Cost can be expressed in three forms: dollars, information, and time.

Dollars The cost of a product in dollar terms is easy to identify. Generally, a product that does more costs more. But not all products in the market have a one-time cost; some have a different cost structure like a monthly subscription or pay per use. Upgrade cost should also figure into the equation (e.g., updates to the latest version annually). If the product does have a one-time cost, ask if the cost includes upgrades at regular intervals and, if not, factor in that additional cost.

Cost Comparison Table

Type	Cost Structure							
One-Time	$199							
Subscription	$14.95	$14.95	$14.95	$14.95	$14.95	$14.95	$14.95	$14.95
Upgrades		$79			$89			$99

Information Information cost relates to the consequence of sharing (or sale of) the system users' personal data to outside entities. Some programs collect and sell a user's information, such as purchasing data, expense trends, and demographic data. Sometimes the data are aggregated; for example, on average, 27-year-old males spend $400 per year on video games, compared to 48-year-old females who spend $40 per year. Sometimes the data are not aggregated; for instance, John buys five videogames per month from a specific developer. Having access to user data and selling that information to the highest bidder enables a software developer or provider to charge its customers less. After all, the company is earning the dollars elsewhere (e.g., through the sale of data to advertisers and other interested parties).

In an age when information is ubiquitous and people are sharing (intentionally or otherwise) personal details online, the idea that available data can be tracked and sold seems a given. But some users are uncomfortable with the idea that personal data, aggregated or otherwise, can be shared with a third party. For example, John may resent the deluge of email, text, or mail advertising that is tailored to his specific taste in video games. Or, he may appreciate the personal, targeted attention, even at the expense of his privacy.

The important thing for you, Alison, or any entrepreneur to consider is the disclosure terms: how the system provider or developer will collect, sell, or share (whether aggregated or specific) the information; to whom the data will be sold; and what the implications are of such an arrangement (i.e., what type of "cost" does it have on your business and clients?). Armed with that clear understanding, you can agree or decline to buy the system or subscribe with that provider.

Time Time cost refers to the hours the system requires its users to invest in order to learn and master it. Time is required as well to keep the system accurate, functional, and relevant.

Don't justify the purchase by *assuming* that learning to operate the system will take less time than tracking expenses manually. That probably is true, given that the benefit of having such a system is to provide efficiency and expertise to a task that most users find cumbersome. But even a well-designed, comprehensive program cannot run itself without user input or involvement. Just as you

shouldn't subscribe to a system if you cannot afford the payments throughout the contract period and just as you shouldn't agree to disclosure terms if you are uncomfortable with them, you shouldn't buy or subscribe to a system if you are unwilling to invest the hours necessary to learn it. If you do, you end up wasting your money, time, and effort—all of which you could have used for more productive reasons.

Does It Look Backward, Forward, at the Present, or All of the Above?

A system has a point of view—backward (past), forward (future), and present. Looking backward means it surveys previous spending data (whether manually entered or shared electronically) and puts similar expenses into categories. This capability helps you make initial assessments about where your money has been spent, which is a tedious task. A system with a backward point of view can help with this monotony, and the degree of helpfulness varies based on the system's efficiencies and your comfort level with those efficiencies. For example, if you aren't comfortable importing data from your credit card because you are concerned about the privacy and security of the system, then you must accept that the system is not going to be as efficient so that you can retain control of your financial information.

A system that looks forward builds a user's prospective budget based on historical trends. If you used to spend $500 per month on groceries, a forward-looking system can allocate $500 per month on groceries. Of course, the prospective budget is really only as good as the historical data entered, so accuracy in reporting and tracking is a key component of the success of the budget. Reporting and tracking, in turn, are only as precise as you enable either to be. That means you are still ultimately responsible for the quality of the information you enter, and only with quality inputs can useful outputs be generated.

The present (or very short-term past) point of view bridges the backward and forward capabilities of the system. It isn't enough to look backward to identify spending trends and potential problem areas, and it isn't enough to look forward by budgeting based on past information. A budget is only useful once it is compared to actual results, because a comparison reveals where budgetary

pitfalls and successes lie. A system that shows up-to-date, real-time actual-versus-budget comparisons for a given period helps a user take action. For example, if the system shows you that you have already spent $450 on groceries by the end of the first week of the month, you will know that you have only $50 to spend for the remaining three weeks. Then, based on that information, you can make a decision about your grocery dilemma—now, at present, instead of later when you've already depleted the budgeted amount.

How Well Does It Communicate with the Boss?

Each system has two bosses: its user and its owner or developer. The best system may be the one designed to serve both bosses equally and transparently.

The key to effective communication with the user is to customize the timing and format of the messages according to the user's preference—whether that's via email, text message, direct mail, or phone call and whether at a certain point (e.g., one day, one week) or in real time (e.g., emergency or news alerts). A system that serves you (the boss) well allows you to tailor the timing and format of the alerts and other notices you need to see.

The content of the communications may vary according to the data harnessed by the system. Banks may send out low-balance or overdraft alerts or bill-pay reminders, budgeting systems may provide overbudget (or near-budget) alerts or savings reminders, tax systems may signal reminders to pay estimated taxes or alerts when tax payments are substantially less than the previous year's. Given the sensitive nature of financial information, these systems may transmit fraud alerts as well. Banks and budget providers may alert users when transactions outside of their "normal" activities (based on dollar thresholds or geographic locations) post to their accounts. Of course, unusual activity may be perfectly legitimate if someone has made a large purchase or traveled outside the country, but given the prevalence of identity theft, most system designers choose to err on the side of caution.

Acknowledge that the system communicates also with its other boss: the company that owns it and has access to the financial data

it captures. (Read the fine print of the software agreement to determine whether the software actually owns your data once it is entered.) The most important thing for the user to know is (1) what information is being captured and retained by the system and (2) how the system is using the information. Transparency is key, and as long as you understand what is being done with your data, you can make an informed decision about whether you can live with the company policy.

What about support? Does the system (or the system's creator) provide accessible, useful, and reliable technical support to its customers? Many products do, but some don't; few things are worse than finding no help in the middle of the night before a make-it-or-break-it deadline. Make sure the system's support and engagement are commensurate with your needs as a user, depending on where you fall on the procrastination and maintenance scale.

Do the Users Actually Use It?

Often we have the purest, most idealistic intentions as we commit to spending and saving goals, budgetary practices, and financial euphoria. But our pure intentions don't always translate into action. We may find ourselves too busy to complete Sisyphean, never-ending tasks we'd rather not do (like budgeting).

If you commit to a financial management system, but you don't use it (beyond your initial engagement with it), you are doing a disservice to your business. Further, if you are paying for it on an ongoing basis, not only are you losing money but you also have put the business in a worse financial position than when you started.

Before investing in a system, you should understand how many users a system already has and how active the user group is. Ask these questions:

- ➤ Do current users log on to the system monthly, weekly, or annually?
- ➤ What is the turnover rate for users? Do people try the system and move on or stick with it?

Such statistics aren't always easy to find, but the answers to these questions can indicate whether a system is conducive to regular use. More often than not, the answers may be posed to the software company's customer service line or obtained from its sales force if they aren't published explicitly online. Regular user activity is a better indicator of a system's viability than just the number of users. In addition, usage by a large population may indicate continuity of the system. It isn't a guarantee that the system will continually be available, maintained, and updated, but it is slightly more comforting to use a system endorsed by a large number of friends and peers rather than by only a few strangers.

Read the user reviews shared by the company as well as those posted online by customers (e.g., on chat rooms and product/vendor review sites). Learn as much as possible—good and bad—about the company or provider and its system. A simple Google search may yield thousands, even millions, of relevant results. This information will guide the questions you ask the company before you subscribe or purchase.

Finally, investigate how users use the system. Here are some questions to ask:

- ➤ Are there apps for budgeting and tax planning on the go?
- ➤ Is the software compatible with tablets?
- ➤ Can it be used on Windows and Mac computers?
- ➤ Are the data stored on a cloud or on the company's hard drive?

There are no "right" answers to any of these questions, only answers that will enable you to decide what can work for your purpose and within your parameters. Understand your needs and preferences, not just the system's capacities and limitations. If you prefer to operate the system from your home computer and nowhere else, you may not need apps on your mobile devices or remote accessibility. Conversely, if you travel a lot, you may want something with portability and no geographic limitations.

Committing to a financial management system is a personal decision. Not every system out there is the right match, and that's okay. With so many different options, you can find one that fits you.

And fit is critical: You are much more likely to use a system if it works with your lifestyle, needs, and preferences.

How Will It Improve My Financial Situation?

The fact that you're even thinking about a financial management system is fantastic. Congratulations! Establishing general awareness is an incredibly important first step, and not one to be taken lightly. In fact, Abby Amin, the chair of the National CPA Financial Literacy Commission, states emphatically, "the first rule of personal finance is to be informed."[44] In that sense, yes—*any* financial management system will improve your financial situation, and a little awareness is better than no awareness at all.

Most of the really great financial systems do more, and "more" falls into three broad categories: education and suggestions, community resources, and integration.

Education and Suggestions The largest system developers provide education to their users through a variety of formats, including articles, webinars, podcasts, and blogs; the company hires professionals to generate the content of these educational materials. General information is available to the public, while some resources are protected and accessible only by users of the system. The quality of the material varies; some resources are amazing and others are less than stellar. The point is they exist, especially for those who are regular users.

Large companies also offer suggestions on lowering debt, budgeting effectively, saving money, curtailing expenses, and improving general financial health.

These suggestions range from being unique and compelling to being standard and trite, but they can be beneficial to users, depending on their level of business savvy. The company itself, however, benefits greatly from issuing these tips. Remember that the company has access to users' data. If the company knows (per the user's data) that the user is paying 22 percent per month in interest charges on a credit card or 7 percent interest on a student loan, it may suggest that the user switch to XYZ credit card or ABC student loan consolidation, which offers a better rate and

thus reduces the user's monthly expense and increases savings. It's a manipulative tactic (for which the company probably receives a referral fee or kickback from the firms it promotes) that may end up putting the user in a worse position in the long run. Or it might help the user save money. The user must evaluate the facts objectively and decide.

Entrepreneurs who use these financial management systems are smart and savvy, and so are the software companies. As long as both parties understand the motivations, true costs, and benefits behind the suggestions, everyone wins.

Community Resources The biggest benefit of signing up for (or purchasing) a system from a large company (instead of using a basic, old-fashioned database) is that it often has a built-in community. Users of the same system can talk about successes and horror stories as well as tips and tricks. Generally the company does not pay these users, and the type of information they provide is not educational or authoritative but rather casual and practical, like friends share over coffee. Community resources also provide open forums in which users answer questions from other users and discuss situations and lessons from experience. These are regular people rather than financial experts preaching best practices, which may not be applicable to a creative entrepreneur's lifestyle. As these communities have proven, misery does love company, and a community of like-minded people may provide not only useful information but also encouragement for a less-than-savory task like budgeting or financial management.

Integration By using a system with integration capability, users can save time. Budgeting systems can often talk to bank and credit card systems, and both may be able to talk to tax systems. Instead of saving receipts for three separate purposes (budgeting, bank reconciling, and taxes), a user can aggregate the information once, and the data automatically flow through various appropriate electronic channels for all three purposes.

Plus, by integrating systems, the records match. That is, an expense that shows up on a business credit card won't go unreconciled

for bank account or budgetary purposes and won't be missed come tax time. There is value and efficiency in the integration, assuming the user is comfortable with the transparency and use of the integrated information. After all, automation and integration can open up a beautiful world of efficiencies and effectiveness.

However, automation and integration are not substitutes for actual understanding. As beautiful as these efficiencies are (and trust me, when they work, they are amazing) they cannot replace knowing what is going on, and a savvy creative professional wouldn't want them to. You should protect yourself against the improper use of your data and from gross inaccuracies by understanding how budgets, cash, and taxes work. Outsourcing and delegation of your financial management is a great thing—as long as these processes do more good than harm.

Evaluating Systems

As soon as a list of financial management systems and tools is published, it becomes outdated. The volume of systems, shared tips, and available-for-download templates is vast, and the landscape changes regularly. Wesabe, the early online financial tracking system, closed in 2010, while Mint (its competitor) continues to thrive.[15] The bottom line is that you should find a system that works within your level of financial sophistication, schedule, business and personal needs and preferences, and goals.

Weighing the pros and cons of various systems, apps, and other tools by using the five analytical questions contained in this section enables you to commit to a system that works realistically for you, no matter how the technological landscape may change. In general, any system provides the features mentioned in these five questions to some degree. Again, the trick is to find the one system that matches your preferences and lifestyle. You wouldn't go to an intense, military-style, boot-camp fitness class if you want a yoga-inspired workout, even though you can get great exercise from either type. Similarly, if you resent nagging and proactive communication, you would dislike a system that sends daily text and email alerts about banking and budgeting activities.

To help you make an informed decision about the most appropriate budgeting, expense tracking, and savings system, evaluate each option with the following criteria:

Evaluating Criteria

Questions	Answers
What Does It Cost?	
➤ What is the price in dollar terms? ➤ Are my data collected, used, or sold? ➤ Is it secure? ➤ Is support available and built into the cost?	
Does It Look Backward, Forward, at the Present, or All of the Above?	
➤ Does it have historical tracking? ➤ Does it have prospective budgeting tools? ➤ Does it have goal-setting tools?	
How Well Does It Communicate with the Boss?	
➤ Can I customize the timing and nature of communications? ➤ Is it available on mobile devices, computers, or clouds? ➤ Who owns the information?	
Do the Users Actually Use It?	
➤ How many active users are there? ➤ Are the product reviews generally positive? ➤ What questions from the reviews do I want answered by the company?	
How Will It Improve My Financial Situation?	
➤ Does it offer articles, tutorials, or other education? ➤ Does it offer community resources?	
What Else Do I Want to Know?	

Outsourcing

So why bother with finding and evaluating a financial management system? Can't you (or Alison) just employ someone who uses a flawless system so that you don't have to do these tasks? It's possible, but unlikely. An accountant can't do everything, even if she is the most brilliant accountant that ever was.

As an entrepreneur, you must take ownership of your financial situation and let go of your anxiety (and maybe cantankerous attitude) about numbers. Managing an entrepreneurial career is absolutely a business, which means sometimes that you have to do things you'd rather outsource—just like you'd rather be painting than promoting your upcoming gallery show online, writing than calling editors to follow up on your project proposals, acting rather than having coffee with a difficult producer who may or may not cast you in his next play. All of these things—using social media and advertising, following up on opportunities, and networking with members of your industry—take time away from your craft. But they are essential to the longevity of your career.

Finances are the same way. Anything is more exciting than creating a budget, paying taxes, or reconciling bank statements. But complaining about doing these things takes more energy than actually doing them. A little short-term sacrifice for a long-term reward always makes good financial sense.

A Financial Teammate

To help you sort through your financial tasks, find a great accountant. Look for one who understands the benefits, unique challenges, and lifestyle of an entrepreneur. Speak to the accountant openly and honestly about where you are and where you want to be financially and about your long-term goals; don't hide your inexperience about finances. Look for an accountant who is kind and professional and who understands and appreciates your artistic pursuits. Here are tips for connecting with an accountant:

> ➤ Ask your peers and the organizations you're affiliated with for recommendations.

➤ Peruse the list of board members of the arts organizations in your city or state, and then identify the treasurers, who are likely accountants with an appreciation for the arts.

➤ Go to finance classes, artist networking events, and fiscal sponsorship groups.

➤ Search online. Finance webinars, guides, and blogs may offer links to accountant listings or resources.

Seeking, meeting, and then trying out professional collaborators (including accountants, attorneys, and financial planners) is a process not unlike dating. There is a financial match out there for you, but sometimes it is hard work to find the right person.

Inventory Systems

Alison's business doesn't involve inventory. She doesn't sell goods; rather, she performs services for clients. But entrepreneurial artists whose business models include the sale of goods (e.g., fine artists, sculptors, printmakers) require an additional system to track inventory.

In its simplest form, an inventory system is a list of each work that an artist has. (A database tool like Excel works well as a starting point for building an inventory system.) The list should include (at a minimum) the work's name, the date it was created, and the cost of direct supplies used to create the work (e.g., paint, canvas, clay, or paper). Once the work is sold, the inventory system should note the date of the sale, the purchaser, and the purchase price.

An inventory system provides a record of the artist's work, but more importantly, it tracks each piece's "cost of sales," which is important for tax purposes. The cost of the supplies used in creating the work are only deductible for tax purposes once the work is sold (and income is recognized). The cost of unused supplies an artist purchases (for future works) is not deductible until the supplies (the work's raw materials) are converted into a work of art and sold.

Maintaining an accurate record of the supplies used to create a particular work also helps an artist understand how to price the work. As we discussed briefly in Chapter 5, the price an artist sets for

her work is informed by the cost of the input items (supplies), the artist's time, and the market for the work. Artists are often asked to reduce or discount the price of a work, and understanding the value of the input items helps inform the minimum price the artist should be willing to accept in exchange for the work. Remember the discussion of walk-away prices in Chapter 10? Evelyn, the dancer/choreographer, articulated the minimum price she was willing to accept to take on a choreography project, and in negotiating with companies, she knew if the consideration she was offered didn't meet or exceed her walk-away price, she wouldn't say yes to the project. An artist's minimum price is the exact same concept, only applied to "goods" (like works of art) rather than "services" (like choreography).

Alison's Solution

Alison didn't purchase a financial management system from the company Elizabeth recommended, but she did learn a lot about her needs by talking to the representative. Instead she pursued a two-part strategy: She invested in a robust system that was relatively expensive, but also met all of her needs; and she hired a part-time bookkeeper to work with her assistant. Between her growing staff, the expensive system, and Alison's delegation skills, she reduced the amount of time she spent on administrative tasks and devoted her time to more client service instead.

Administrative work hasn't disappeared—it is still about 20 percent of Alison's time—but she has reduced it (and increased her productivity!) substantially.

Financial features, tools, systems, and even the expertise of finance professionals will continue to evolve. What won't change, even as the creative class grows, is the importance of *understanding* the technology, the financial rules behind them, the benefits, and the pitfalls to avoid (such as hidden costs, security and privacy risks, and access issues).

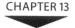

The Business Plan

Along with analytical reasoning and a financial management system, the business plan translates the seemingly risky move of launching a career as an entrepreneurial artist or a creative entrepreneur into one that is calculated and thus less risky. Drafting a business plan forces entrepreneurs to think through the specifics of their career; in doing so, they build a foundation for a successful endeavor. And once they have laid out this foundation, talking about it—whatever "it" may be—becomes easy.

Ellen's Elevator Pitch and Business Plan

Noah stands in the corner, watching the attendees at this networking event but avoiding eye contact. He is too nervous to participate in small talk and too intimated by the aggressive attendees, who jostle arms and proffer business cards like nine-year-olds trading baseball cards.

"Awful, isn't it?" says a woman behind him.

"It's total chaos out there. How do you even go about meeting people?" he replies. "Hi. I'm Noah."

"They start with the same question: 'So what do you do?'" she says, extending her hand. "Ellen."

"So what do you do?" Noah says, smiling.

She laughs. "I'm an architect. I started my own firm seven years ago. I work with artists and arts organizations, and I specialize in redesigning warehouse spaces for creative purposes. I'm finalizing two major projects right now, one of which just got an amazing write-up in the *Times*, and I'm getting ready to teach a master class in Boston next month."

Noah takes a big gulp from his glass of water. He wants to run away from this place, from this highly accomplished, well-put-together woman. He feels so small in comparison.

"What do you do?" Ellen prompts him.

"Well, I, uh, I design. I'm a designer, I guess. But I don't really like what I'm doing right now. Actually, I don't know. My life did not turn out like I imagined. And maybe I should get out of here," Noah stammers.

"You have seriously got to work on your pitch," Ellen jokes.

"To be perfectly honest I don't have interesting things to say like you do," Noah sighs. "I'm trying to leave my job so I can go off on my own. Maybe I can meet some clients, make some connections, save some money. I've been going to some classes, learning from friends who are in the same position as me. But I'm not really sure what I'm doing or what I should be doing—at least not yet."

"Want to know a secret?" she leans into Noah and whispers. "I don't know what I'm doing either. I volunteered to teach the class in Boston. I'm not getting paid for it, but it will be a great experience and it might help me line up my next project. Some days I feel completely uninspired. Some of my emails and phone calls go unreturned. And I'm seriously thinking about applying for architecture jobs again, because sometimes I think that would be easier. We have a lot in common. I just have a better elevator pitch."

"Why is it called an elevator pitch, anyway?" Noah asks.

"It's supposed to be concise—short enough to last an elevator ride with someone you're trying to impress, like a potential client or collaborator. If the pitch is too long, you'll bore the other person. If it's too short, you're not selling yourself enough," Ellen explains.

"Interesting. Tell me more," Noah urges.

"Okay, let's sit down at that table," Ellen says, pointing to a nearby spot. "First, relax; don't think anyone here is better than you. Second, talk about the work you love to do, the work you've done and are proud of, the work you want to get into. Skip all the rest. Third, perk up. Don't say you don't know what you're doing. Join the club! Not many people know what they're doing. Don't talk about your disappointments and your bad days—not when you're trying to make a good impression and not at these events. You want to be seen and remembered as someone who has it all together, someone who can be trusted with a big project."

"Like you. You give off that impression that you have it all together," Noah observes.

"Exactly. Now, let's try your pitch again. Instead of telling me what you do, tell me about your last project," Ellen instructs him.

Noah ponders his pitch for a few moments. "Last month, I finished a massive campaign for an upstart technology firm. We redesigned everything about the brand from its logo to its slogan to its website, and that campaign has gone global and brought in a number of large accounts to the firm. We worked directly and collaboratively with the founders to capture their vision."

"That was awesome! I would hire you or recommend you to someone in a heartbeat. I got excited about your work because you were excited about it."

Noah exhales, relieved that he has passed his first test. "Would you mind if I ask how you did it?" he asked Ellen. "Started your own firm, I mean. How did you know it would work out?"

"I don't mind, and I didn't know," Ellen replies. "Not for sure anyway. I knew I could always try something else if it didn't work out. And I believed in the business plan I wrote."

"You have a business plan? Weren't you just going to freelance?" Noah's eyes widen.

"Freelancing is a business. And for it to be a successful business, you have to first think of it as a business. Here, I'll send you my business plan," Ellen says, pulling out her smartphone to email the document to him.

That night, Noah settles into his favorite armchair to read Ellen's business plan. It has a cover page that contains the name of the company, contact information, and a confidentiality note asking readers not to share the document without her permission. The plan reads like a really great story, and it describes in detail what Ellen is going to do, why she is best qualified to do it, and how she is going to do it. It is thorough and articulate, laying out various contingency scenarios and Ellen's research-based plans to manage them. The business plan reads as if the undertaking is nearly risk free and is a reasonable decision. As he reads, Noah nods and jots down notes.

Business Plan Components

A business plan is the concretization of an idea. It is an entrepreneur's staring point, where she articulates specific details about an idea. It forces the entrepreneur to analyze (and sometimes defend, change, or abandon) the idea factually, not emotionally. It is a "living document," as the US Small Business Administration calls it, meaning it is updated regularly, and it "outlines the route a company intends to take to grow revenues." [46] Essentially, the plan is a script with a standard set of components, such as executive summary, market analysis, company description, organization and management, marketing sales, financial information, and appendix. With that said, you should apply as much creativity as possible so that your business plan is a true reflection of you and your craft. (Keep in mind, of course, that the business plan still needs to present clear answers to all the business questions.)

Executive Summary

Although the executive summary is the first part of the business plan, it should be written last. It should

- ➤ summarize all the pertinent information found in the plan (to give the reader a condensed version of the document); and
- ➤ be well written to entice the reader to read the rest of the plan.

Market Analysis

In this section, aim to answer these questions:

- ➤ What problem will the business solve?
- ➤ Why is the business necessary?
- ➤ What is the existing demand for the services or goods the business will provide?

This section is also where you should address geography and the industry.

- ➤ Where will the business operate?
- ➤ Is it limited to a bricks-and-mortar (physical) location, or will it have electronic reach as well?
- ➤ Are there areas where the business may particularly thrive?
- ➤ What geographic areas will the business avoid completely? Why?
- ➤ What characteristics make a particular geographic area attractive?
- ➤ Will the business fulfill a particular niche in the industry? Is it a new niche or an existing one?
- ➤ Is the company's aim more broad (than niche)? Will it solve an industry-wide problem?

Simply put, the market analysis identifies the size, type, and geographic parameters of the business.

Company Description

This component kicks off the entire business plan, answering the question "What problem will the business solve?" Here, you should state your business's response to the needs, barriers, and other problems you identified in the market analysis section. Present a detailed description of the company, noting if the business will operate on a for-profit or nonprofit basis, and specifying the entity type (e.g., a corporation, partnership, limited liability corporation, or sole proprietorship). Companies may consider pursuing one of two relatively new entity types as well, a B corporation or an L3C (low-profit limited liability company), which blend a for-profit model with a social or charitable purpose. These hybrid entities recognize that plenty of businesses operate in the growing gray area between the for-profit and nonprofit worlds.

What will be the business's programs? Its operations? Its service lines or product divisions? If the work has already begun (e.g., you already take on freelance projects while still employed full time), include a history of the business's operations and experiences. Discuss the timing of the operations. State also pertinent organizational facts.

- Is the company up and running?
- When are operations projected to begin (in whole or in part)?
- Is the business registered or licensed to operate in certain states or countries?
- For nonprofit entities, does the organization expect to receive an IRS charter within 12 months?

Organization and Management

How is the business organized? What does the chart of staff look like? Who is running the operations? Who is advising the business? What key players are vital to the business's long-term success? These are the main questions that the section answers.

Describe the company's hierarchy and the roles of people within this hierarchy. If there are people who already fill these roles, include

their names and brief biographies (which should state experience and expertise relevant to the business's service or product). In this way, this section is a massive curriculum vitae for key personnel. If you plan to add personnel later, broadly describe the roles they will fill. You should also identify if the future staff will be contractors or employees or will work full-time or part-time and when they will be added to the operations.

But the business may involve just one key person: you, the founder or executive director. That's okay, especially when the business just started operations. In that case, include your biography and curriculum vitae. Make sure these documents are comprehensive, compelling, and relevant to the business's main mission and vision.

If the business has key advisors or investors, include their names and brief biographies. Do the same if it has a board of directors, and list each member's term of service (how long the person will serve on the board).

Marketing and Sales

This section articulates the business's strategy for promotion and sales. That is, how will the business advertise to reach new clients or new communities?

This section should also discuss the business's competition. You (and other entrepreneurs) may be tempted to assert that your work has no particular competition, but you are likely incorrect in your assessment. Every idea, product, service, or movement—no matter how unique—has a competitor, and this competition may come in many different packages.

Take a performing arts group, for example. If the group performs modern dance pieces, its direct competitors may be other modern-dance troupes. The competitors may be local (based in the same geographic area) or may be visiting (touring groups, seasonal acts). The group's indirect competitors are the other companies that may not perform modern dance or perform in the same community but may nonetheless entice the group's audience to try watching other types of dance. In fact, any live form of entertainment could be considered the group's competition, splitting its

base of patrons. Some audience members may choose to attend a play, an opera, a comedy act, a music recital or concert, and so on instead of a modern dance show. Television, film, and the Internet are also viable forms of entertainment that compete with the dance group's business. The competitors of the modern dance troupe (or any product or service) can be illustrated in spheres to indicate how they affect the troupe by angling for the same entertainment dollars of the audience members.

Competition Spheres

The fact that a business has competitors isn't the interesting part of the marketing and sales section. Clearly, you've been made aware of this fact when you did your market analysis or when you researched the industry in which you are operating. The interesting part here is how you will decide to *differentiate* your business from

all the other players in the same market. For the troupe, it will have to figure out *who* would choose to attend a modern dance performance on a Saturday night rather than enjoy another event or stay home. Once it identifies this audience, the company will need to determine *how* to lure these people to its shows, bring their friends, and keep all of them coming to every new production. The troupe has to articulate its competitive advantage—*what* makes its dancers special and its shows different and relevant, compared with all the other dancers and companies in the industry.

This understanding helps drive the group's marketing and sales strategy, and the strategy should be consistent with its competitive advantage. For example, a dance company that touts its environmental conscience as the thing that sets it apart from the rest shouldn't use printed advertisements mailed to its subscribers or plaster posters and fliers all over town. That paper-intensive promotion strategy isn't coherent with the company's claim of environmental friendliness.

Financials

This section is reserved for the business's historical and prospective financial information. If the business has existing operations, add financial statements (a balance sheet, profit and loss statement, and cash flow statement at a minimum) for the most recent year. If the statements have been audited, include the accountant's audit report. A nonprofit organization should attach a recent copy of its annual tax return (Form 990), and for-profits should include tax information if it is relevant to the reader's understanding of the operations. Sole proprietors (self-employed entrepreneurs) should never include personal tax information (except possibly a redacted Schedule C); instead, they can provide financial statements.

Regardless of your business structure, you should prepare budgets for one operating cycle and include them in this section. You may also create a long-term budget (covering three or five years) that reflects the growth projections, market demand, and promotion strategies you articulated in the other components of the business plan.

Dedicate an extensive section to revenue. For a nonprofit, revenue includes funding from both earned and contributed sources,

and for a for-profit, it includes sales projections of goods or services. In addition, think about contingency funding. That is, does the business have a reserve it can tap into if its sales projections prove to be too optimistic? How will it continue to operate if sales goals or funding requests are not met? Do a what-if analysis for the business budget (the same process you did for creating a personal budget) and articulate your findings.

Tied to this contingency analysis and the budget in general is a cash flow analysis. As we learned in Chapter 9, cash doesn't always match up with sales, depending on the payment arrangement. For example, if Noah completes a freelance design project in March, he may not get paid for that work until May (or later). Evelyn may choreograph a show every day for three months but may not see payment for her hard work until the show opens. Abby may be commissioned to paint a mural today but may not get a check until it is complete—maybe even a year later. Meanwhile, the business still has to operate and cover expenses.

Expenses, not just income, must be included in this section as well. What are the business's projected expenses? Where can they be cut if necessary? A nonprofit may ask, how are the expenses allocated across the three major functional categories (program, management and general, and fund-raising)? Other types of businesses may ask, how are the expenses divided between operating and nonoperating activities?

Break-Even Analysis The break-even point is the point at which the business has sold enough products or performed enough services to cover both its fixed and variable costs. This is a key metric (and thus must be assessed within the financial section) because it determines how financially risky an endeavor might be. The break-even point may be expressed in terms of service dollars (e.g., 4 clients paying $10,000 each) or the number of products sold (e.g., 1,500 books sold at $19 each). However it is expressed, that point absolutely must be reached in order for the business to break even—that is, not lose money. In a break-even analysis, the point is calculated using a long list of assumptions about fixed and variable costs as well as revenue

dollars. If any of those assumptions are materially wrong, the break-even point is worthless—until it is recalculated anyway.

Knowing the break-even point allows you to articulate exactly what you have to do to not lose money or to reduce the risk of your project. If you are a service provider who works out of your home, you may need to cover only a minimal amount of expenses (e.g., website hosting, computer software, supplies, business cards). Thus, your professional break-even point may be low, making your business profitable. From a personal perspective, though, your break-even point may be higher, because you must pay rent, utilities, health insurance, child's daycare (if applicable), and so on. In this sense, the business may be riskier for you than for someone with fewer personal financial obligations.

Entrepreneurs should know both their personal and professional break-even points. But personal break-even points should be omitted from the business plan if the plan will be shared with funders or investors.

Appendix

The appendix includes any information the business deems relevant to the reader's understanding of its operations. It may include the business charter, bylaws, policies and procedures, research conducted by the business, public relations pieces like newspaper articles featuring the business or longer profiles of key personnel. The appendix is primarily a spot at the end of the document where entrepreneurs include additional information that doesn't fit elsewhere.

Target Audience When writing the business plan, you should always consider your audience. Who will be reading the plan? Will potential clients, funders, or investors peruse it? What about potential contractors or employees? Is it only written for yourself? It doesn't matter what the answers are, and the answer to each question may vary over time and across industry. The point is that the plan should be written with one audience in mind and addressed consistently throughout.

Noah's Happily Ever After

After Ellen leaves Noah that day, he practices the elevator pitch Ellen coaxes out of him. He then perfects it and tries it on other people—to high applause.

He does meet a bunch of people, and he does get better at introducing himself, even though he still feels disingenuous about leaving out how miserable he is at his current job. Everyone he talks to thinks he has a "cool" job. Most work at hedge funds or corporations in which the work is predictable. They all admire his creativity, and recognize the name of his firm. His confidence does grow with each "you're talented, I can't do what you do," but their comments also make him wistful about how lost he is about his career path.

After reading Ellen's fantastic business plan, Noah is inspired and full of ideas. The next day, he starts drafting his own. He shows it to Elizabeth first, who is ecstatic about his prospects. She reminds him to meet with some of his friends, who are full-time independent contractors, to pick their brains as well.

Noah calls some designer friends to commiserate over wine and take-out food. From hearing his peers, he learns he is the norm, not the exception, and how others are coping with sporadic gigs and rising costs. He invites the group back, and the next time each person brings a friend. Noah invites Ellen to the meetings—that is, when she is in town and not too busy with her other projects—as well as other entrepreneurs who share their success stories.

The group consists of creative classers—entrepreneurial artists and creative entrepreneurs alike—with different experiences and areas of expertise. After several informal sessions, their conversations have gotten better. Eventually the group moves out of Noah's apartment and into a restaurant.

Noah not only learns from the group but also shares information about his own struggles, something that comes as a surprise to him. The questions, issues, and concerns that others raise are not always the same as his. Not everyone knows the answers, and no one claims to be an expert. But no one ever feels like his or her fears, future plans, and questions are taboo topics. Many of them, like Noah, are exploring new goals in an effort to achieve both creative fulfillment and financial stability.

Slowly but surely, Noah finds his very own spot in the massive gray area of the happiness graph. It's a spot that works for his own reality. And with all kinds of advice from Ellen, the financial classes he attends, and his circle of artist friends, he is now seriously talking to the group about making his big move.

New faces and familiar ones crowd the back room at Jimmy's, the official venue of Noah's monthly meetings of creative entrepreneurs. Noah greets everyone, shaking hands, patting backs, and giving hugs. He surveys the room and exhales. He can't believe how much his life has turned around in three quick years. He still thinks about that day Elizabeth encouraged him to start talking to other people about his job woes. And that fateful networking day he met Ellen, whom he believes changed the course of his life, is still etched in his brain. Ellen quibbles with that description, as any good mentor would. She says she merely facilitated the changes he knew he wanted to make.

Noah grabs the microphone and hops onto the small stage. He waves at the smiling crowd, about 300 strong.

"Almost three years ago," he begins, "We started this group in my living room, not long after I met tonight's guest speaker. She taught me the art of the elevator pitch. If you'll indulge me, I'd like reintroduce myself to you."

To applause, Noah begins.

"My name is Noah, and I'm a designer. About a year ago, I formed my own firm to work with entrepreneurs and small startups. I apply an integrated design approach to their businesses, and I'm really proud to announce that my most recent project is going to be profiled in *Communication Arts*, one of my favorite design magazines. Equally important to me is this group, which now has hundreds of members and offers support and resources to creative entrepreneurs."

"Without Ellen, I wouldn't be able to articulate any of that. And without her, none of it would be true. Ladies and gentlemen, I'm thrilled to introduce to you my friend, my mentor, the incomparable architect and entrepreneur extraordinaire Ellen McCrane!"

Not surprisingly, Ellen's presentation wows the audience. She concludes her remarks with an exercise and invites anyone who wants to share his or her elevator pitch from the stage. A line quickly forms.

"I am Caroline. I am permanently imperfect at being a creative entrepreneur. I work as a freelance journalist, and I also moonlight as a blogger for a website that garners over a million hits per month. I finally mastered budgeting, and I won a Pulitzer Prize last year. Not for budgeting."

"I'm Alison. I've been running my own HR firm for close to five years now. I have a five-person office, and our work involves stream-lining company policies and procedures and advising executives on employee rights and federal rules. My goal is to grow my client list by 10 percent this year, and I've focused on streamlining my own procedures to do just that."

"Hello, I'm Logan. I'm an actor. I am an understudy in a play right now, and I've written a dramatic monologue that I'm meeting a few producers about. I've done a few commercials, and I have an upcoming audition for a soap opera that will air exclusively on YouTube. But, sshh ... you didn't hear that from me. I still tend bar once in a while, because I love it and the cash is easy. Plus, there is no better place for character research!"

"Derek, here. I am a classically trained saxophonist, but I play all kinds of music. I record a lot of chamber music, mostly for TV and movie soundtracks, and I've recorded two solo albums. I love playing live, improvisational music with a bit of a twist, and I want to keep doing this for the rest of my life. I feel like such a real professional saying all that, and it's kind of true!"

"My name is Elizabeth. I analyze Asian financial markets. Last month, my first article was published in the *Journal of Finance*, and I hope to do more of those articles in the future."

"I'm Evelyn, and I'm a dancer. After a few years of being an independent choreographer, I'm back to performing full-time as a principal member for a small traveling dance company. We perform up and down the East Coast. My goal, just like everyone here, is to get my financial life in order, which is a big focus of Noah's group. But I've come a long, long way since this group's early days."

"My name is Abby. I'm a professional painter and an amateur sculptor and photographer. I'm not very good at talking about my trade, but over the years—thanks to the courses I took with Noah—I've gotten really good at handling the business of my art. I'm even a master at budgeting and negotiating! Those skills are very handy, now

that I'm married and a working mother. My latest gallery show just opened a few days ago, but my plan is to one day own an art shop."

Noah can't help but smile as he watches his friends mingle with newcomers and those they haven't met. He is elated and proudly watches them share their successes and trials.

No one claims to know it all. No one pretends to be an expert in managing a creative career. But neither does anyone plead total ignorance to any aspect of running his or her career. Their introductions and stories are coated with empowerment and confidence, not iced with disclaimers about numerical illiteracy or marketing ignorance. Underlying the spirit of their self-descriptions is the belief—the real, genuine, convincing belief—that they can master any aspect of their entrepreneurial careers. And that they won't be afraid to ask for help or assistance when they need it, not because they can't do something, but rather because they can.

Ellen appears behind him. "It's pretty great, isn't it?" she asks.

Noah jumps back, feeling a sense of déjà vu. He is transported to the first time he met Ellen, and he laughs aloud. "Last time we were in this situation, it was awful. But tonight it is pretty great."

"I always knew it could be this great," he concludes.

▼

Budgeting

This section includes examples of how to estimate amounts for certain budgeting categories. It is meant to help you get unstuck when creating your own budget—whatever your parameters. These are simply tips and thoughts about various categories to spur your imagination. This is not absolute, nor is it rigid. It is simply a starting point.

Other Costs

There are few rules when it comes to listing costs in the other category. This catchall category captures costs unique to various industries and business types. Nonprofit organizations incur fund-raising costs, while for-profit companies do not (although a corollary might be application fees or the costs to set up meetings with investors or funders, which could go into the administrative cost category instead of the other category). A dance company may budget for costumes, set pieces, or the rights to use a piece of music or choreography in a production. A visual artist, on the other hand, may budget for supplies and transporting work from festival to festival or from studio to gallery. The costs in the other category are as unique as the entrepreneurial business itself.

Space Costs

Rent is a predictable expense that is easy to budget. It is likely fixed for a year (assuming you've signed a yearlong lease), and plenty of information is available to estimate the cost of rent per month if you haven't signed a lease. Consider searching Craigslist, Zillow, or other real estate–heavy sites as a starting point.

Utilities, however, may be wildly unpredictable. In some months, an electric or gas bill may be extraordinarily high; in others, extraordinarily low. Look at the past year's utility bills to estimate what each month may cost going forward. If you have no such bills, ask

the space's previous tenant, a neighbor, or the landlord or management company to disclose the amount they typically pay. You may also call the utility company to provide you with the average billing cost for the actual space or for the same square footage in your area. The company can't guarantee the information, but it should be willing to help. The estimate doesn't have to be perfect because it's just a starting point, and in the absence of exact information, a rough estimate is better than nothing.

Equipment Costs

Unless you own or plan to own a major piece of equipment (e.g., potter's kiln, stage prop, combine), you don't have to worry about budgeting for depreciation or major repairs. But if you do or plan to own or rent such equipment, you should budget for depreciation, use, or repairs of that equipment. There is no single definition of "major," unfortunately. It depends on your situation and the nature of your business. If you are an individual artist, for example, you may "expense" (write off in one year) anything you purchase that is less than $10,000, so for you "major" means more than $10,000. (In IRS terms, this is called "election to expense certain depreciable property" under Section 179. Special rules and caveats exist for this expense, so consult IRS guidelines before making the election.)[47]

Meanwhile, a nonprofit organization with a $50,000 annual revenue may take a more conservative approach and set a policy stating that anything that costs more than $5,000 is major and will be "capitalized" (treat the outlay as an asset and depreciate it annually).

To illustrate how depreciation works, let's pretend you bought a potter's wheel for $50,000, and you expect it to last for 20 years. Even if you paid for the wheel in the first year ($50,000 in cash left your pocket), you can spread the expense over its useful life (20 years). Instead of budgeting for a $50,000 outlay in one year and nothing for the next 19 years, you include a $2,500 expense per year ($50,000 ÷ 20 years). This "matches" the expense of the wheel against the time period in which you'll use it, and it is a typical (if simplified) accounting convention.

Technology Costs

Technology costs include the charges for maintaining an online presence, such as web hosting, website design, web server, and search engine optimization consultants. This category also includes costs or fees related to desktop or tablet computers, smartphones and other mobile devices, business-related software or applications, scanners, occasional usage of a fax machine, conference call dial-ins, or hosting live chat meetings. Because technology is so ubiquitous in our lives, listing all the fees and charges we incur to use technology is hard. But do your best; an incomplete list is better than no list at all.

Personnel Costs

To estimate salary expenses or fees paid to professionals (e.g., for a theater owner, personnel could include contract carpenters, accountants, performers), do some research online. Employment websites provide aggregated salary information for various positions; use that data as a starting point. Alternatively, browse actual job postings for comparable positions to determine the current reasonable rates, which vary on the basis of the professional's city or state, years of experience, skill level, union affiliation, and other factors.

In this section, include an estimate of the salary you pay to yourself as well. Are you willing to work without taking a salary for the first year? Are your actors willing to perform for free? Many entrepreneurs are more than willing to sacrifice their own bottom lines to see a project brought to fruition. However, the budget should reflect an estimate for salaries, as though funding were not a limiting factor. That's not to say you should pay yourself $20 million to run a summer arts festival. Salary amounts must be reasonable but not so low or nonexistent that you are making drastic self-sacrifices or driving yourself and others to poverty. If someone decides to volunteer, document that in the actual results of the budget, not the estimates. The goal in creating a budget is to find the income to fund the expenses, not to make the expenses unrealistically small. A budget built too small won't help the entrepreneur, project, or business in the long run.

You may be lucky enough to receive pro bono advice (called "in-kind" support in the nonprofit world). Wonderful! Take full advantage of it, but don't forget to add it to the budget in two places. First, if you join a group or pay a reduced one-time fee in order to access the pro bono service, include the associated membership fee. Second, add a line in the budget on the expense side for the professional service you didn't have to pay but would have paid for anyway.

For example, say you budget to pay an attorney to review your legal filings and contracts, but you end up gaining access to a pro bono attorney through a volunteer group, which you paid $175 to join. The attorney gives you a bill showing that his legal services cost $2,000 were he to charge you. In addition, you plan to meet with a marketing consultant three times, because marketing consultation is a free benefit of participating in your equity group ($50 membership dues per year). Although ordinarily you wouldn't pay for marketing consulting (online research reveals that marketing consultants charge an average rate of $35 per hour), you take advantage of the service because it is free. So what should your budget show? It should show the $175 fee to join the volunteer group (which provides access to the pro bono attorney) and the $50 dues for participating in the equity group. Both fees belong in the memberships and subscriptions section of the budget. The professional fees section should show the amount for legal services ($2,000). If your business is a nonprofit or is petitioning for grant funding from a foundation or another group, include the pro bono or in-kind services in both the expense and income sections with a caption such as "in-kind services" or "in-kind contributions." If your business is a for-profit or you are budgeting for your own purposes, include the pro bono services on the expense side only, not the income side as well. Make a note that the expense is a noncash expense so that you remember not to pay for that amount; you may also include it in a separate section toward the bottom of the budget, after the total of all the expenses you'll actually pay for in cash. The budget should not reflect any amount for marketing consulting—even the $105 ($35 per hour × 3 hours) average service rate—because you wouldn't normally pay for consulting and thus you don't budget for it.

Indirect Personnel Costs

Personnel costs also include expenses such as taxes, health insurance benefits, and workers' compensation. Businesses pay taxes on the amounts paid as salary to all employees but not to contractors (so call contractors "contractors" and employees "employees"). Misclassifying an employee as a contractor (a common mistake) can lead not only to taxes owed but also to penalties and interest on the amounts, and taxes can be imposed at the federal, state, and local levels. Many personnel tax resources are available (ADP is the most common). They are worth the investment if you plan to draw a salary on an ongoing basis or pay others' salaries.

Whenever you have staff—even if the staff is just yourself—you incur indirect staff costs related to birthday celebrations in the office, attendance at meetings or conferences, employee training or professional development, and so on. These indirect costs add up quickly, so they should be included in the budget. Investment in personnel and their skills and knowledge is one of the smartest long-term investments a business can make, even if that business consists of a lone entrepreneur. A freelancer, for example, should attend industry conferences and networking events, take classes, and meet with a mentor for occasional lunches. By budgeting for these costs ahead of time (making a financial commitment to or investment in career improvement), the freelancer can avoid the dilemma of deciding whether to pay the electric bill on time or to pay for a seminar that could substantially help her career growth. Budgeting allows her to do both.

Office Costs

Office costs are probably the least exciting and most unpredictable costs in a budget. They include everything from print cartridges to envelopes, from stamps to insurance. And checks—include business checks in this section. Your printer needs paper, and your desk needs basic supplies like pens, notepads, and a calculator. If you are running a business that does regular or occasional mailings, take into account the supplies you need for that purpose. Budget

to purchase your own office supplies so that they are available when you need them.

And don't forget insurance. There is no right answer about how much insurance you should carry, and you may need to obtain several types of insurance, depending on your business. Common types are liability insurance for you and for the project, property (or renter's) insurance, and travel insurance. A good place to start learning is the professional organization to which you belong, like an actors' guild or a freelancers' union. Most of these associations offer insurance to their members (or at least direct members to reputable insurance providers) that are reasonably priced and provide suitable coverage for the business type.

The business need for advertising, marketing, and public relations changes over time, depending on various factors unique to the business and other factors driven by the economy at large. You may find it useful to hand out business cards to acquaintances and contacts or to distribute a brochure to potential clients. Alternatively, you may skip the printing or mailing expense and create a PDF brochure to email or post on your website or blog. You may love using Google Ads and Facebook advertising, or you may consider them a complete waste of time. You may buy advertising space in a trade journal or magazine, or you may write an article that covers something you do well (advertising plus public relations). There are as many advertising, marketing, and public relations strategies as there are advertising and marketing professionals. Planning for something suitable takes time and, of course, resources, so budget accordingly. But how much is appropriate? Ask your friends or colleagues—start there. Is there a company or small business (comparable to yours) that they admire or love hearing about? Find out who is responsible for the advertising and marketing for those businesses, then talk to those people for some tips. Everyone is really busy, but most people (when approached nicely) are accommodating when asked to share knowledge, resources, lessons learned, insider information, and even cost estimates.

Travel Costs

Some travel is inevitable when you are an entrepreneur. If you live in an area with a great public transportation infrastructure, you may take the subway, the bus, or a taxi to attend an event or a meeting or to meet clients. If you live in an area without mass transit, you may drive. For tax purposes, you can deduct car trips according to the IRS's standard cost per mile or your actual expenditures for gas, repairs, and maintenance. If you go out of town or out of the country for business-related reasons, you incur costs for a train or bus ticket, a flight, a rental car, or cab fares to reach your destination. In addition, you'll have to stay at a hotel and you'll have to eat. Budgeting for travel expenses can make the trip inherently less stressful (financially anyway). It is unrealistic, but optimistic, to plan to eat peanut butter sandwiches, to crash on a friend's couch, or to rely on a friend to chauffeur you around while you are traveling on business.

You may not know exactly what trips to plan or estimate as you build your budget at the beginning of the year, but it is reasonable to think that you may take at least one (local or nonlocal)—to a trade show, a conference, a festival, or an art show. Make some assumptions about how many trips you'll take per year and then start estimating the average costs. As your business grows and you get a better sense of the worthy conferences or events you'd like to attend, you'll be better able to estimate future travel budget amounts. But taking a generic approach is completely fine, too.

ACKNOWLEDGMENTS

Special thanks to the following people, who willingly shared insights, stories, and laughs with me as I wrote this book, and above all to **Michael** and **Olivia**, my two favorite people, who supported me throughout the process and let me sneak away now and then to write.

- ➤ *Larry Smith*, founder of *Smith* magazine and creator of the Six-Word Memoir books (including one that features my six-word memoir!)
- ➤ *Russell Fallstad* of The Dueling Fiddlers and Heartstrings Academy
- ➤ *Brett Landry*, DMA candidate and percussionist extraordinaire
- ➤ *Alison Hemming*, head gun and founder of The Hired Guns, who facilitated the only (known) poetry contest won by a CPA (yours truly)
- ➤ *James Richards*, founder of Townscape Landscaping & Design and founding member of the creative class (long before there was such a thing)
- ➤ *Claire Grant*, grant writer, exceptional roommate, and creative entrepreneur extraordinaire
- ➤ *Will Maitland Weiss, Fran Smyth, and Karen Zornow Leiding* whose work with the Arts & Business Council of New York helped me rekindle my lost enthusiasm for my professional work
- ➤ *Doug Seibold, Kate DeVivo, Rachel Hinton*, and the entire team at Agate Publishing who made this project and all our shared undertakings seamless and enjoyable

NOTES

1. This scenario was first proposed by David Bornstein, "A Better Way to Teach Math," *Opinionator* (blog), *New York Times*, April 18, 2011. http://opinionator.blogs.nytimes.com/2011/04/18/a-better-way-to-teach-math/.

2. National Endowment for the Arts Research Note #105, "Artists and Arts Workers in the United States," 2011. http://www.nea.gov/research/Notes/105.pdf.

3. Bureau of Labor Statistics, "May 2011 National Occupational Employment and Wage Estimates," accessed April 2012. http://www.bls.gov/oes/current/oes_nat.htm#11-0000.

4. ———, "Arts and Design Occupations," In *Occupational Outlook Handbook*, 2010-2011 edition, accessed March 2012. http://www.bls.gov/ooh/arts-and-design/home.htm.

5. ———, "About," In *Occupational Outlook Handbook*, 2010-2011 edition, accessed March 2012. http://www.bls.gov/oco/oco20016.htm.

6. Alain de Botton, *The Pleasures and Sorrows of Work* (New York: Pantheon Books, 2009).

7. Richard Florida, *The Rise of the Creative Class: And How It's Transforming Work, Leisure, Community and Everyday Life* (New York: Basic Books, 2002).

8. ———, "What Critics Get Wrong About the Creative Class and Economic Development," *Atlantic Cities*, July 3, 2012. http://www.theatlanticcities.com/jobs-and-economy/2012/07/what-critics-get-wrong-about-creative-class/2430/#.

9. National Endowment for the Arts Research Note #2, "Artist Employment in 1982," January 24, 1983, accessed May 2012. http://www.nea.gov/research/Notes/2.pdf.

10. Tim Dirks, "The History of Film: The 1930s," *Filmsite*, accessed December 2012. http://www.filmsite.org/30sintro2.html.

11. Coole Park & Gardens, "Home" and "Literary Connections" (web pages), accessed December 2012. http://www.coolepark.ie/index.html.

12. Todd London et al., *Outrageous Fortune: The Life and Times of the New American Play* (New York: Theater Development Fund, 2009).

13. "What Would You Do if You Knew You Couldn't Fail? Creating SMART Goals," adapted from *Attitude is Everything* by Paul Meyer, University of Kansas, accessed January 2013. http://www.oma.ku.edu/soar/smartgoals.pdf.

14. Peter Gollwitzer et al., "When Intentions Go Public: Does Social Reality Widen the Intention-Behavior Gap?" *Psychological Science*, 20, no. 5 (2009): 612–18. doi: 10.1111/j.1467-9280.2009.02336.x.

15. "Learning Bank," Federal Deposit Insurance Corporation, last updated April 2004, accessed January 2013. http://www.fdic.gov/about/learn/learning /what/money.html.

16. "Fidelity Fiduciary Bank Lyrics" from Mary Poppins soundtrack, accessed January 2013. http://www.stlyrics.com/lyrics/marypoppins /fidelityfiduciarybank.htm.

17. Prime Interest Rate History, "History of the US (Fed.) Prime Rate from 1947 to the Present," accessed May 2012. http://www.wsjprimerate.us/wall _street_journal_prime_rate_history.htm.

18. Bankrate.com, "Barclay's High-Yield Rate for a Five-Year CD as of May 17, 2012," accessed May 2012. http://www.bankrate.com/cd.aspx.

19. Liz Skinner, "Investors Find Financial Products Confusing: Survey," *Investment News*, May 13, 2012. http://www.investmentnews.com /article/20120513/REG/305139979.

20. US Securities and Exchange Commission, "Getting the Facts: The SEC's Roadmap to Saving and Investing," updated August 2007, accessed May 2012. http://www.sec.gov/investor/pubs/roadmap.htm.

21. ———, "The Investor's Advocate: How the SEC Protects Investors, Maintains Market Integrity, and Facilitates Capital Formation," updated April 2012, accessed May 2012. www.sec.gov/about /whatwedo.shtml.

22. Jonah Lehrer, "Don't! The Secret of Self-Control," *New Yorker*, May 18, 2009.

23. Thomas Stanley and William Danko, *The Millionaire Next Door* (New York: Gallery Books, 1998).

24. Juliana Grenzeback, "Converting the Enemy: Budgeting During Planning," NEA Resources, accessed April 2012. http://www.nea.gov/resources/lessons /grenzeback.html.

25. Stacey Bumpus, "5 Ways to Start an Emergency Fund," *LearnVest.com*, August 14, 2012, accessed January 2013. http://www.learnvest.com /knowledge-center/5-ways-to-start-an-emergency-fund/.

26. *Business Wire*, "Monster Meter Poll Reveals 34 Percent of U.S. Workers Surveyed Have Only One Week or Less of Savings to Cover Expenses if Laid Off from Work," August 25, 2009, accessed May 2012. http://www .businesswire.com/portal/site/google/?ndmViewId=news_view&newsId =20090825005344&newsLang=en.

27. American Institute of Certified Public Accountants, "360 Degrees of Financial Literacy," accessed May 2012. http://www.360financialliteracy.org.

28. American Institute of Certified Public Accountants and Ad Council, "Feed the Pig," accessed May 2012. http://www.feedthepig.org.

29. John A. Byrne, "MBA Tuition Rises 5.7% This Year." *Poets and Quants*, accessed January 2013. http://poetsandquants.com/2011/11/14 /mba-tuition-rises-5-7-this-year/.

30. "Tuition and Payment," Harvard Extension School, accessed January 2013, http://www.extension.harvard.edu/registration/tuition-payment.

31. "Cost of Living: How Far Will My Salary Go in Another City?" *CNN Money*, data as of November 2012. Compared Atlanta, GA, salary of $50,000 to San Francisco, CA, accessed January 2013. http://money.cnn.com/calculator /pf/cost-of-living/.

32. Chad Wadsworth, "The Cost of Raising a Child," *USA Today*, December 24, 2012, accessed January 2013. http://www.usatoday.com/story/money /personalfinance/2012/12/23/cost-raising-kids/1788415/.

33. Harris Interactive, on behalf of The National Foundation for Credit Counseling, "The 2009 Consumer Financial Literacy Survey Final Report," March 2009. www.nfcc.org/newsroom/FinancialLiteracy/files/2009Financial LiteracySurveyFINAL.pdf.

34. ———.

35. This language is provided for illustrative purposes only. It is not meant to be a substitute for legal advice.

36. Michael Cohn, "IRS Files Tax Liens Against Singers Lil Kim and Sean Kingston," *Accounting Today*, February 6, 2012. www.accountingtoday.com /news/IRS-Files-Tax-Liens-Singers-Lil-Kim-Sean-Kingston-61656-1.html.

37. CBS News/AP, "Wesley Snipes Begins Prison Term," December 9, 2010. www.cbsnews.com/stories/2010/12/09/entertainment/main7132784.shtml.

38. BostonGlobe.com, "Tax Scandals of the Rich and Famous: Richard Hatch," accessed February 2013. http://www.boston.com/business/taxes/gallery /famoustaxfraud?pg=11.

39. BostonGlobe.com, "Tax Scandals of the Rich and Famous: Willie Nelson," accessed February 2013. http://www.boston.com/business/taxes/gallery /famoustaxfraud?pg=32.

40. IRS, *IRS Publication 334: Tax Guide for Small Businesses* (Washington, DC: Department of the Treasury, Internal Revenue Service, 2011). http://www.irs.gov/pub/irs-pdf/p334.pdf.

41. "Bartering Income," IRS, updated January 2013, accessed January 2013. http://www.irs.gov/taxtopics/tc420.html.

42. IRS, *IRS Publication 583: Starting a Business and Keeping Records* (Washington, DC: Department of the Treasury, Internal Revenue Service, 2011). http://www.irs.gov/pub/irs-pdf/p583.pdf.

43. Richard Florida, "Rise of the Creative Class," *Washington Monthly*, May 2002. http://www.washingtonmonthly.com/features/2001/0205.florida.html.

44. James Schiavone, "4 Tips to Stay in the Loop on your Finances," *AICPA Insights*, April 27, 2012, accessed May 2012. http://blog.aicpa.org/2012/04/4-tips-to-stay-in-the-loop-on-your-finances.html.

45. Marc Hedlung, "Why Wesabe Lost to Mint," (blog post), Precepie.org, accessed May 2012. http://blog.precipice.org/why-wesabe-lost-to-mint.

46. US Small Business Administration, "Create Your Business Plan," accessed January 10, 2013. www.sba.gov/category/navigation-structure/starting-managing-business/starting-business/how-write-business-plan.

47. "Form 4592 Specific Instructions: Part I Election," IRS, 2011, accessed May 2012. http://www.irs.gov/instructions/i4562/ch02.html#d0e397.

AllPsychologySchools.com. "Counselor and Psychologist Salary Ranges." Accessed May 2012. http://www.allpsychologyschools.com/psychology-careers/article/salaries.

American Institute of Certified Public Accountants. "360 Degrees of Financial Literacy." Accessed May 2012. http://www.360financialliteracy.org.

American Institute of Certified Public Accountants and Ad Council. "Feed the Pig." Accessed May 2012. http://www.feedthepig.org.

Apple.com. "Apple Store: iWork." Accessed May 2012. http://store.apple.com/us /product/MB943Z/A?fnode=MTY1NDAzOA.

Bernard, Tara Siegel. "Why a Budget is Like a Diet—Ineffective." *New York Times*, December 31, 2010.

Cultural Data Project Governing Group. "CDP Blank Profile." 2011. http://www .culturaldata.org/wp-content/themes/cdp/pdf/CDP-BlankProfile.pdf.

Gladwell, Malcolm. *The Tipping Point*. Excerpt from Chapter 2: Are You a Connector? Gladwell.com. Accessed May 2012. http://www.gladwell.com/tippingpoint/tp _excerpt2.html.

Hill, Rodger B. "Historical Context of the Work Ethic." 1992, 1996. Last updated June 2005, Accessed May 2012. http://www.coe.uga.edu/~rhill/workethic/hist.htm.

Internal Revenue Service. *2011 Form 1040-ES Tax Package: Estimated Tax for Individuals*. Washington, DC: US Department of the Treasury, Internal Revenue Service, 2011. http://www.irs.gov/pub/irs-pdf/f1040es_11.pdf.

Intuit.com. "What People Are Saying about Quicken." Accessed May 2012. http:// quicken.intuit.com/quicken-personal-finance-software-reviews.jsp.

———. "Our Brands." Accessed May 2012. http://about.intuit.com/brands/.

———. "QuickBooks." Accessed May 2012. http://quickbooks.intuit.com/commerce /catalog/home.jsp?_requestid=46107.

IRS.gov. Form 4592 Specific Instructions: Part I Election. Accessed May 2012. http:// www.irs.gov/instructions/i4562/ch02.html#d0e397.

iTunes Preview. "iReconcile—Checkbook, Budgeting, & Reporting." Accessed May 2012. http://itunes.apple.com/us/app/ireconcile-checkbook-budgeting /id334050665?mt=8.

———. "Toshl Finance." Accessed May 2012. http://itunes.apple.com/us/app/toshl /id384083725?mt=8.

Kestner. John. "Proverbial Wallets." Accessed May 2012. http://eco.media.mit.edu /static/proverbialwallets/index.html.

Microsoft.com. "Microsoft 2010 Home & Business." Accessed May 2012. http://www2 .buyoffice.microsoft.com/usa/?torb=3&WT.mc_id=ODC_ENUS_GenBuy_Control.

Mint.com. "Back in the Day." Accessed May 2012. http://www.mint.com/company.

Patzer, Aaron. "Mint Acquired by Intuit for $170m Two Years After Winning TC40." *Tech Crunch*, September 2009. Accessed May 2012. http://techcrunch .com/2009/09/14/the-value-of-techcrunch50-mint-acquired-by-intuit-for-170m -two-years-after-winning-tc40/.

Quicken. "Budgeting: Stretch a Small Income." Article ID: INF16207, August 11, 2011. Accessed April 2012. http://quicken.intuit.com/support/help/money-guide /budgeting--stretch-a-small-income/INF16207.html.

Schiavone, James. "4 Tips to Stay in the Loop on Your Finances." *AICPA Insights*, April 27, 2012. Accessed May 2012. http://blog.aicpa.org/2012/04 /4-tips-to-stay-in-the-loop-on-your-finances.html.

Skidmore, Joel. "Achilles." *Mythweb.com Encyclopedia*. Accessed May 2012. http://www
 .mythweb.com/encyc/entries/achilles.html.

———. "Sisyphus." *Mythweb.com Encyclopedia*. Accessed April 2012. http://
 www.mythweb.com/encyc/entries/sisyphus.html.

Trapani, Gina. "8 Great Quicken Alternatives." *PC World*, August 23, 2007. Accessed May
 2012. http://www.pcworld.com/article/136799/8_great_quicken_alternatives.html.

Wray, Andrew. "Top 5 Budget and Personal Financial Apps for iPhone." *iMore*, May 10,
 2011. http://www.imore.com/top-5-budget-finance-tracking-apps-iphone.

YouNeedaBudget.com. "Features." Accessed April 2012. http://www.youneedabudget
 .com/features.

INDEX

Elaine Grogan Luttrull, CPA, is the founding owner of Minerva Financial Arts, a company devoted to improving financial literacy among artists and arts organizations through tax services, budgeting support, business planning, and education. She teaches at the Columbus College of Art and Design and The Ohio State University, and she previously served as the director of financial analysis for The Juilliard School and in the Transaction Advisory Services practice of Ernst & Young in New York. Her presentations have been featured nationally by the DeVos Institute of Arts Management at the Kennedy Center, Americans for the Arts, the Arts & Business Council of New York, the Ohio Art League, and the Foundation Center. She lives in Columbus, Ohio.

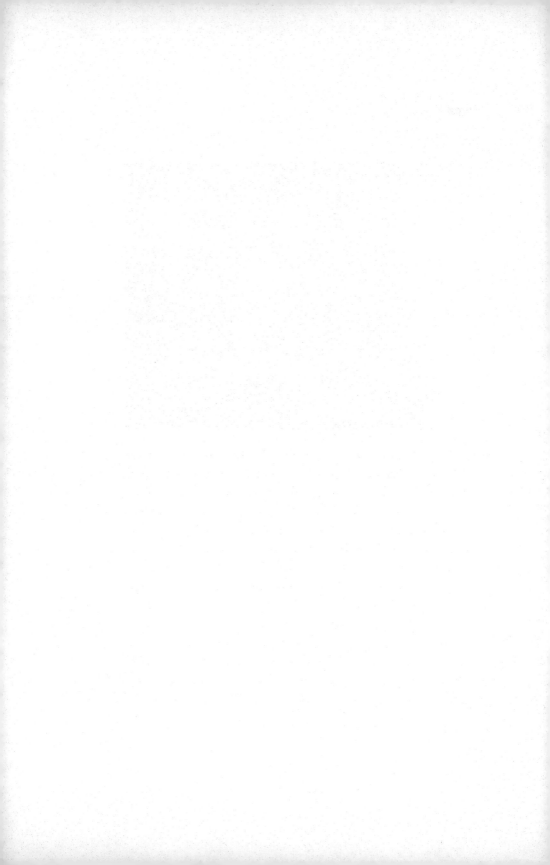

Lightning Source UK Ltd.
Milton Keynes UK
UKOW05f0835021116
286686UK00003B/189/P